R.S. PRUSSIA

THE EARLY YEARS

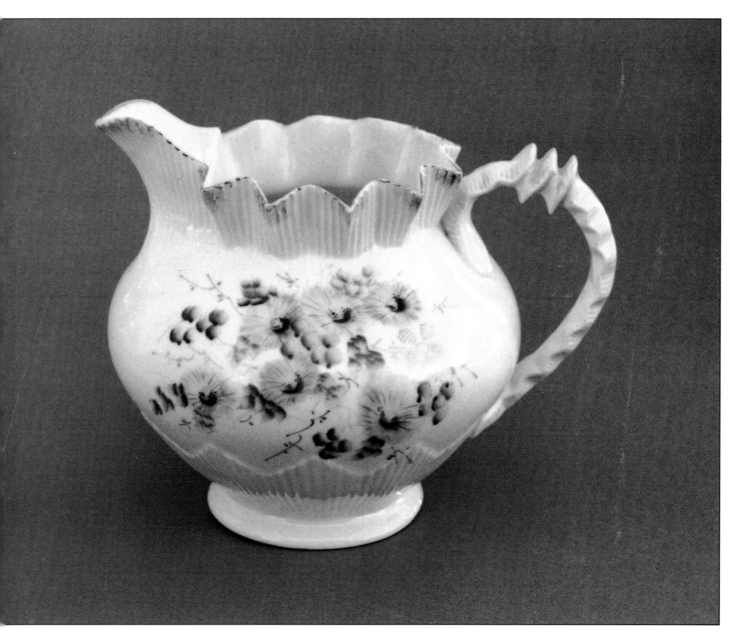

Schiffer Publishing Ltd

4880 Lower Valley Road, Atglen, PA 19310 USA

Lee & Carol Marple

Designed by Bonnie M. Hensley

Published by Schiffer Publishing Ltd.
4880 Lower Valley Road
Atglen, PA 19310
Phone: (610) 593-1777; Fax: (610) 593-2002
E-mail: Schifferbk@aol.com
Please write for a free catalog.
This book may be purchased from the publisher.
Please include $2.95 for shipping.
Try your bookstore first.

We are interested in hearing from authors
with book ideas on related subjects.

Table of Contents

Acknowledgements

The pictorial record presented in this book was made possible by the contributions of several collectors. The authors want to specially thank Delores Gilbert, Granny's Antiques (Michigan), for allowing us to photograph part of her collection, and for the additional photographs of objects we overlooked. Photographs of unusual mold patterns, such as the "Waldorf" tankards, were contributed by Tim and Gayle Nance (Florida). Our ability to illustrate the diversity of the "Melon" mold pattern is due to the generosity of Richard and Barbara Elliott (Ohio).

The search for catalog reference material was facilitated by Dr. James S. Measell, who provided us with a source for G. Sommers & Co. catalogs. These catalogs gave us the first accurate dates for the manufacture of many R.S. Prussia mold patterns.

The authors want to thank Carol Sandler, Director at the Strong Museum Library, and David Nathanson at the National Park Service Library who went out of their way to copy material from catalogs not available to us through interlibrary loan. The listing of libraries holding collections of trade catalogs sent to us by Eleanor McD. Thompson (Winterthur Museum) was of substantial help in locating additional reference material. Finally, Tim Blevins and Patricia McCann at the New Mexico State University Library were exceptionally helpful in retrieving and reproducing archived material in the Amador Collections, part of the Rio Grande Historical Collections. The variety and depth of catalogs in this collection provided us with a completely new perspective for the production of china by Reinhold Schlegelmilch, and contributed significantly to the documentation for objects illustrated in this book.

Introduction

The purpose of this book is to provide an insight into the early porcelain manufactured by the Prussian firm of Reinhold Schlegelmilch Porzellanfabriken und Malerei (Reinhold Schlegelmilch Porcelain Factory and Painting Studio.) Our motivation is to correct many of the misconceptions about the china produced by this firm for the American market. Even though a great deal has been written previously about R.S. Prussia, most has been based on folklore, rather than fact. Collectors owe a great deal to the pioneering effort of Bernd Hartwich (Leipzig) in setting the record straight about the operations of Suhl porcelain manufacturers. No less important is the contribution of R.H. Capers, for translating Hartwich's thesis[1] and relevant parts of several issues of the German *Adressbuch der Keram-Industrie* (Directory of the Ceramic Industry, or more commonly, the Coburg Directory). These publications provide details of the changing economic fortunes of the Reinhold Schlegelmilch firm over the years of its operation.

What we seek to do here is to begin a chronological presentation of the porcelain (china) exported to America by the firm prior to 1900. Two events have made this possible. First, we developed a simple, yet accurate comparative process for identifying the china produced by this firm. The crucial part of this process is the organization of objects into overlapping two-dimensional sequences according to their mold and transfer patterns. Second, we accessed trade catalogs published by both wholesale and retail concerns. Most of the known R.S. Prussia mold patterns produced up through 1911 can now be dated from their appearance in one or more of these catalogs.

R.S. Prussia produced up to the turn of the century may be classified into two categories. From 1869, the opening of Reinhold's Suhl factory, to 1892, a variety of objects are known to have been exported to the United States. However, none appear to be illustrated in the wholesale or retail catalogs we have examined. As a result, we know very little, and are unlikely to know much more about the import china produced in this period.

China in the second period, and subject of this book, was made between 1893 and 1900. During this time, there was an overall increase in European china exported to the United States, owing partly to a lowered U.S. tariff. Floral, outline transfer decoration was used exclusively. Mold patterns during this time are known to be marked with either the RS Celebrate, RS Wing, or the RS Steeple logos. This period abruptly ended in 1900, when outline transfer decoration was largely replaced by full color decalcomanias.

R.S. Prussia carried by wholesale firms from 1900 to the beginning of W.W. I can be further classified into three additional periods. China produced from 1900 through 1904 is characterized by Art Nouveau shapes and printed floral decorating patterns. In our opinion, some of the most artistic decorative china the firm ever produced was exported during this time under the "Royal Vienna Germany" trade name. The expansion of sales to wholesale firms appears to have been the driving force for the use of many other trade names. At present, most are generally unknown to collectors.

Catalogs clearly show the china widely collected as R.S. Prussia was made no earlier than 1904 and no later than 1910. This ware is easy to recognize, as it is often marked with a classic RS Prussia Wreath. Decorating transfers incorporate a wide variety of new portrait, scenic, and still life subjects. Art Nouveau mold patterns, prevalent at first, were quickly phased out.

China produced in the third period, between 1910 and the start of W.W. I, is characterized by simple mold shapes. Embossed designs, prevalent in the previous 15 years, disappear completely. Except for the hand decorated ware of the type shipped to John Roth, highly stylized floral transfer patterns predominate. Wholesale catalogs and stationery show the firm used one or more variants of the RS Germany Wreath trademark in this period.

The retention of rather plain tableware from the Early Years is a reflection of the high regard for fine, white china. Discard and breakage over the years take a slow, steady toll. Much has been saved, however, and has worked its way into the antique trade. We hope this publication provides useful information for collectors and dealers alike, and generates a greater interest in this unique phase of Reinhold's hand painted porcelain.

Values

A presentation of this type is not complete without a value guide. Overall, our guide reflects a combination of antique dealer and collector valuations. Except for cobalt decorated items, pre-1900 ware is currently not found at specialized auctions featuring R.S. Prussia and other fine china. The value of an unmarked item from this early period is largely based on function, base color, and artistic execution. Uncommon items, such as candlesticks, letter holders, and picture frames normally command a premium. Bowls and plates with little color are frequently discounted.

There is, at present, a strong demand for objects with cobalt underglaze decoration. These items are far more expensive than their counterparts in other colors, with the possible exception of lavender. Prices of marked objects are considerably higher than unmarked ones. Regional differences may affect the availability and price of early R.S. Prussia. In our travels, we find prices much lower on either coast than in the midwest. The price range provided here reflects some of these differences.

As is common for price guides, the values are for objects in excellent condition. The set price is always quoted in the captions. The price of an item with signs of wear to gold decoration, or with chips and/or internal fractures should be far less than quoted here. On occasion, some pieces may be offered or purchased well outside either end of the quoted ranges. Neither the Author nor the Publisher assumes responsibility for any losses incurred as a result of consulting this guide.

Endnotes

1. Copies of the translation of The History Of The Suhl Porcelain Factories, 1861-1937, are available for a nominal fee from the Int'l Assoc. R.S. Prussia Collectors. Original thesis submitted in 1984 under the title *Die Geschichte der Suhler Porzellanfabriken 1861 bis 1937*.

Chapter One
Identification of Early R.S. Prussia

Collectors of R.S. Prussia are generally inconsistent in the use of the term "R.S. Prussia". Consequently, our use of this term needs to be clarified before proceeding further. We use R.S. Prussia in a very broad sense to denote **all** of the porcelain (china) produced by Reinhold's firm through the Art Nouveau movement up to W.W. I. In our experience this definition follows the practice of most antique dealers. However, it is at odds with the definition based on the classic RS Prussia Wreath trademark (Gaston 1994). In our opinion, R.S. Prussia is an excellent generic name, and should be used for more than just those objects marked with a single trademark. While an exact definition might seem to be unnecessary, it is of considerable importance. We did not recognize this until we began to methodically classify both marked and unmarked china by mold pattern and type of decoration.

In spite of many publications on the subject of R.S. Prussia, none squarely address the issue of how to identify unmarked objects. Terrell suggests identifying unmarked items by the comparison to trademarked ones (Terrell 1982). This rather obvious process works well for china produced after 1905, when the marking of china became more prevalent. However, in our experience, few identifying marks appear on china we thought to have been made before 1904.

We instinctively knew there should be some way to track the products made by a single firm. Records uncovered by Hartwich show there to be an uninterrupted flow of Reinhold's china to America from 1888 up to W.W. I. In addition, Hartwich notes "Year after year, new decor and shapes appeared which reflected the artistic influence of the then current (German) fashion" (Hartwich 1984). This evolution of mold and decorating patterns accounts for the success of our initial attempt to identify unmarked R.S. Prussia produced after 1900.

The process we finally used to identify early R.S. Prussia is easy to execute, and is based on the comparison of mold patterns and printed transfers. This is accomplished by systematically linking patterns of unknown objects to those of trademarked objects by a series of identities. Our first task was to form a reference group comprised of RS Steeple trademarked objects. The choice of the RS Steeple mark was based on an earlier registration date (December 1898) than the RS Wreath mark (March 1905) (Capers

1996). Despite statements to the contrary (Gaston 1994; Barlock and Barlock 1976), we can find absolutely no documentation for the pre-1900 use of the classic RS Prussia Wreath trademark. Photographs of Steeple marked items were collected, then arranged in a two-dimensional array. Items with identical mold patterns were placed in rows, and identical transfer patterns were put in columns.

In general, two types of decorating patterns were used on RS Steeple marked objects. Objects marked over the glaze with the red RS Steeple Germany were invariably decorated with full color decalcomanias (decals). Objects hand painted with either cobalt blue, green (cadmium ?), and red monochrome transfers were generally marked under glaze with either the RS Steeple Germany or the RS Steeple Prussia trademark shown in Plate 1. The mold/transfer positions in the two-dimensional array were adjusted to accommodate these features.

A second array was started with objects marked with the RS "Wing" mark. This mark, illustrated in Plate 2, has the necessary characteristics of a trademark, but it is not listed in the 8th (1904) edition of the *Keram-Adressbuch* or later issues (Capers 1995a, Capers 1995b). We guessed the use of this mark preceded the registration of the RS Steeple mark. Although Gaston suggests this mark was not used on export ware, owing to a perceived scarcity of marked objects (Gaston 1986), we now know collectors find them far too frequently to not have been exported to America.

In the early stages of construction of the Wing mark array, every related object was decorated by the outline transfer process. Most collectors of R.S. Prussia are not familiar with outline transfer decoration. Here, a monochromatic transfer is first applied to define the shapes of leaves, flowers, and stems. Colored enamels are then applied by hand, and fixed to the glaze by firing. Finally, gold is applied (either by brush or by transfer), fired, and polished to complete the decoration. A rare example of an object with just the outline transfer is illustrated by the mustard pot in Plate 3. This gold transfer is unusual, as most transfers are sepia or muddy green. A sepia example of the transfer in Plate 3, painted with colored enamels, is illustrated in Plate 4.

Objects having an identical mold pattern to one in the array, but no corresponding decorating pattern, were ac-

commodated by the addition of a new column. New mold patterns were accommodated by the addition of rows. An extensive addition of transfer decorated objects could be made to the segments of the RS Steeple array containing monochrome subjects. Eventually, we found we could add objects to either the RS Steeple or RS Wing mark arrays. With a simple rearrangement, we formed a single sequence of overlapping mold and transfer patterns beginning with the RS Wing mark and ending with the RS Steeple Prussia trademark.

The use of the Wing mark prior to the Steeple mark was subsequently validated by the known dates of distribution for many of the RS Wing marked mold patterns present in the array. In addition, the hand painted decoration of RS Wing marked objects may also be found on clocks, marked either "Patent applied for", or "Patented 16. July 1895." shown in Plate 5. The latter was made in accordance to a U.S. patent (#542,780) issued to R. Schlegelmilch (Suhl) and assigned to George Borgfeldt of New York.

Fortunately, objects with outline transfer decoration are readily available in the antique marketplace. In less than two years, we found many items of all kinds on the shelves of antique malls and stores throughout the country. The addition of photographs of other objects in the same systematic fashion described above greatly expanded the mold/transfer overlap, and increased our level of confidence in the identification of early R.S. Prussia.

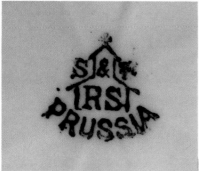

Plate 1. RS Steeple (Prussia) trademark, registered (Germany) 10 December 1898. Green underglaze.

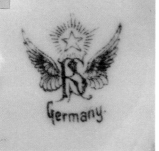

Plate 2. Unregistered mark, "RS Wing", brown overglaze.

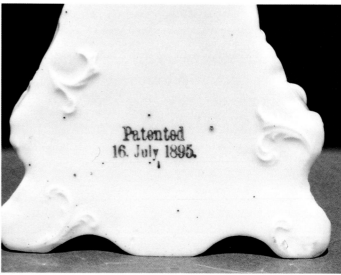

Plate 4. Example of sepia outline transfer OT 26 hand painted with colored enamels.

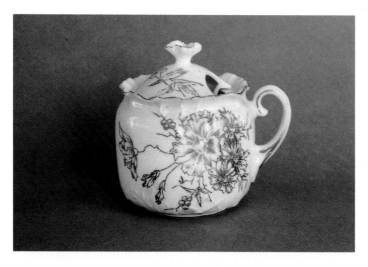

Plate 3. Undecorated example of gold outline transfer OT 26. All outline transfers are given the same number designation, regardless of the transfer color, or the colors used in painting over them. For us, some transfers have a unique feature to help in their identification. However, in this and the following captions, we designate floral transfers only by our record numbers.

Plate 5. Patented clock case, "Patented 16. July 1895." made according to U.S. Patent #542,780 filed 29 December 1894, issued July 16, 1895.

Chapter Two
Evolution of R.S. Prussia

Once the sequence linking RS Wing and RS Steeple marks had been developed, several events took place in rapid succession. First, we gained access to photographic records of several collections of outline transfer decorated ware. Second, we located a nearly continuous run of G. Sommers and Co. (B. Sommers and Co. before 1886) *Our Leader* catalogs dating from 1882 to 1912. R.S. Prussia was a significant part of the imported china section in these catalogs. Last, we located trade catalogs from other wholesale and retail firms in the archives of libraries throughout the United States. Very quickly, we had more information about china produced between 1880 and 1914 than we ever thought possible.

Catalog information changed our perception of the variety and style of porcelain ware sold before 1890. Very few porcelain objects of any kind seem to be sold through the wholesale trade. Most objects normally served a utilitarian purpose, and came from France, Bohemia, or Germany. The simple, angular shapes of the pitchers shown in Plate 6 are representative of ware from this period.

China in catalogs dating from 1890 to 1895 is very simply decorated, if at all. When painted, most designs are limited to fruit or floral subjects. On the other hand, the mold patterns are exceptionally complex. The "Coralline" pattern (spelled Coraline in Butler Bros. catalogs) illustrated in Plate 7 is representative of china produced in this period.

Another observation from wholesale catalogs is the appearance of new mold patterns on a yearly basis after 1893. In addition, few patterns were offered for more than three years, regardless of decoration. More often than not, major wholesale firms introduced a given pattern at exactly the same time. The yearly appearance of new decor and shapes is consistent with the historical aspects of Reinhold's porcelain (Hartwich 1984). Up to 1910, the introduction of new porcelain mold patterns largely took place in the Fall or Winter. Clearly, most fancy china, and especially R.S. Prussia, was sold to the trade for holiday sales.

When we combined the information from catalog sources with the information from our photographic sequence, several other facts became apparent. First, and perhaps most important, the majority of Reinhold's production at Suhl from 1869 to 1893 cannot be accounted for. In spite of an R.S. advertisement in the fourth edition of the *1893 Keram-Adressbuch* listing high tea services, ornamental containers, vases, demitasse, and everyday tea and coffee services (Capers 1995), there are simply too few catalog illustrations of any type to identify R.S. Prussia made in this period. In retrospect, the lack of interest in German porcelain may have been the direct result of the import duty first imposed by the Tariff Act of 1870. Matters were made worse by the 1883 Tariff Act. According to Hartwich (Hartwich 1984), this Act had an immediate, negative impact on Reinhold's orders from the USA. The diminished ability to compete in the American market was not relieved by the McKinley Tariff Act of 1890. Not until the Tariff Act of 1894 was the duty for decorated goods dropped from 60% to 35%, a rate making European china affordable to American buyers.

Second, beginning in 1894, imported porcelain products began to be marketed aggressively by wholesale firms. Ware from the combined R.S. factories at Suhl and Tillowitz were featured in the sections of "Fancy Imported China." While a lower tariff suddenly made European china less expensive, other events allowed Reinhold's firm to capitalize on the situation. In December of 1894, the "...porcelain factory was converted into an open trade company..." (Hartwich 1984). This change may have been needed to expand product sales to wholesale distributors. Certainly, the opening of the Tillowitz plant in early 1895 was another factor. Not only did this plant add manufacturing capacity, it did so at a lower unit cost. Collectively, these factors contributed to what was to become an explosive growth in R.S. Prussia exports to the United States.

The third conclusion we reached from combined sources is the use of "Carlsbad" china to denote early R.S. Prussia in many catalogs. We also have catalog examples of china described as either "Carlsbad", or "French made", but marked with "Germany" trademarks. These catalog references were confusing until we recognized they were used to denote quality, rather than a country of origin. The best European china produced outside France was often made of kaolin clay mined from deposits in Zedlitz (near Carlsbad), Austria. Known R.S. Prussia mold patterns are also found to be described as extra fine china, or fine transparent china. The distinction of R.S. Prussia from china of other firms in pre-1900 catalogs is made possible by our

combined Wing/Steeple array, by key words in the catalog description, and by the price. Invariably, R.S. Prussia objects are among the highest priced in any category.

Concurrent with the acquisition of catalog information, we augmented our initial photographic sequence with pictures from other collections. This had two immediate consequences. First, we incorporated objects having the RS "Celebrate" mark into the beginning of the Wing/Steeple sequence. The RS Celebrate mark, Plate 8, was used for George Borgfeldt and Co., a known importer of early R.S. Prussia. The Borgfeldt company was based in New York, New York, and was exceptionally active in U.S. trademark registration from 1895 to 1926. While several American trademarks for china were registered prior to 1900, the RS Celebrate mark was not among them. Based on the mold patterns we know of, the earliest we expect the mark to have been used is 1895. The red back stamps "Patent applied for" and "Patented 16. July 1895." found on clocks with china cases put their manufacture after the beginning of 1895. The outline transfer decoration on these patent dated clocks is identical to the decoration used on RS Wing marked objects. We are now certain the RS in the RS Celebrate and RS Wing marks is an abbreviation for Reinhold Schlegelmilch. Unfortunately, we have not been able to locate any catalogs or other advertising material from the Borgfeldt firm.

The second consequence of information from other collections was a further increase in the overlap within the Wing/Steeple array. At first we did not understand why some transfers could be found on so many different mold patterns. Ultimately, we realized this is the result of the way R.S. Prussia was marketed. Many wholesale catalog descriptions include "assorted colors", or "no two alike." The 1896 Butler Brothers catalog description in Plate 9 gives an example of "assorted decorations", a common phrase in catalog listings. The high degree of overlap within the array is no more than a consequence of a limited inventory of transfers. This practice, used most likely to control manufacturing costs, provided us the means to reconstruct a large part of the sequence for the introduction of R.S. Prussia into the United States.

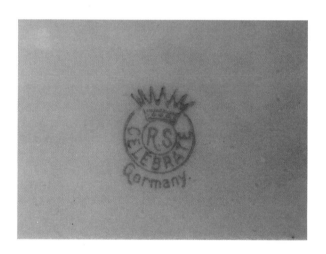

Plate 8. Unregistered RS Celebrate mark used for George Borgfeldt & Co.

IMPORTED

CHINA HOUSEHOLD GOODS.

Comprising a small line of staple selling articles, which represent quantity importations of unprecedented magnitude. The prices speak for themselves.

China Plates—7-inch, basket pattern, having elegant gilt bands and hand-painted center in fruit or flower decorations. Put up ⅓ dozen assorted designs in a package. A splendid article for table use, card plate, or ornamental use........ *Doz.* $1 95

China Plate—8-inch, superfine, delicately tinted designs in various shapes, such as representing a napkin upon a plate., etc.. etc. They are exquisitely beautiful and will sell fast. ⅓ doz. assorted in pkg.... 3 95

OUR DIME ASSORTMENT
HAND PAINTED CHINA PITCHERS.

A wonderful article for the money, really worth double price. They are just right for a liberal sized cream pitcher or make a beautiful ornament. Assorted in 4 shapes and 12 decorations to the doz. Packed 1 dozen in box.
..........Order here. Price, 89 cts. per doz. *89c. per dozen.*

Gross. *Doz.*

Our 25c. Assortment Cream Pitchers—Consisting of the same elegant assortment offered by us last season, but on which we could not begin to supply the demand. The assortment comprises six different shapes and assorted hand painted decorations to the box. The pitchers are large and are just right for table use. At 25 cents they will sell at sight. Put up ⅓ dozen to a box $2 10 *One of the pitchers in our 25c. Assortment.*

Our 50c. Assortment Table Pitchers—Consists of six beautiful large pitchers in four patterns and assorted hand painted decorations. These beautiful pitchers hold nearly a quart, and are in point of excellence unsurpassed. They are almost too good for table use, yet are strong and serviceable. Put up ⅓ dozen in box............ 3 90

Plate 6. Butler Bros. "Our Drummer" 1885 catalog illustration of typical china pitchers sold from about 1882 to 1890. *Courtesy Strong Museum Library.*

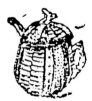

Plate 7. The Maze (San Francisco) 1894 retail catalog illustration of china mustard pot. *Courtesy of Davidson Library, University of California Santa Barbara.*

Mustard Pots.
12056—Gold Stippled, fine china, 25c.
12057—Tinted Decoration, fine china, 25c.
12058—Cobalt Blue and White, fine china, 25c.

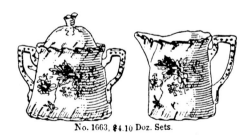

No. 1663, $4.10 Doz. Sets.

No. 1663, Pleated Design—Gold edges, handles and knob, handsome floral decorations, made of thin transparent china, pitcher 3½ inches high, sugar 3¼, but very large in circumference. Assorted decorations in pkg. of ¼ doz...... 4 10

Plate 9. Illustration of No. 1663, cream and sugar set offered in "assorted decorations" in a Butler Bros. 1896 catalog. *Courtesy of the Strong Museum Library.*

Chapter Three
Wholesale Distributors of R.S. Prussia

Beginning in 1895, the amount of imported china carried by wholesale firms grew rapidly. R.S. Prussia was at the forefront of this growth, with catalog listings after 1900 often rising 50% within a two year period. Part of this growth was due to the way German manufacturing firms sold to American representatives and wholesale firms.

At the beginning each calendar year, Reinhold's firm sent a very large shipment of sample stock to each wholesale firm. These goods were made from new and existing production molds, and thus contained exact representations of the merchandise to be delivered in the Fall. The wholesale firms were billed for these samples, but at a large discount from the regular price.

Once received, the samples could take several routes. One option was to give them to travelling salesmen representing the wholesale firm. Nerlich (Canada) used this approach to increase their wholesale orders. C.E. Wheelock (Chicago), after making their Fall selections, normally sold the samples in large lots to department stores. Butler Bros. displayed them in their sample houses for viewing by interested customers. Those wholesale firms ordering merchandise for later sale through catalogs also sent selected samples to artists for the creation of catalog illustrations.

Orders by wholesale firms had to be placed very early in the year so there would be sufficient time to manufacture and ship the finished goods by early Fall. Just as the wholesale shelves began to fill, orders began to arrive from retail merchants, as Fall catalogs were already in their hands. Immediate shipment from stock guaranteed a fast turnover by the wholesale firm, and in addition, guaranteed the retail merchant the receipt of goods before the holiday buying season got underway.

We learned of the sequence above from a note accompanying a color illustration in a 1903 C.E. Wheelock wholesale catalog. In this year, the firm did not immediately sell their samples, but retained them for their regular trade. Combined samples from German manufacturers were offered in large, 20 dozen lots for $50. The discount for individual items ranged from 10 to 33%. We were aware of the sudden appearance of R.S. Prussia in Fall catalogs of firms publishing several catalogs per year. However, we were unaware of the role marketable samples played in the sale of German export goods to American buyers.

Two additional consequences of the sampling programs used by German export firms are in need of further comment. First, if a given mold/decorating pattern combination was not ordered by any American firm in the Spring, no more was made. Therefore, some objects are here only because of their sample status. Chapter 8 takes on added significance, owing to the likelihood of including scarce, sample objects.

The second consequence of the sampling program is that it leads us to reject one possibility for the origin of "ambiguous" marked objects made from R.S.Prussia molds. Both R.H. Capers[1] and M.F. Gaston suggest other decorating firms may be responsible for objects marked with "Germany Saxe Altenburg" or "Royal Vienna Germany". We are certain they are not. When orders for specific items were received after the shipment of samples, the firm knew exactly how much time, labor and material was going to be needed to fulfill them. Manpower levels could be quickly adjusted to meet the anticipated demand, as factory owners at the time could make arbitrary dismissals. Hartwich notes for Suhl porcelain factories, there "...were long working hours and high work intensity on one side, and part-time work and unemployment on the other."[2] Add to this the high cost of raw materials delivered to Suhl, and the limited two to three year lifetime of mold patterns, the stocking of whiteware by Reinhold's firm would be a prohibitively expensive practice. Consequently, we do not think Reinhold's firm ever manufactured an excess of whiteware before W.W. I. If our logic is correct, then there can be no sale of surplus or outdated whiteware to other German firms for decoration and export to America. We see in this early period the initial use of trade names for certain kinds of merchandise. In our opinion, these names simply facilitated the sale of similar merchandise into different avenues of the American marketplace. One must look at the events taking place in the 1900-1904 period to understand why they were needed, and why their use widened. We plan to do this in a later publication.

Most of the major wholesale firms selling R.S. Prussia in the United States produced catalogs. We were surprised to find many of these catalogs had been retained by firms, or by individuals to whom they were sent, and are now archived in historical libraries. We present below a short summary for several wholesale firms who were major distributors of R.S. Prussia.

Butler Brothers: This firm grew rapidly from a modest start in 1877. Located first in Boston, the company soon (1897) moved its headquarters to New York. The first expansion was to Chicago, (1879), then to St. Louis (1898), and Minneapolis (by 1908). Showrooms (sample houses) were located (by 1904) in San Francisco, Dallas, Kansas City, and Baltimore. Butler Bros. *Our Drummer* catalogs may be found in many locations[3]. The earliest catalog showing Reinhold Schlegelmilch china (a toy commode set) is the New York "Santa Claus" issue of 1890. To date, the earliest tableware pattern considered to be R.S. Prussia is in the "Santa Claus" issue of 1892. Beginning in 1909, R.S. Prussia offerings were reduced, and by 1910, they were virtually discontinued.

Falker and Stern: This firm was located at 144-150 Lake Street, Chicago. Showrooms were maintained in Dallas and Chicago. Falker and Stern first issued trade catalogs in 1888. Although the run in the Amador Collection was incomplete, the earliest catalog containing R.S. Prussia patterns was Fall, 1898[4]. These patterns were given various names, eg. "Clytie", a common practice among wholesale firms. Catalogs issued 1900 and later mention either RS, ST, or Schlegelmilch origin in the description of individual catalog illustrations.

G. Sommers and Co.: This firm was based at 181-189 E. Fourth St., St. Paul, Minnesota. The firm retained examples of most of their *Our Leader* catalogs issued from the modest beginning in 1882 up to 1940[5]. Shipping instructions in pre-1900 catalogs indicate merchandise was sent from San Francisco northward to the Canadian border, and east to the Great Lakes. Starting 1895, the firm imported increasing amounts of R.S. Prussia. In 1912, however, the import of all porcelain china from Europe was suddenly replaced with china from Japan.

Webb-Freyschlag Mercantile Co.: This firm was located on Delaware Street in Kansas City, Missouri. Although the firm issued *Our Traveller* several times a year, showrooms were opened in both Denver and Dallas during the holidays. This firm offered a narrow range of merchandise. However, many types of R.S. Prussia items carried by Webb-Freyschlag were not offered by other wholesale firms[6].

Endnotes

1. This proposal may be found in *Capers Notes on the Marks of Prussia*, Alphabet Printing Inc., 1996, p.70.

2. This, and other working conditions are discussed at length by Bernd Hartwich in *The History of the Suhl Porcelain Factories, 1861-1937*, p.36. Translated by Int'l Assoc. R.S. Prussia Collectors, 1993.

3. Butler Bros. catalogs from the 1890-1910 period are at the Strong Museum Library (NY), New York State Library (NY), Amador collections -Rio Grande Historical Collections (RGHC) - New Mexico State University Library (Las Cruces), and at the National Park Service Library -Harpers Ferry Center WV. Catalogs from later years are also in private collections.

4. Falker and Stern catalogs can be found in the Amador Collections.

5. G. Sommers & Co. catalogs can be found at the Minnesota Historical Society Library, St. Paul (MN)

6. Webb-Freyschlag catalogs may be found in the Amador Collections.

Chapter Four
The Mold - Large Outline Transfer Matrix

The principle of the matrix, and details of its construction were developed in Chapter 1. Even though the matrix forms the basis for the presentation of illustrations in Chapter 6, it is essentially a data table. We think it unlikely for collectors to want to study this table at first reading, so it is included as Appendix 1. There are, however, two aspects of the matrix warranting further comment.

First, the degree of overlap of mold and transfer patterns is easily visualized from the matrix. This relieves us of the need to illustrate every transfer pattern used on each of the mold patterns. Accordingly, we are able to better represent the diversity of objects in Chapter 6. To be sure we included examples of each transfer pattern; however, we also prepared the Transfer Pattern/Plate Number cross-reference table, Appendix 2.

Second, we need to emphasize the absence of restrictions in the construction of the matrix, other than those already specified. If an object could be added to the matrix, it was. The inclusion of very plain and sometimes ugly objects is an unavoidable consequence. In addition, the potential for inclusion of china from other manufacturers is undiminished. In this regard, we find we have yet to add an example we suspect to have been made by a firm other than Reinhold Schlegelmilch, in spite of our examination of more than 2,000 objects. Having said this, we need to make an exception in the case of objects decorated with small, printed transfer patterns. The small transfers on the heart shape box illustrated in Plate 544, also appear on "Brunswick" trademarked objects from the Furstenberg factory. Unlike outline transfers, printed transfers used by Reinhold's firm were likely to have been sent to other firms. The use of identical decals on porcelain produced by different firms is quite rare, and not a particular problem until the start of the next, post-1900 period.

Chapter Five
Mold Identification and Numbering System

Prior to deciding on a format for the illustrations, we asked collectors and dealers of R.S. Prussia how they try to identify unmarked objects. Almost without fail, the mold pattern was the first, most important, and sometimes only criteria mentioned. We began to realize it is very confusing to use a system where two or more numbers are used for the same mold pattern. Accordingly, we present each mold pattern separately, and in a sequence closely following the known or approximate year of introduction.

Transfer patterns are not systematically numbered. Some OT (outline transfer) patterns used on early ware were discovered after patterns on later ware had already been numbered. Several patterns may be found in other books[1]. We used previous assignments rather than create new transfer pattern numbers.

Illustrations for each mold pattern are not presented in the same order as the decorations appear in the matrix. For each mold, we first show marked items, then plates, bowls, sugar/cream sets, table sets, tea sets, chocolates, and small pieces. Handle and finial variations are treated as a subsection of the mold by the addition of a letter to the mold number. Generally, objects with full color, small printed decals are put at the end of each mold section.

The comparison of outline transfer patterns requires considerable attention to detail. Various color combinations may be used with a given transfer. When this happens, the overall appearance may be quite different. Moreover, not all of the outline may have been applied if it failed to fit on an object. If a transfer pattern looks unfamiliar, one may find it to be part of a larger pattern. While photographs usually suffice, a side-by-side comparison is occasionally needed to assure the identity of two transfers.

Finally, we need to emphasize the individual input into the quality of painting. Some paintings are excellent, most are just what one would expect to find on common tableware. However, the unique nature of the designs and the painting of them restricts them from being copied by other manufacturers. The appearance of a given transfer pattern on objects made from several mold patterns virtually guarantees their manufacture by a single firm.

Endnotes

1. Several types of outline transfer patterns appearing on RS Steeple marked ware have been coded by Mary F. Gaston in *The Collectors Encyclopedia of R.S. Prussia*, (Collector Books, Paducah, KY, series 4, p. 25ff)

Chapter Six
Mold Patterns with Large Transfer Decoration

This segment features R.S. Prussia molds decorated with large outline transfers. The minimum requirements for a mold pattern to be included in this section are 1) two different outline transfers must appear on the mold, and 2) the identical transfers must appear on other mold patterns. Not all of the mold patterns we started with met these requirements. Consequently, some patterns have either had to be deleted, or moved to the final section of examples with one identified transfer pattern.

We start the presentation of many mold patterns with a catalog illustration. Most firms usually carried a given pattern for several years, and we note this information in the caption. Other firms carrying the same pattern are noted as well, along with the known years of sale. Catalog descriptions are reproduced from the original source.

For each caption, we provide a very brief description of the object, followed by the mold pattern number, outline transfer number, and size. When appropriate, mark information follows. Uncommon marks on early R.S. Prussia are reproduced in the Plate following the marked object. We also provide a trivial name for the mold pattern if it helps us with pattern recognition.

The few printed color transfers appearing in this section generally fall into two categories. The first category is comprised of compact floral clusters and these clusters are designated by the prefix P. The second is comprised of full color transfers (decals) appearing in later years on the Hidden Image mold pattern. These transfers are given an "HI" prefix, even though they may appear on objects marked with R.S. Prussia trademarks.

Clearly, several levels of decoration were used on early china. Extensive use was made of gold stencils showing birds or trees on either plain or lightly shaded ware. We have noted these as the "bird", "palm", "daisy", and "daffodil" transfer patterns. These decorations were the easiest to apply, and they generally appear on the least expensive china. On the other hand, the application of color required additional firings in the kiln. Without question, hand painted transfer decorated ware was expensive to produce, and therefore sold at a premium on either plain or gold decorated goods.

Certain colors, such as pink, blue, green, and (to a lesser extent) yellow, appear on early sets of plates or bowls. This is not surprising, in retrospect, as these items were usually sold by the dozen or half-dozen lots of assorted tints. At the beginning of this period, color, as well as gold, was used sparingly on much of the ware. Generally, a light apple green is the predominate color for this period. A true representation of this color in photographs, and hence the illustrations, is difficult to achieve. The more uncommon colors are bright red and cobalt blue, but lavender is by far the most scarce.

Marks on early R.S. Prussia are found infrequently. This section includes many, but not all of the mold patterns known to be marked. Marked objects not meeting the minimum requirement are included in the section of mold patterns with one identified decoration.

We start this section with a preliminary "A" series of molds. We are certain these mold patterns were produced at Suhl. Our difficulty in showing this is due to the lack of decoration. They are therefore set aside from the following OM (Old Mold) series of molds owing to the minimal number of overlapping decorations. There inclusion is warranted, however, as they are the first patterns to be used on a variety of porcelain objects offered by major wholesale firms prior to 1895.

Molds A1 and A4 appear in several 1893-1895 trade catalogs. Many different objects in these patterns were placed rather quickly into the existing wholesale distribution system. To place this variety of merchandise would have been difficult for a foreign manufacturer unless they had already established a demand for their products. In our opinion, these two mold patterns were the first to be sold to American wholesale distributors by Reinholds' firm.

The identical hand painted decoration on both Mold A1 an A2 clearly link these two molds to the same origin. In addition, the two outline transfers, OT 6 and OT 61, provide an overlap with documented R.S. Prussia objects. Molds A2, A2V, OM 2, and OM 10A appear with an unusual puffed flower decor. While similar, the variation of individual flowers is sufficient to assure their application as part of the decorating process. The raised dots appearing on Mold A3 were also applied as decoration, for there is just enough random variation, and coalescence of dots, to rule out application by a mechanical process. In objects we have examined, the number of dots per square inch averages between 75 and 95. Were it not for the decora-

tion, the total number of dots on a 10.5" plate would be in excess of 6,400. The labor cost in the production of these objects must have precluded them from being classed as common tableware, and their import may have actually preceded the 1894 easing of American import duties.

Finding an example of the Coralline pattern, Mold A4, was the result of our routine inspection of either the bottom or the back of an unusual piece of porcelain. Occasionally, we are pleasantly surprised. The red color of the Coralline mark, plus the branch, immediately suggested an R.S. origin. When we began to look, it was clear a wide variety of objects in this pattern were carried by several major wholesale firms. Even though mold pattern A5 is illustrated in Butler Bros. catalogs, we did not recognize it until sorting through photographs for inclusion here. Only in the final weeks of preparation of this book did we find sufficient decorated examples of both Molds A4 and A5 to link them to OM mold patterns.

Well documented R.S. Prussia mold patterns are found in the OM mold series. Two primary sources are used to establish origin. First, a number of patterns were in production when the RS Steeple trademark was in use. Although quite uncommon, cobalt decorated trademarked examples do exist. This fact is not generally known, and we did not find it out until we started keeping records. Second, the overlap of hand painted transfer outline decoration links RS Wing, RS Steeple, and RS Celebrate marked mold patterns. This continuity can result only when one manufacturer is involved in the production of these patterns.

The OM section of molds begins with a Mold OM 1, a pattern supplied to many wholesale firms, as well as Borgfeldt & Co. We illustrate three of the four known mold patterns, OM 1, OM 6, and one mold at the beginning of Chapter 8, known to be marked with the RS Celebrate mark. Few RS Celebrate marked objects are in collections today, owing most likely to their bizarre shapes and decoration.

Objects bearing the RS Wing mark first appear in illustrations of Mold OM 2. Examples of other wing mark objects appear in subsequent mold patterns, and a cross-index is provided in Appendix 3. Overall, the only similarity to RS Celebrate marked objects is in decorating patterns. Some transfer patterns are used on other molds, but many appear to be associated with just one mold pattern. This fact strongly supports a distribution through factory representatives. RS Wing marked objects are not particularly scarce. We have found many partly because we look for them on china most people never bother to examine, and partly because we now know what to look for.

Several decorative patterns on objects in Mold OM 2 suggest this mold may have been in use prior to 1894. The first type, illustrated in Plate 46, incorporates hand applied, raised dots. This dot pattern is distinctly different from those associated with objects marked with the RS Arrow marks. The dots on arrow marked objects are much larger and run together frequently. In addition, there are no small sections where the dots are grouped in parallel rows. The application of individual dots must have been a laborious process, even if mechanically facilitated. The high perceived value of this ware type might have been sufficient to overcome the high tariff imposed on decorated china during the 1883-1894 period.

The second type of unusual decoration appearing on Mold OM 2 is cobalt underglaze painting (eg. Plate 49). To achieve a sharp image must have been exceeding difficult, for cobalt color tends to migrate in the firing process. Here, we suspect many pieces were rejected, compared to the ones eventually exported to America. While the example we illustrate may have been a sample, we think it unlikely, as the firm was advertising their blue underglaze painting in an advertisement in the *Keram-Adressbuch-4th Edition 1893*.

Patents and other innovations seem to be recurring events in the series of R.S. Prussia mold patterns made between 1893 and 1900. The addition of a round mirror to a shaving mug in the "King George" pattern (Mold A 1) appears to be one of the first patented ideas. The same mirror appears in the shaving mug in the Coralline pattern (Mold A 4). The upside down looking handle on Mold OM 6 was purposely designed to rest on the table. The hinged lid on the syrup pitcher in Mold OM 8 was the subject of another patent. Here, the lid was designed to stay in place when the jug was tipped, but it could be easily removed for cleaning. Legal protection (Gesetzlich geschützt) was obtained for the design of Mold OM 13. A patent for porcelain clock cases made for G. Borgfeldt Co. was one of two issued in the United States by Reinhold's firm. All of these activities are consistent with Hartwich's description of the development and implementation of new technology for the manufacture of porcelain china (Hartwich 1984).

Without question, Reinhold's major innovation to show up in this period is in the marketing of products. Whether original, or copied from another firm, is something we will never know. Faced with the problem of trying to sell virtually the same product to both factory representatives and wholesale firms, who in turn were selling to retail agents at different prices, the firm appears to have created a much needed point of difference by the judicious use of trade names. Both "Royal Coburg" and "Old Vienna", illustrated in this chapter, appear on mold patterns in production before 1900. The evolution of these and other names picked up momentum in the 1900-1904 period. To a large extent, the firm could control the type of merchandise sold through a given route by limiting the type of samples sent at the beginning of the year. We currently think Royal Coburg was one of many marks used on china shipped to wholesale concerns, even though reference to R.S. Prussia marks or trademarks do not appear in catalogs until 1906.

Illustrations in Chapter 6 end with mold patterns used for a short period beyond 1900. Both outline and printed

transfers may be found on these patterns. When most of the examples were decorated with outline transfers, they were included here. Examples decorated primarily with printed transfers will hopefully appear in a later publication.

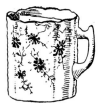

$2.20 Doz.

No. 693, $2.25 Doz.

No. 692, Transparent China Cups and Saucers—Made of superb King George ware, half-tinted inside, hand-painted in rich floral designs in colors and gold. Cup 2¾x3¼, saucer 6-inch. Fine goods, worth 35 cents. ½ doz. in pkg., assorted Quantity price.................In lots of 4 doz. or more, $2.05 2 15
No. 693, Mustache—As No. 692, mustache. ½ doz. in pkg... 2 25
Quantity price.................In lots of 4 doz. or more, $2.15

Plate 12. Catalog illustration of No. 693 cup/saucer, Mold A1, from a 1892 Butler Bros. Santa Claus edition. Note the different handle compared to the shaving mug. *Courtesy Amador Trade Catalog Collections, Rio Grande Historical Collections, New Mexico State University Library.*

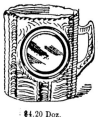

$4.20 Doz.

No. 683, 25-Cent Porcelain China Mug—Made of the transparent King George ware, cylinder shape, corrugated surface, scalloped gold edge top, half-tinted inside, tasty assorted gold and color decorations, gold lined handle, good soap partition with holes. Size 3½x3¼. ½ doz. in pkg............... 2 20
Quantity price........ 4 doz. or more, $2.10

686, Patent Mirror Shaving Mug—*For half dollar trade.* With patent beveled mirror on side, gold rimmed, transparent china, size 3½x3¼, gold edged top, half-tinted inside. Plain white and assorted decorations in pkg. of ½ doz. equally assorted.................. 4 20
Quantity price.............................When ordered in lots of 3 doz. or more, $4.00

Plate 10. Illustration of No. 683 Porcelain China Mug in the "King George" pattern from Butler Bros. 1893 Mid-Winter (Jan-Feb) catalog. Also shown is No. 686 shaving mug with Patented mirror in the same pattern. Not patented in America. This pattern was also shown in the 1893 G. Sommers & Co. and the 1894 The Maze Department Store (San Francisco) catalogs. *Courtesy of National Park Service Library, Harpers Ferry WV.*

Plate 13. Cup/saucer, Mold A1, decor OT 6, 2.75" h. $25-$50.

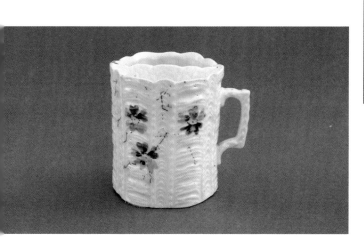

Plate 11. Shaving mug, Mold A1, decor OT A 1, 3.25" h. $25-$50.

Plate 14. Toothpick holder, Mold A1, the decor is the same as the shaving mug in Plate 11. $25-$50.

Plate 16. Tea caddy (no top), Mold A2, raised (slip painted?) flower decor, 5.75" h. The flower petals stand well above the surface. With top $100-$200.

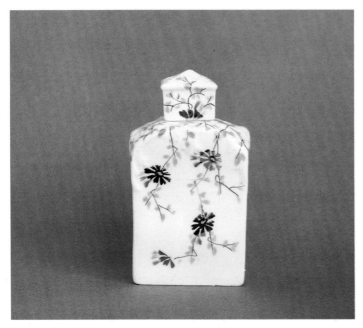

Plate 15. Tea caddy, Mold A2, same decor as Plate 14, 5.75" h. $100-$200.

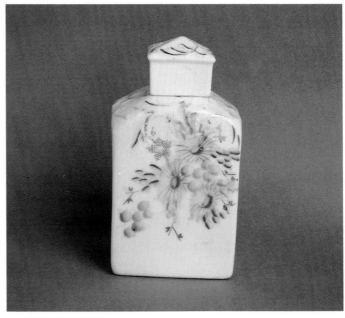

Plate 17. Tea caddy, Mold A2, decor OT 61, 5.75" h. $100-$200.

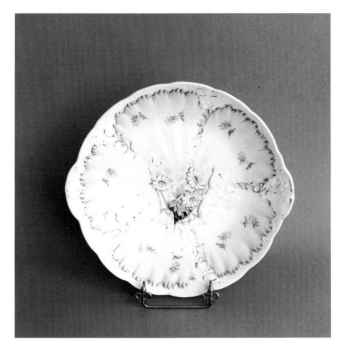

Plate 18. Charger, Mold A2 variation, raised flower decor. 10.25" d. $25-$50.

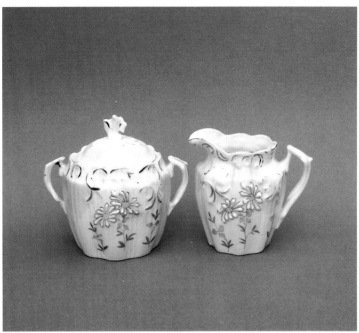

Plate 19. Cream/sugar set, Mold A2 variation, raised flower decor, sugar 5" h. $50-$100.

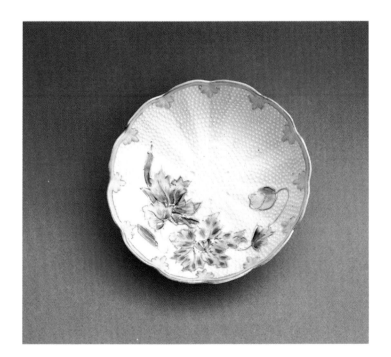

Plate 21. Plate, Mold A3, freehand flower decor OT 73, 8.25" d. The medallion in the center of the mold is frequently hidden by raised dot or floral decoration. $25-$50.

Plate 20. Deep plate, Mold A3, raised dot and freehand flower decor OT 73, 7" d. The floral pattern on this mold may be varied slightly, depending upon the size of the object. $50-$100.

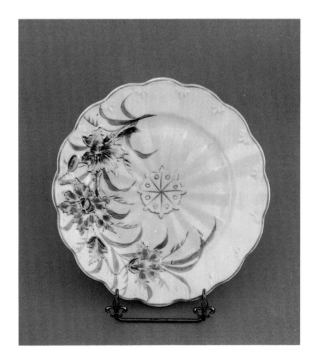

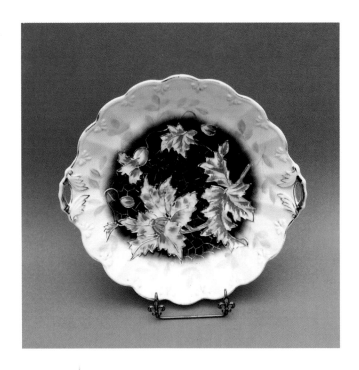

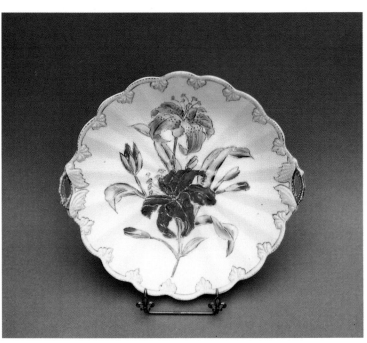

Plate 22. Cake plate, brown center, Mold A3, freehand flower decor OT 73, 11.25" d. $50-$100.

Plate 23. Cake plate, Mold A3, raised dot and freehand flower decor, 11.25" d. $100-$200.

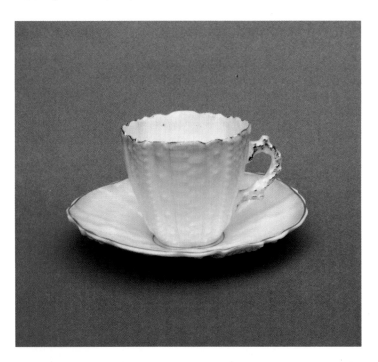

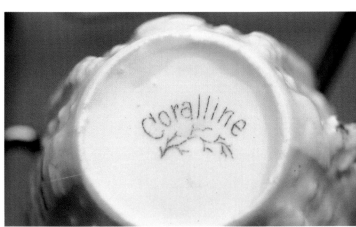

Plate 26. Close up of Coralline brand name (plus wreath), on Plate 24. $100-$200.

Plate 25. Demitasse cup/saucer, shaded blue, Mold A4, cup 2" h. Marked with "Coralline" and two crossed branches in red. This mold pattern is the more common variation of two noted as Coraline in trade catalogs. Under $25.

Plate 24. Illustration of No. 7 mug, Mold A4, offered without saucer in an 1895 Butler Bros. catalog. Many other objects were made in this pattern, called "Coraline", including several different four piece table sets. Other firms offered a two versions of this pattern, one with a shell shape in the mold, and one with coral. These patterns are also illustrated in 1893 G. Sommers & Co., 1894-1898 C.M. Linnington "Silent Salesman", and 1894 "The Maze" (retail) catalogs.

No. 679, $1.79 Doz No. 7, $1.87 Doz.

No. 679, King George Ware—Exquisite King George ware, corrugated surface, cylinder shape, size 3¼x3, half tinted inside, gold rim, gold lined handle, tastefully decorated in gold and colors. ½ doz. in pkg.... 1 79

No. 7, Coraline Pattern,—Extra large size, 3½x3⅝, transparent china in rich pattern, clouded gold rustic handle, gold scalloped top. 6 tints in pkg. of ½ doz............. 1 87

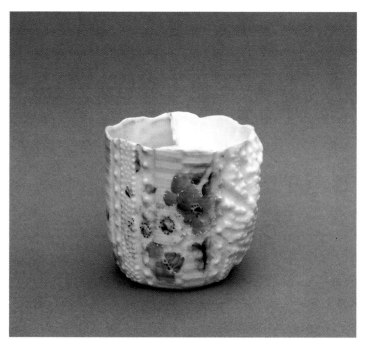

Plate 27. Shaving mug with mirror (mirror not shown), Mold A4, decor OT 7, 3" h. This mug was most likely made by the same process described for a Patent Mirror Shaving Mug, No. 686, illustrated in a 1893 Butler Bros. catalog.

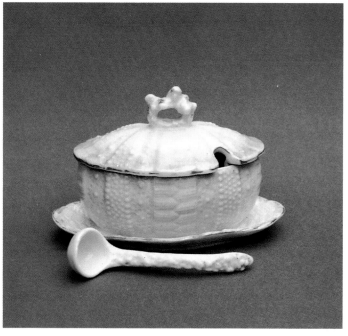

Plate 29. Mustard pot with spoon, shaded blue, Mold A4, 3.25" h. $50-$100.

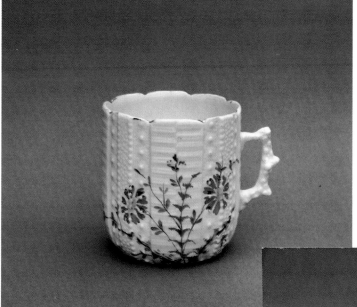

Plate 30. Small or child's tea set, Mold A4, decor OT 3, pot 4" h. $200-$400.

Plate 28. Mug, Mold A4, decor OT A1, 3.5" h. $25-$50.

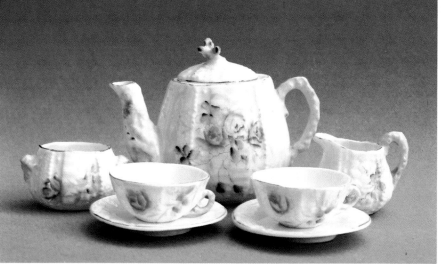

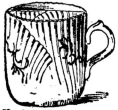 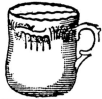

No. 812, $1.87 Doz.　　　No. 13, $1.95 Doz.

No. 812, Patent Strainer—Transparent china, fluted, 4 in each package in half tints and gold and 2 in gold decoration with colored handles, 3½x3¼. One of the best values of '94.　½ doz. in pkg....　1 87

No. 13, Gold Decoration—Transparent china, rococo shape, pure white china, gold clouded decorations, fancy soap partition with holes, gold band top and handle, 3½x3¼　1 95

Plate 31. Illustration of No. 812 shaving mug with Patent Strainer from a Butler Bros. 1895 catalog. Mold A5 is different from the later Mold OM 9 by a small, horizontal raised pattern about half way up the side of vertical objects. Also shown is No. 13 mug in Mold OM 2.

Plate 34. Covered butter dish, Mold A5, plate 6" d. $100-$200.

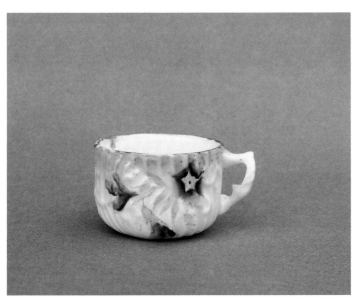

Plate 35. Cup, Mold A5, decor OT 6, 1.75" h. Under $25.

Plate 32. Celery jar, Mold A5, decor OT 4, 4.5" h. $50-$100.

Plate 33. Celery jar, Mold A5, 4.5" h. $50-$100.

Plate 36. Toothpick holder, Mold A5, daisy chain decor, 2.25" h. $25-$50.

Plate 38. Celery, Mold OM 1, decor OT 19, 6" h. RS Celebrate mark. $100-$200.

Plate 37. Illustration of The Marlboro Chocolate and Tea Set, Mold OM 1, in G. Sommers & Co. 1895 catalog. *Courtesy of Minnesota Historical Society Library.*

The Marlboro Chocolate and Tea Set. $1.50.

The "Marlboro"— No. 88. For chocolate or tea. High shaped pot with cover, and sugar and creamer to match. Magnificent gold and colored decorations.

Price per Set, $1.50.

GENUINE WORKS OF ART, AND WONDERFULLY CHEAP.

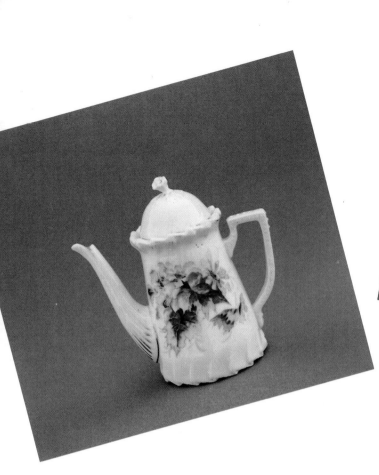

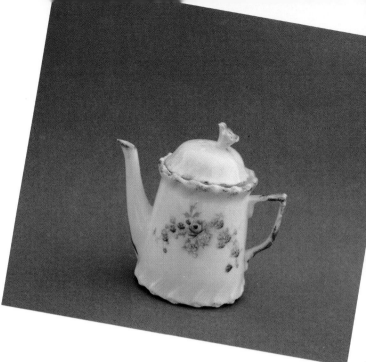

Plate 40. Teapot, Mold OM 1, decor ST 17, 6" h. $50-$100.

Plate 39. Marlboro Chocolate or Teapot, Mold OM 1, decor OT 19, 8" h. Upright pieces in this mold pattern have pleated top and bottom edges. $50-$100.

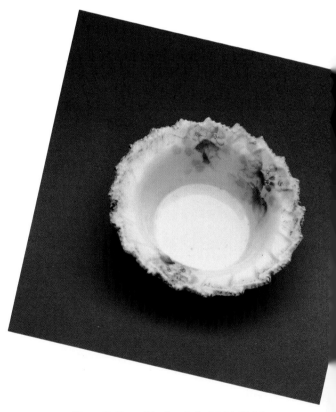

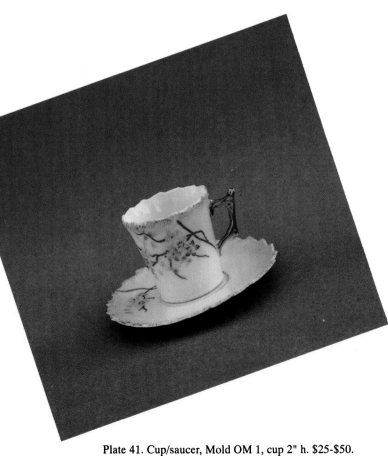

Plate 42. Ramekin (partial), Mold OM 1, decor OT 4, 3.25" d. With underplate. $50-$100.

Plate 41. Cup/saucer, Mold OM 1, cup 2" h. $25-$50.

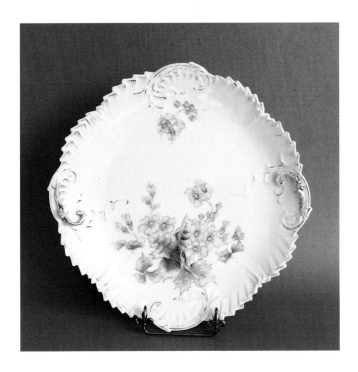

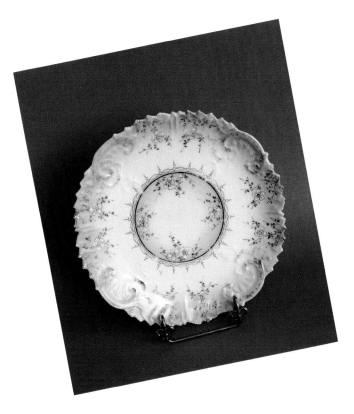

Plate 43. Cake plate with applied, raised handles, Mold OM 1A, decor OT 58, 11.5" d. Illustrated in the 1894 "The Maze" (San Francisco) catalog. $100-$200.

Plate 44. Cake plate, pink rim. Mold OM 1A, daisy outline decor, 9.25" d. $25-$50.

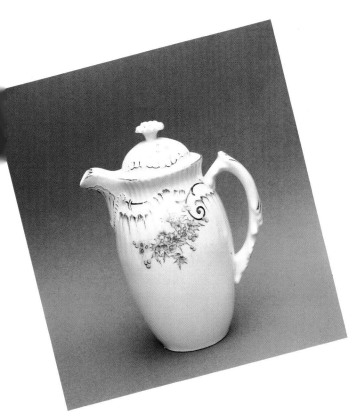

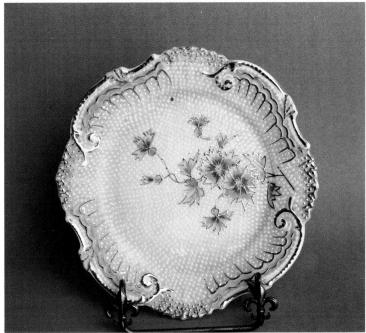

Plate 45. Chocolate pot, Mold OM 2, decor ST 20, 10" h. RS Wing mark. $100-$200.

Plate 46. Plate, Mold OM 2, decor of raised, hand applied dots around floral pattern, 6.25" d. This dot pattern, may be the Dew Drop pattern referred to in an advertisement in the *Keram-Adressbuch 4th edition, 1893*. The mold pattern is shown in the 1894 Maze Department Store, and only the 1895 Butler Bros. catalogs. $25-$50.

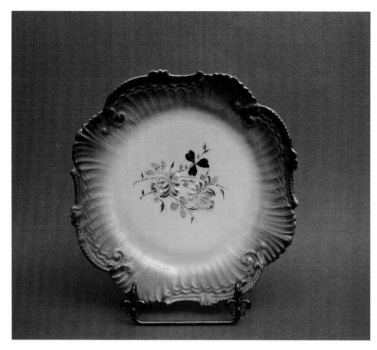

Plate 47. Plate, Mold OM 2, same applied flowers appearing on Mold A2 tea caddy, 7.5" d. Under $25.

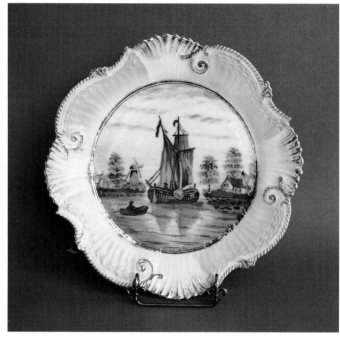

Plate 49. Plate, pink/white rim, Mold OM 2, cobalt scenic, 10.5" d. This may be the blue underglaze painting mentioned in Reinhold's advertisement in the 1893 *Keram-Adressbuch 4th edition 1893*. $100-$200.

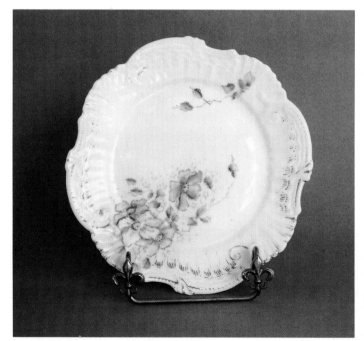

Plate 48. Plate, Mold OM 2, decor OT 39, 6.25" d. $25-$50.

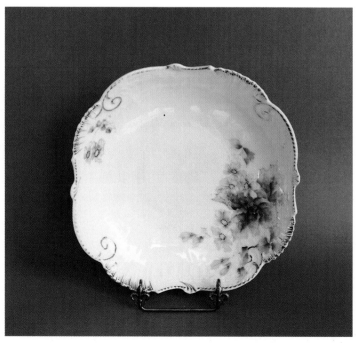

Plate 50. Shallow bowl, Mold OM 2, 9.5" d. $50-$100.

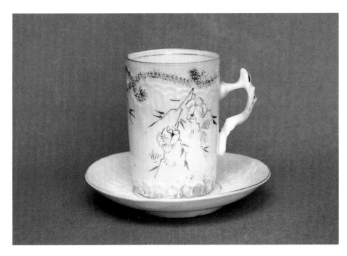

Plate 51. Cocoa cup/saucer, yellow rim, Mold OM 2, small flower gold stencil decor, cup 2.8" h., saucer 4" d. $25-$50.

Plate 54. Tray, leaf shape, Mold OM 3, decor OT 60, 6" l., 5.5" w., RS Wing mark. $50-$100.

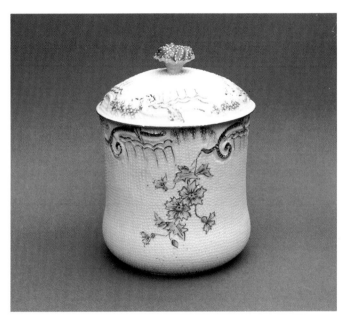

Plate 52. Biscuit jar, Mold OM 2, raised dot decor, 7.5" h. $100-$200.

Plate 53. Mustard pot, Mold OM 2, 3.25" h. $25-$50.

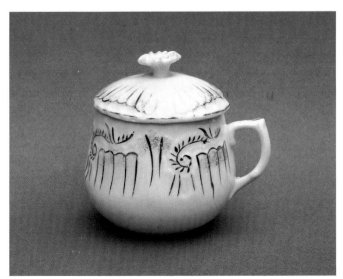

Plate 55. Tray, leaf shape, Mold OM 3, decor OT 3, 6.5" l. $25-$50.

No. 84. Fancy Tea Set. 75 cts.

No. 84—Full size, fancy china tea set, consisting of a very handsome tea pot, sugar bowl and cream pitcher. Made of Carlsbad China, shapes and decorations as shown in the cut. Last year this set would have been worth $1.25.
Price per Set Complete 75 Cents.

Tea Set—No. 80. The cut shows the shapes, but does not do justice to the delicate beauty of this dainty set. The cup is a light china, after-dinner size, and all the pieces correspond in size. Real china tray, tea pot, sugar, creamer, cup and saucer, 8 pieces.
Price per Set Complete, 95 Cents.

Full Size Tea Set—No. 86. Made of real china, but heavy enough to stand regular table use. Set consists of a handsome shaped china tea pot, holding 6 ordinary tea cups full of water; cream pitcher and sugar bowl to correspond in size and shape. Beautiful decorations.
Price per Set Complete, $1.10.

No. 80. Price, 95c.

Plate 56. Illustration of No. 84 fancy tea set in Mold OM 4, from G. Sommers & Co. Fall 1895 catalog. The crinkled shape handle is one of several used on this mold. This mold was also shown in the Butler Bros. 1896 catalogs. *Courtesy of Minnesota Historical Society Library*

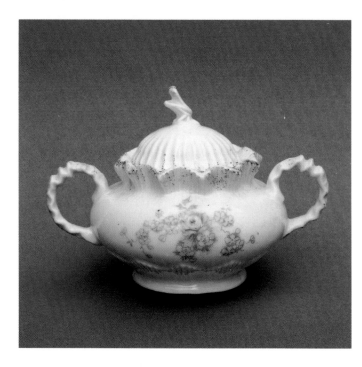

Plate 58. Covered sugar, Mold OM 4, decor ST 17, 3.5" h. $25-$50.

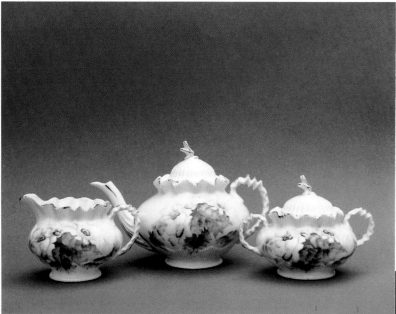

Plate 59. Cream and covered sugar set, pink edges, Mold OM 4, daffodil + chain decor. Cream 3" h., sugar 3.5" h. $50-$100.

Plate 57. Tea set, Mold OM 4, decor OT 19, pot 5" h., RS Wing mark. $200-$400.

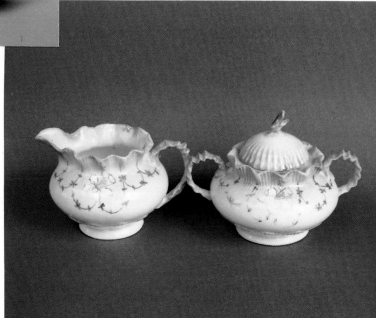

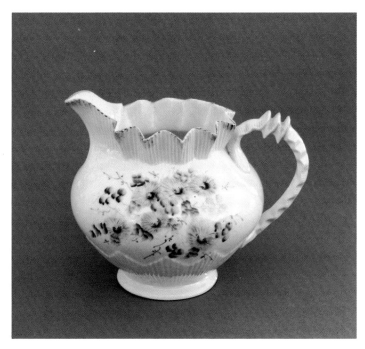

Plate 60. Lemonade pitcher, Mold OM 4, decor OT 61, 7" h. $100-
$200.

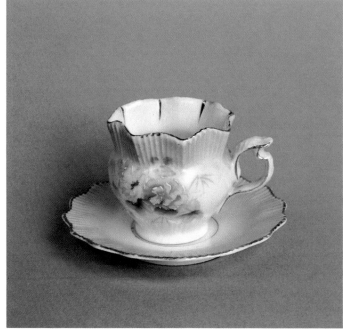

Plate 62. Demitasse cup/saucer, pink top, Mold OM 4A, decor OT
1, cup 2" h. $25-$50.

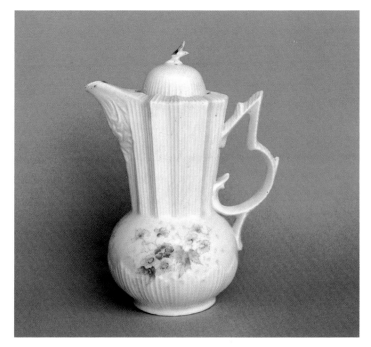

Plate 61. Chocolate pot, yellow at top, Mold OM 4A (handle
variation), decor OT 4, 8" h. $100-$200.

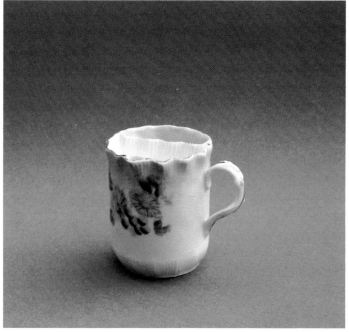

Plate 63. Shaving mug, Mold OM 4A, decor OT 61, 4" h. This item
was offered as No. 1407 ($1.60 per dozen) in a 1896 Butler Bros.
catalog. $50-$100.

No. 25. Leaf Fruit or Berry Set, $1.75

Our New Leaf Fruit or Berry Set.—No. 25. The set consists of the beautiful leaf sauce dish described elsewhere as No. 428, and six dainty leaf sauce plates to match. The whole forming the most attractive set that we have ever offered. (7 pieces.) Price per set, complete.. 1 75

Plate 64. Illustration of No. 25 heart shaped berry set from G. Sommers and Co. 1896 catalog. This mold also offered by G. Sommers & Co. from 1896-98. *Courtesy of Minnesota Historical Society Library*

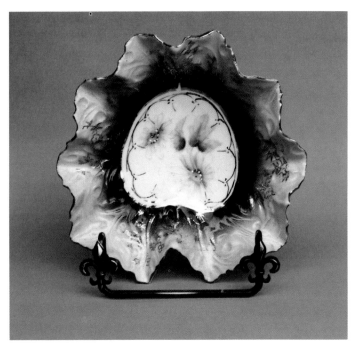

Plate 65. Individual salad or berry bowl, shaded brown edge, Mold OM 5, decor OT 21, 5" w. Under $25.

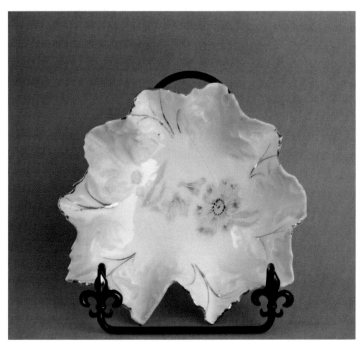

Plate 66. Individual bowl, Mold OM 5, decor OT 18, 5" w. Under $25.

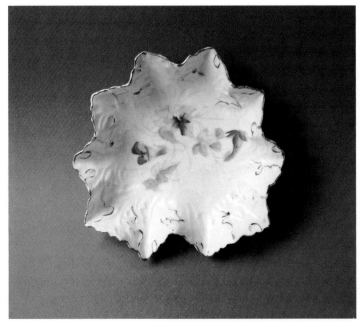

Plate 67. Individual bowl, Mold OM 5, decor OT 24, 5" w. Under $25.

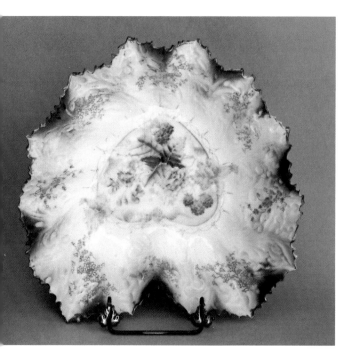

Plate 68. Salad or berry bowl, shaded brown edge, Mold OM 5, decor OT 25, 10.5" d. $100-$200.

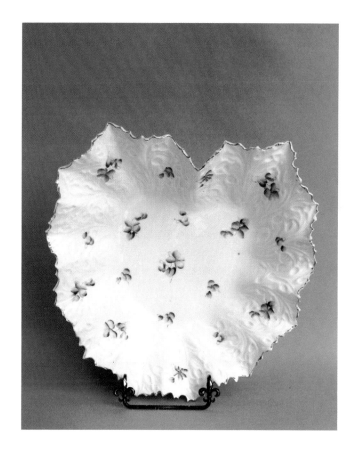

Plate 69. Salad or berry bowl, Mold OM 5, decor OT 63, 10.5" d. $100-$200.

CHOCOLATE POTS.

A few years ago considered luxuries, but now used in nearly every household.

No. 1620, Special 50c Chocolate Pot—Thin porcelain, fine white body, deep cover, covered spout, gold designs on cover, spout and both sides, large handle, good height, being 5½-inch (including cover 7¼.) A money maker for you. ½ doz. in box

No. 1621, Pleated Pattern—Large top, gold edge and knob, decorated in tints and colored flowers, total height 7 inches, odd gold ornamented handle which rests on table. ⅓ doz. in pkg...........

No. 1620, $3.50 Doz.

No. 1621, $4.15 Doz. No. 1622, $6.00 Doz. No. 1623, $8.30 Doz.

.622, Embossed Design—A beauty to offer at 75c. Tasty decoration in natural color wers with gold tracings all over, large gold traced handle, fancy cover, medium size. decorations in box of ¼ doz

623, Extra Size Chocolate Pot—Should retail for $1.25. Transparent china, rich coration in heavy gold clouds and tints; large fancy gold clouded handle and handled ver, covered spout. Each in pkg............

Plate 70. Illustration of No. 1621 chocolate pot in Mold OM 6 from Butler Bros. Fall 1896 catalog. This mold is easily distinguished from Mold OM 1 by the lack of pleats at the bottom. Also shown is No. 1622 chocolate pot in Mold OM 8, and no. 1620 chocolate pot with RS Wing mark decor. No examples of No. 1620 are known. *Courtesy of the Strong Museum Library*

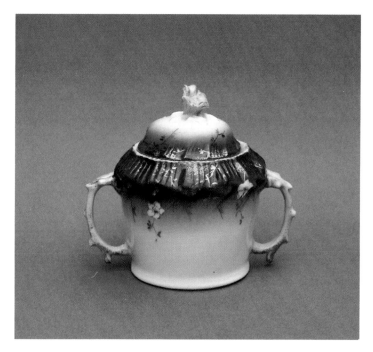

Plate 71. Sugar bowl, brown, (Upside Down Handle) Mold OM 6, daisy decor, 4" h. Handle deliberately positioned to rest on the table. RS Celebrate mark. $50-$100.

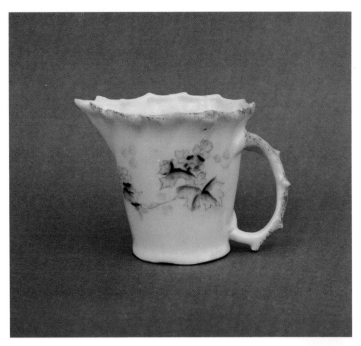

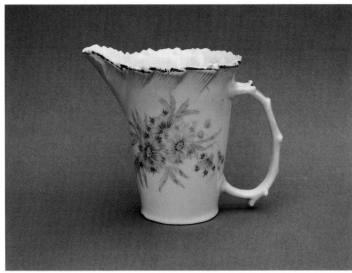

Plate 73. Pitcher, Mold OM 6, decor OT 18, 4.5" h. $25-$50.

Plate 72. Cream pitcher, Mold OM 6, decor OT 4, 4" h. $25-$50.

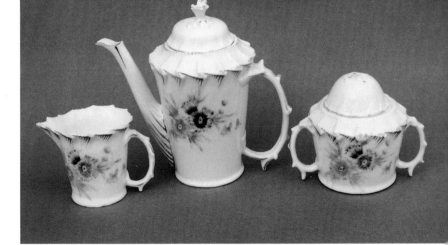

Plate 74. Tea set - pot, cream, covered sugar (finial missing), Mold OM 6, decor OT 18, pot 6.5" h. $100-$200.

Plate 76. Plate, green rim, (Beaded Ruffle) Mold OM 7, decor OT 19, 7.5" d., RS Wing mark. $50-$100.

NO. 26

Fancy shapes, floral and gilt decorations, assorted, all half dozen in a package.

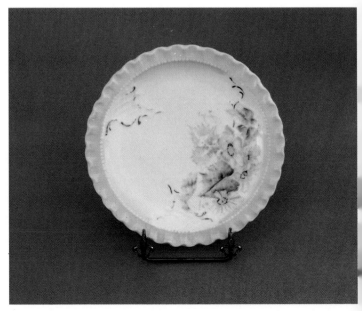

Plate 75. Illustration of No. 26 cup/saucer in Mold OM 7 from J. Zernitz 1898 catalog. This mold was also shown in the G. Sommers & Co. 1896, Butler Bros. 1896, and Webb-Freyschlag 1899 catalogs. This was a very popular pattern with wholesale firms. Catalogs show many other items not illustrated here. *Courtesy Amador Trade Catalog Collections, Rio Grande Historical Collections, New Mexico State University Library.*

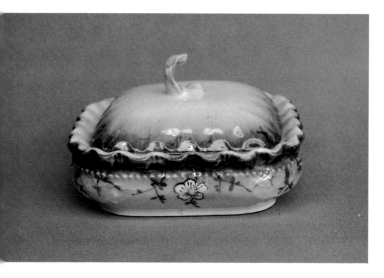

Plate 77. Box, green edge, Mold OM 7, small flower stencil decor, 3.5" w., RS Wing mark. $100-$200.

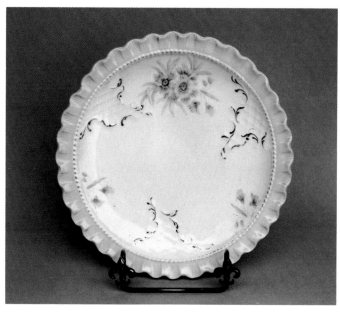

Plate 79. Plate, blue rim, Mold OM 7, decor OT 18, 7.5" d. $25-$50.

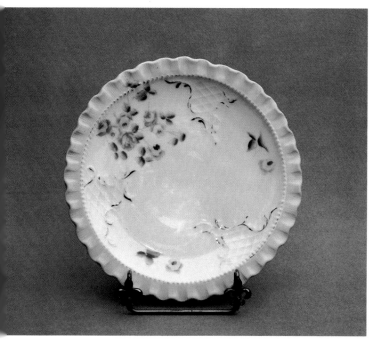

Plate 78. Plate, pink rim, Mold OM 7, decor OT 3, 7.5" d. The identical plate is illustrated in the G. Sommers & Co. Fall 1896 catalog. $25-$50.

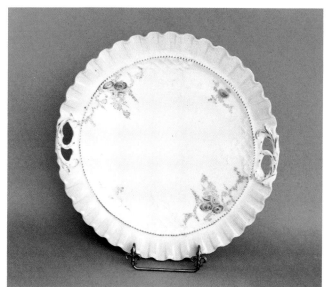

Plate 80. Cake plate, pink rim, Mold OM 7, decor OT 11A, 11.25" d. $50-$100.

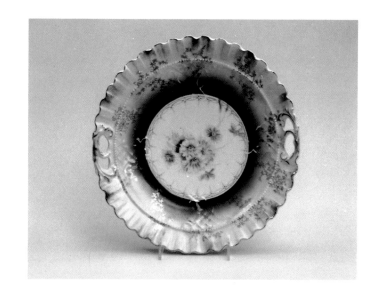

Plate 81. Cake plate, brown shaded edge, Mold OM 7, decor OT 21, 11.25" d. $50-$100.

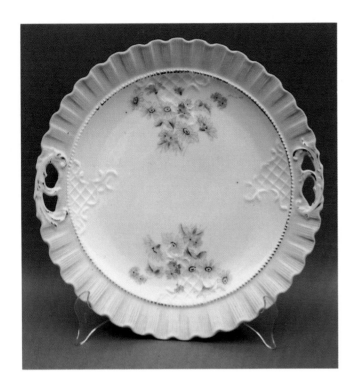

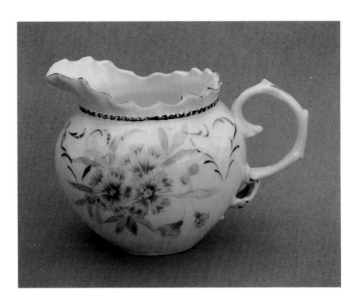

Plate 84. Cream pitcher, Mold OM 7, decor OT 18, 3.25" h. Under $25.

Plate 82. Cake plate, light blue edge, Mold OM 7, 11.25" d. $50-$100.

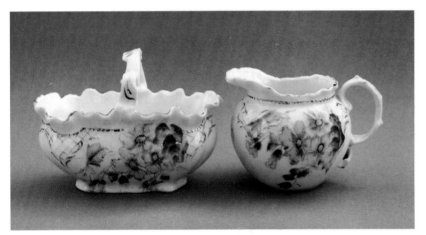

Plate 83. Sugar basket and creamer, Mold OM 7, decor OT 61, basket 4" h. $100-$200.

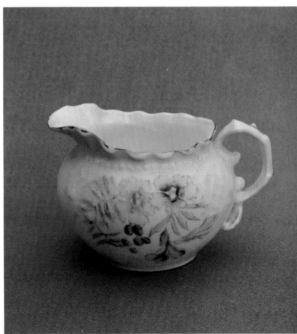

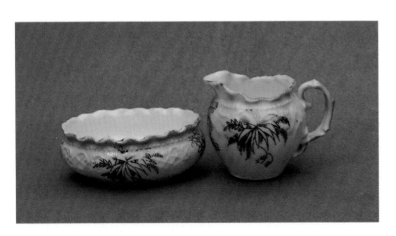

Plate 85. Open sugar/cream set, pink rim, Mold OM 7, palm tree stencil decor, sugar 2.25" h. $25-$50.

Plate 86. Cream pitcher, Mold OM 7, decor OT 6, 2.25" h. Under $25.

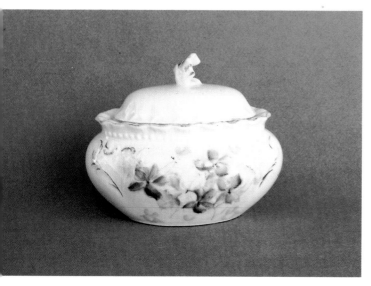

Plate 87. Covered sugar, Mold OM 7, decor OT 63, 3.25" h. $25-$50.

Plate 90. Spooner, Mold OM 7, decor ST 20, 4.5" h. $50-$100.

Plate 88. Milk pitcher, green rim, Mold OM 7, decor ST 14, 6" h. $50-$100.

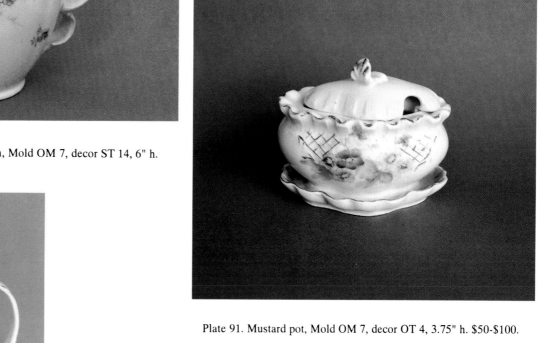

Plate 91. Mustard pot, Mold OM 7, decor OT 4, 3.75" h. $50-$100.

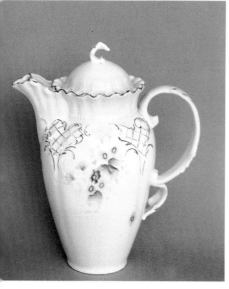

Plate 89. Chocolate pot, yellow rim, Mold OM 7, decor OT 4, 9" h. $100-$200.

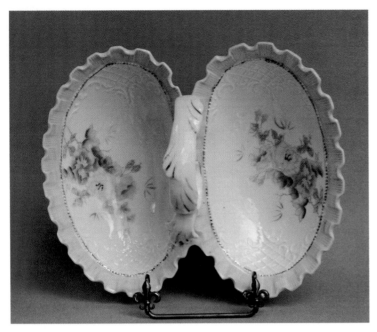

Plate 92. Cabaret, blue rim, Mold OM 7, decor OT 1, 9" w. $100-$200.

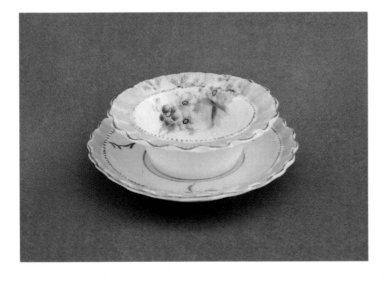

Plate 93. Ramekin with underplate, pink rim, Mold OM 7, decor OT 4, bowl 4" d. $50-$100.

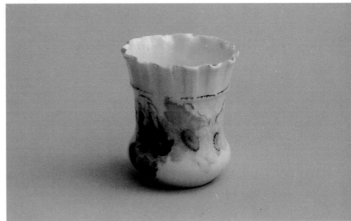

Plate 95. Toothpick holder, Mold OM 7, decor OT 19, 2.5" h. $50-$100.

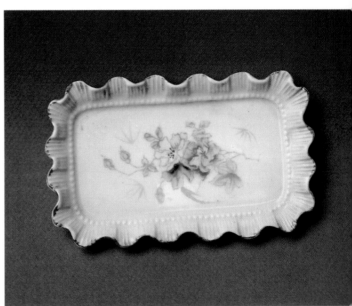

Plate 96. Pin tray, Mold OM 7, decor OT 1, 3" w., 5" l. This item is listed as No. 357 ($1.88 per dozen) in a 1896 Butler Bros. catalog. Under $25.

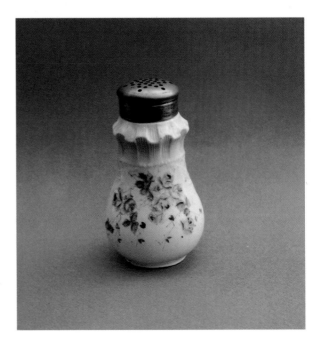

Plate 94. Salt shaker, Mold OM 7, decor OT 3, 4" h. $100-$200.

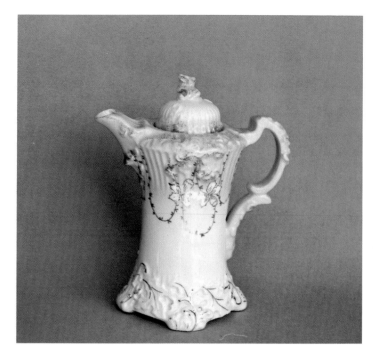

Plate 97. Chocolate pot, pink top, Mold OM 8 (Clunky Handle), daffodil decor, 8" h. $100-$200.

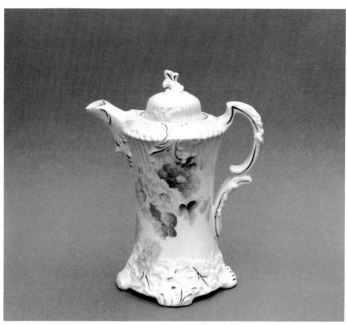

Plate 99. Chocolate pot, Mold OM 8, decor OT 7, 8" h. $100-$200.

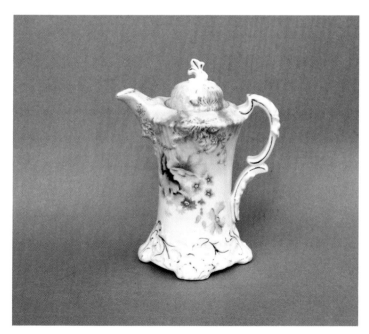

Plate 98. Chocolate pot, pink top, Mold OM 8, decor OT 2, 8" h. $100-$200.

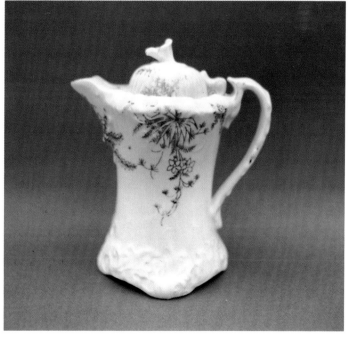

Plate 100. Tall syrup can, Mold OM 8, palm tree stencil decor, 5.5" h. This same item is illustrated in a Butler Bros. Fall 1896 catalog, and the description features a patented, hinged lid. This mold also illustrated in G. Sommers & Co. 1896 catalog. $100-$200.

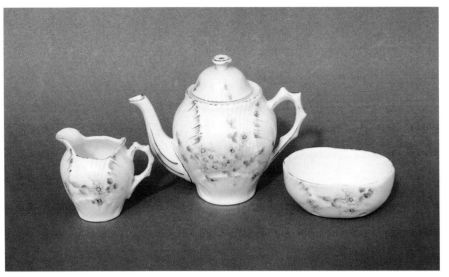

Plate 101. Toy tea set, (Overlapping Shell) Mold OM 9, decor OT 61, pot 4.25" h., RS Wing mark. $100-$200.

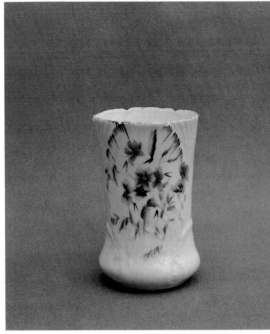

Plate 104. Spooner, Mold OM 9, decor OT 46, 4.5" h. $50-$100.

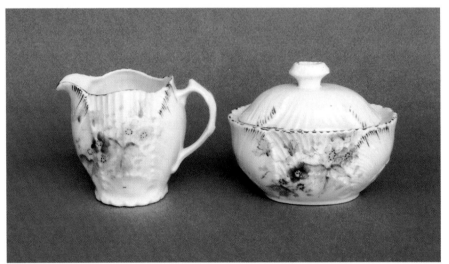

Plate 102. Cream, covered sugar set, Mold OM 9, decor OT 4, sugar 3.25" h. $50-$100.

Plate 103. Large cream, covered sugar set, Mold OM 9, decor OT 46, sugar 4.75" h. $50-$100.

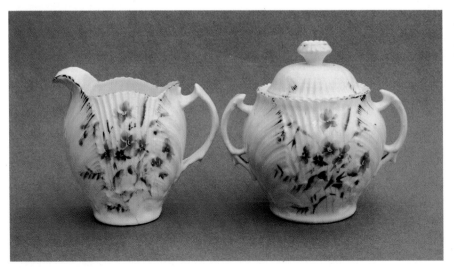

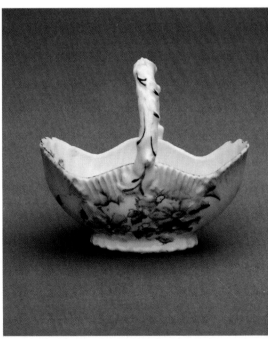

Plate 105. Sugar or candy basket, OM 9, decor OT 43, 4.5" h. $50-$100.

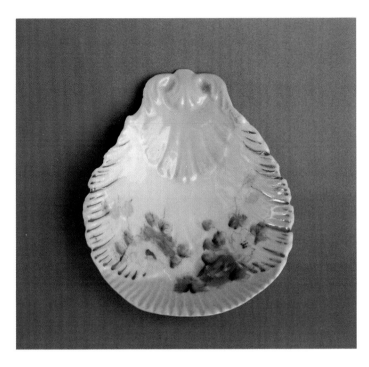

Plate 106. Tray, Mold OM 9, decor OT 1, 4.5" l. Under $25.

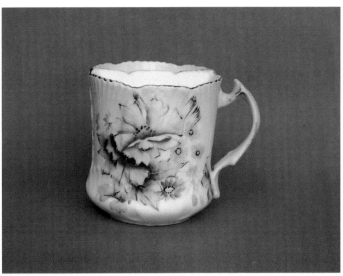

Plate 107. Shaving mug, light blue ground, Mold OM 9A, handle variation, decor OT 2, 3.3" h. $100-$200.

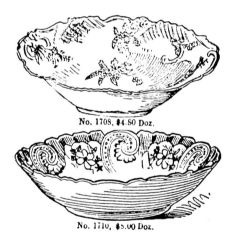

No. 1708, $4.80 Doz.

No. 1710, $5.00 Doz.

No. 1708, Tinted and Gold Salad Dish—Round shade, fancy gold edge, raised floral decoration in gold and colors and fancy gold scroll work on flange, very thin china, shaded lustre tints. Assorted decorations in pkg. of ½ doz............ 4 80

No. 1710, Large Round Table Dish—Porcelain china, thin and transparent, flaring shape, 10¾-inch, decorations in gold, colors and enameled flowers, scalloped gold clouded edges. Assorted tints and decorations in pkg. of ¼ doz......... 8 00

Plate 108. Illustration of No. 1710 salad dish in Mold OM 10, from a Butler Bros. Fall 1896 catalog. This salad was first offered by the firm in 1895. *Courtesy of the Strong Museum Library.*

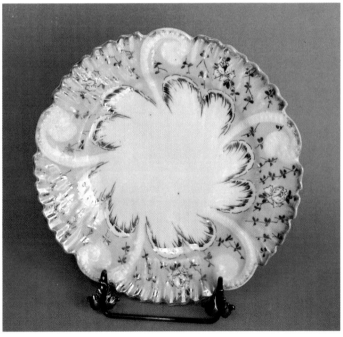

Plate 109. Plate, pink rim, (Candy Cane) Mold OM 10, small flower decor, 7.5" d. Objects in this mold are known to be RS Wing marked (see Gaston IV, Plate 414). $25-$50.

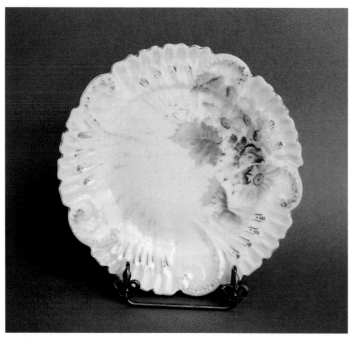

Plate 110. Plate, Mold OM 10, decor OT 19, 8" d. Under $25.

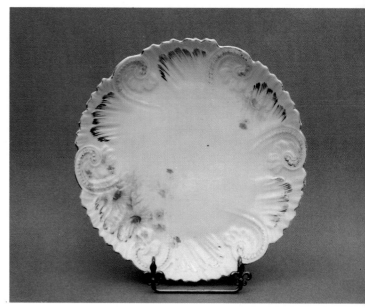

Plate 113. Bowl, buff rim, Mold OM 10, decor OT 66, 7.5" d. $25-$50.

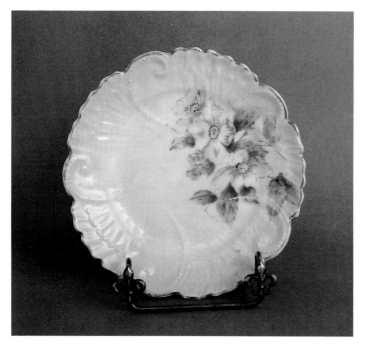

Plate 111. Plate, Mold OM 10, decor OT 43, 8" d. Under $25.

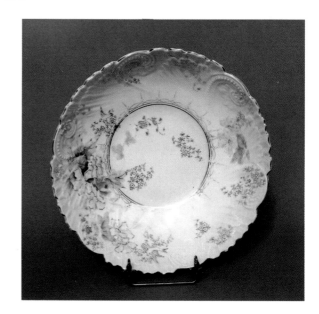

Plate 114. Bowl, shaded ivory rim, Mold OM 10, decor OT 9, 11" d. $100-$200.

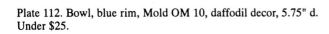

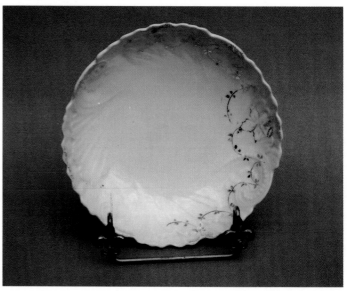

Plate 112. Bowl, blue rim, Mold OM 10, daffodil decor, 5.75" d. Under $25.

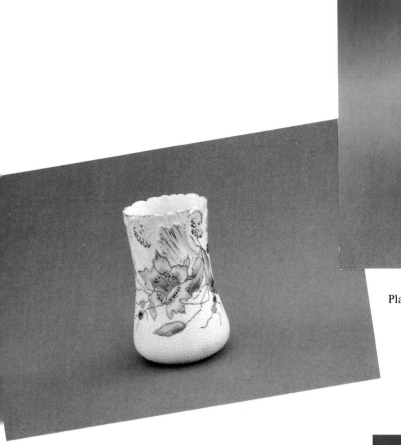

Plate 116. Shaving mug, Mold OM 10, 4.5" h. $100-$200.

Plate 115. Spooner, Mold OM 10, raised dot decor OT 73, 4.7" h. $100-$200.

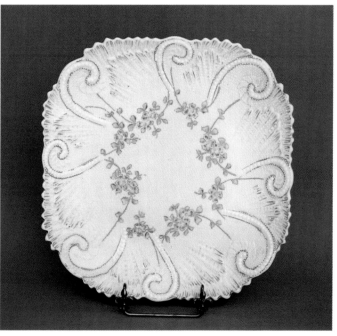

"Dresden Plate." No. 415.

Rich "Dresden" Plate, No. 415—A very richly decorated plate, deep colored ground, with gold tracery and exquisite colored floral decorations; open handles. 11 inches in diameter; heavily embossed gold flanges. Can be used for many purposes for table use. This plate is decorated in imitation of the famous Doulton ware. (See illustration)...............

Plate 117. Illustration of No. 415 "Dresden" plate, Mold OM 10A, with decor OT 5 from G. Sommers & Co. Fall 1897 catalog. *Courtesy of Minnesota Historical Society Library.*

Plate 118. Cake plate, Mold OM 10A (double candy cane), raised dot decor, 11" d. This may be an example where the pattern was expanded to accommodate a large piece. $100-$200.

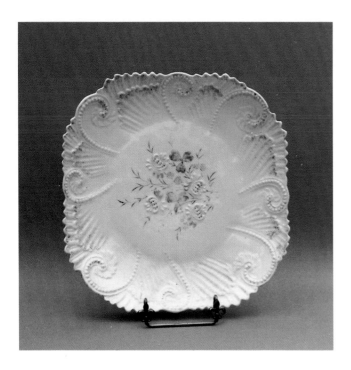

Plate 119. Cake plate, Mold OM 10A, raised flower decor, 11" d. $50-$100.

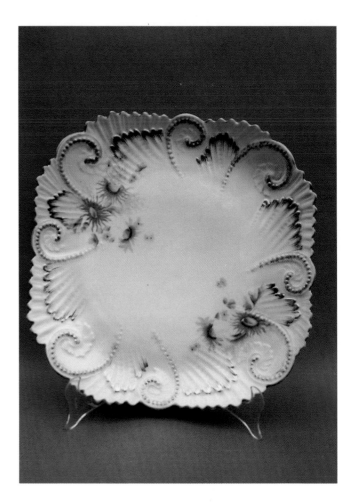

Plate 121. Cake plate, buff/blue edge, Mold OM 10A, decor OT 66, 11" d. $100-$200.

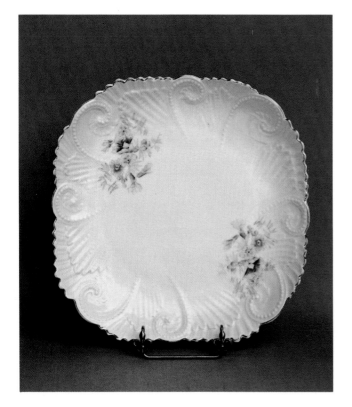

Plate 120. Cake plate, shaded pink rim, Mold OM 10A, decor OT 5, 11" d. $100-$200.

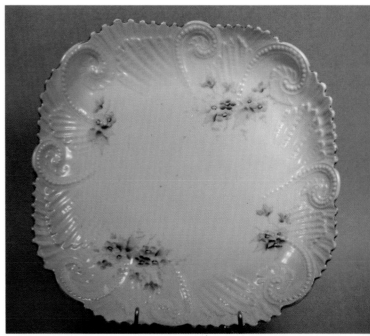

Plate 122. Cake plate, pink rim, Mold OM 10A, decor OT 4, 11" d. $100-$200.

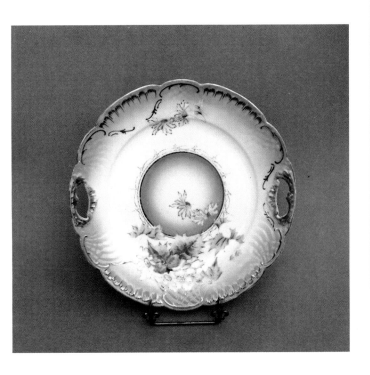

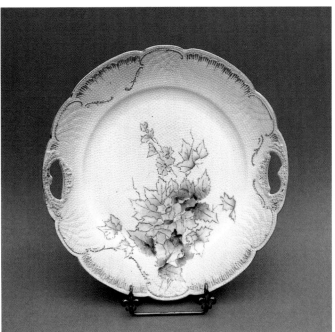

Plate 124. Cake plate, shaded pink rim, Mold OM 11, raised dots and decor OT 68, 11" d. $100-$200.

Plate 123. Cake plate, shaded green rim, Mold OM 11, decor OT 19, 11" d. $100-$200.

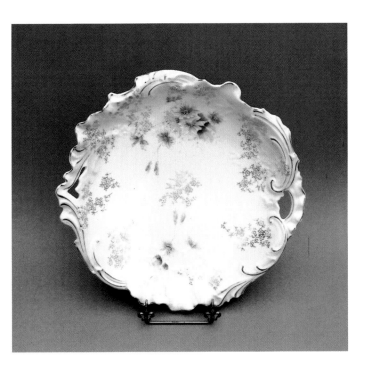

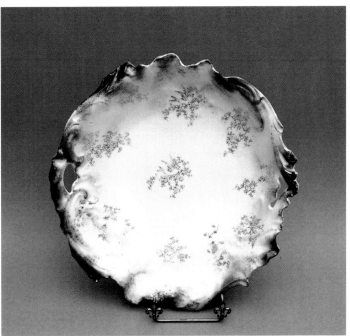

Plate 125. Deep plate, shaded brown rim, Mold OM 12, bird stencil decor, 12" d. Embossed leaves and flowers in the mold. $50-$100.

Plate 126. Deep plate, shaded buff rim, Mold OM 12, decor OT 21, 12" d. $100-$200.

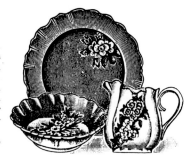
Plate 127. Illustration of "PSYCHE" mush and milk set in Mold OM 13 from Falker and Stern Fall 1898 catalog. This mold also illustrated in a 1898 Golden Eagle (Denver, Colorado) retail catalog, and Butler Bros. 1896 catalogs. *Courtesy of Amador Trade Catalog Collections, Rio Grande Historical Collections, New Mexico State University Library.*

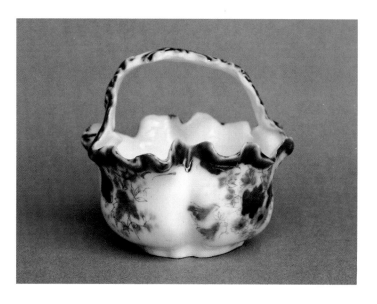

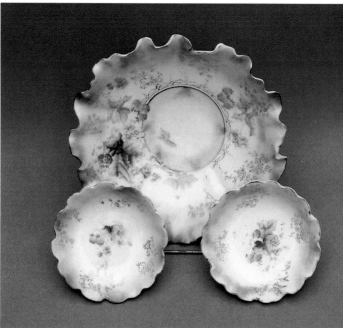

Plate 130. Berry bowl and two individual bowls, Mold OM 13, decor OT 25. Master berry 9.5" d., small bowls 5.5" d. $200-$400.

Plate 128. Handled basket, "Melon" mold OM 13, decor FD M, 3.75" h., 4" w., RS Steeple Germany green mark. We use the existing "FD M" designation for this floral decoration, part of the series coded by M.F. Gaston in *Collectors Encyclopedia of R.S. Prussia, Fourth Series.* $200-$400.

Plate 129. Berry bowl, shaded brown edge, Mold OM 13, bird stencil decor, 10" d. Marked "Gesetzlich-Made in Germany-geschützt." Owing to the prior use of the bird stencil decor, the mold pattern appears to be the protected part of this object. $50-$100.

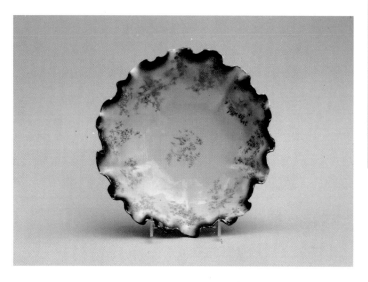

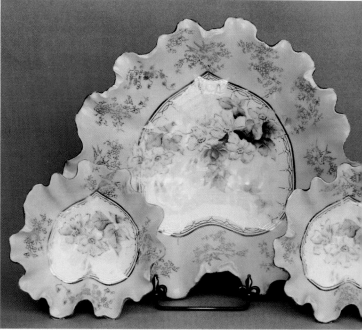

Plate 131. Berry set, heart shape, pink and blue rims, Mold OM 13, decor OT 9. Large bowl is 10.5" d., individual bowls 5.5" d. $200-$400.

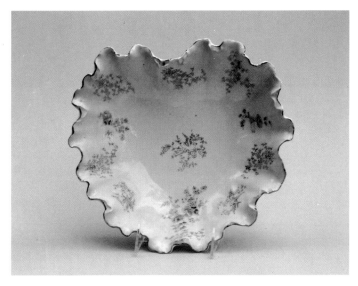

Plate 132. Berry bowl, heart shape, shaded green edge, Mold OM 13, decor OT 40, 11" d. $100-$200.

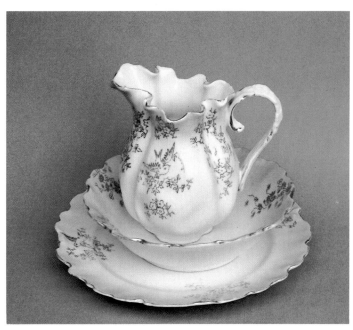

Plate 135. Mush and milk set, Mold OM 13, bird stencil decor, milk 4.75" h., bowl 6.25" d., plate 7.75" d. $50-$100.

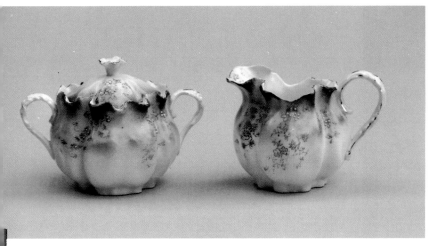

Plate 133. Covered sugar/cream set, light purple top edges, Mold OM 13, bird stencil decor, sugar 4" h. $50-$100.

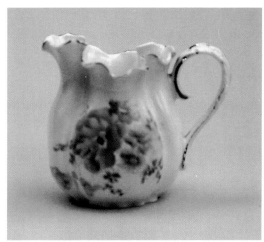

Plate 136. Cream pitcher, Mold OM 13, decor OT 34, 3.5" h. $25-$50.

Plate 134. Open sugar/cream set, pink/yellow bands, Mold OM 13, bird stencil decor, sugar 1.8" h. $50-$100.

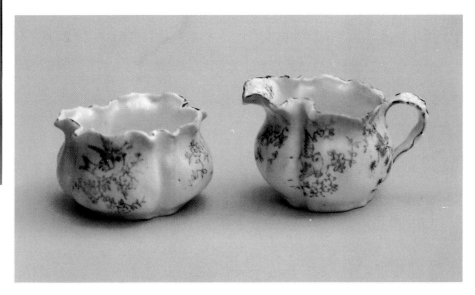

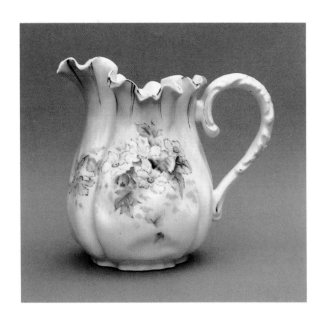

Plate 137. Water pitcher, Mold OM 13, decor OT 9, 8.5" h. $200-$400.

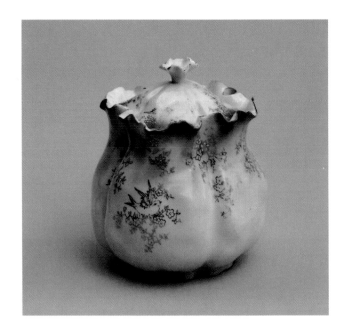

Plate 140. Biscuit jar, Mold OM 13, bird stencil decor, 6.25" h. $100-$200.

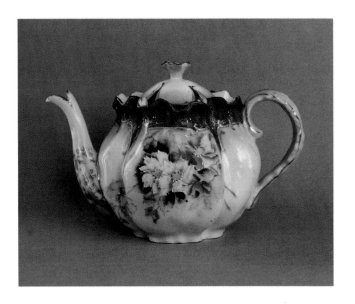

Plate 138. Teapot, red rim at top, Mold OM 13, decor OT 5, 5" h. $100-$200.

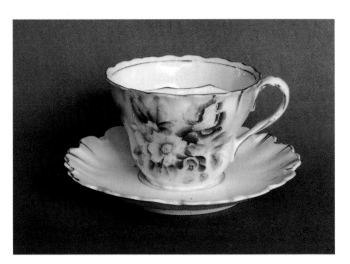

Plate 141. Mustache cup/saucer, Mold OM 13, decor OT 5, cup 2.75" h. $50-$100.

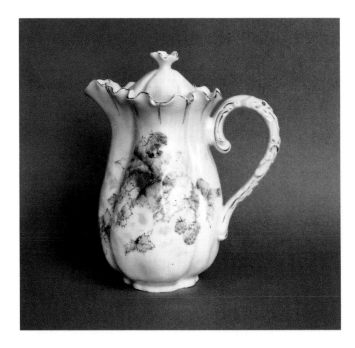

Plate 139. Chocolate pot, peach rim at top, Mold OM 13, decor OT 25, 7.5" h. $100-$200.

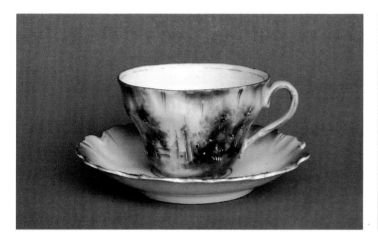

Plate 142. Tea cup/saucer, Mold OM 13, hand painted castle scene decor, cup 2.75" h. $50-$100.

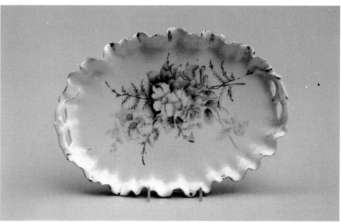

Plate 145. Serving tray, Mold OM 13, decor OT 5, 8" w. x 12" l. $50-$100.

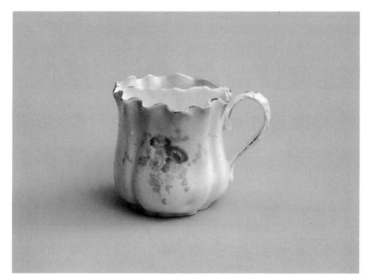

Plate 143. Shaving mug, Mold OM 13, decor OT 11A, 3.5" h. $50-$100.

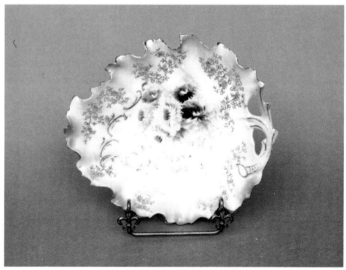

Plate 146. Tray, Mold OM 13, decor OT 11A, 7" l. $25-$50.

Plate 147. Mustard pot, Mold OM 13, decor OT 7, 3.25" h. This item was advertised in the Golden Eagle 1898 retail catalog "No. 814a, Fancy Mustard Pot...best Carlsbad china, gold traced and floral designs, complete with china spoon -- 25c". $50-$100.

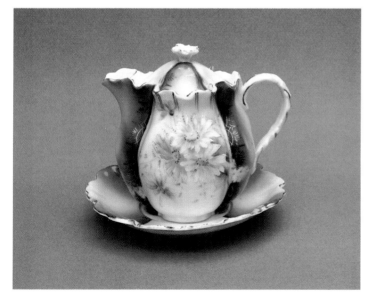

Plate 144. Syrup and underplate, Mold OM 13, decor OT 21, syrup 4.75" h. $100-$200.

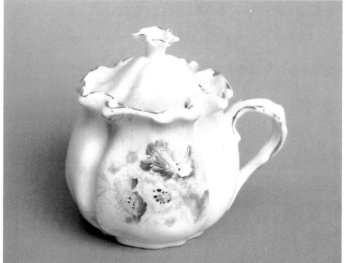

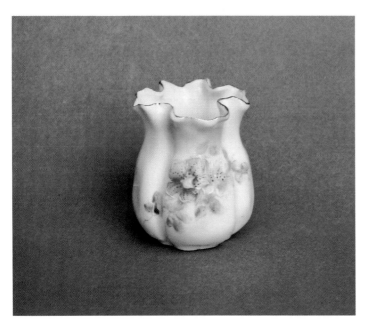

Plate 148. Toothpick holder, Mold OM 13, decor OT 17A, 2.75" h. $50-$100.

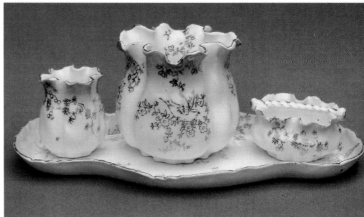

Plate 151. Smokers set, Mold OM 13, bird stencil decor, cigar holder 3.25" h. This set is illustrated in the 1896 Butler Bros. catalog, two years prior to the first appearance in a Falker and Stern catalog. $100-$200.

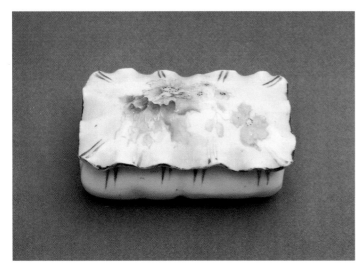

Plate 149. Match box, Mold OM 13, decor OT 2, 4" l. $50-$100.

Plate 150. Chamber stick, Mold OM 13, decor OT 17, 5.5" d. $100-$200.

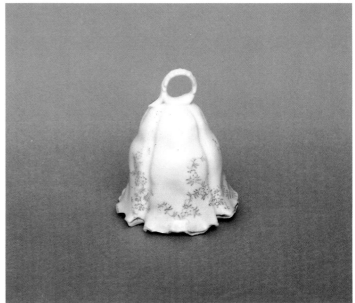

Plate 152. Bell, wood clapper, Mold OM 13, bird stencil decor, 3.5" h. $100-$200.

Plate 153. Inkwell/pen tray, Mold OM 13, bird stencil decor, 4.5" h. $100-$200.

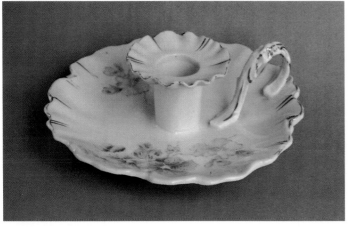

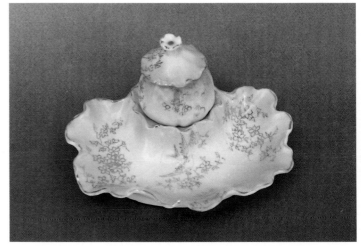

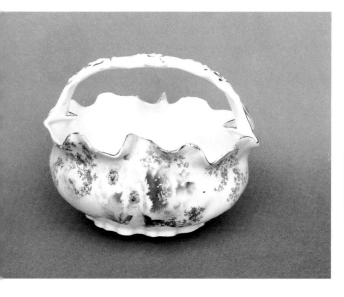

Plate 155. Hatpin tray, Mold OM 13, decor OT 11A, 8.75" l. $100-$200.

Plate 154. Basket, Mold OM 13, decor OT 7, 7" w. $200-$400.

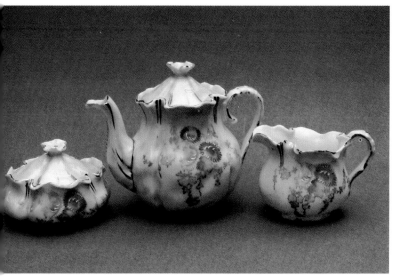

Plate 156. Partial child's tea set - covered sugar, teapot, cream. Mold OM 13, decor OT 11A, pot 3.75" h. $100-$200.

R S 301. $1.50.

RS 301. Thin china, heart shape, around top of jar and base of cover is a tinting of light green, handle is gold traced, also edge of cover, decoration—colored flowers. ½ doz. in pkg. **Per doz., $1.50**

Plate 157. Illustration of RS 301 mustard pot in Mold OM 14 from the 1903 Falker and Stern Spring catalog. Between 1900 and 1903, Falker and Stern changed their inventory numbering system several times. The RS + number in this illustration indicates their acquisition during the 1900 to 1901 period. Also shown in the 1896 Butler Bros. catalog (No. 144). *Courtesy of Amador Collections, Rio Grande Historical Collections, New Mexico State University Library.*

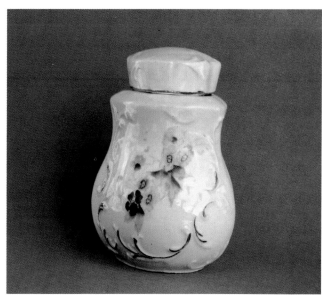

Plate 158. Tea caddy, (Heart) Mold OM 14, decor OT 4, 5.5" h., RS Wing mark. $200-$400.

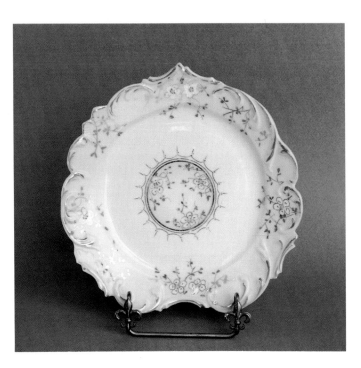

Plate 161. Individual berry bowl, Mold OM 14, decor OT 1, 5.5" d. Under $25.

Plate 159. Plate, pink rim, heart shape, Mold OM 14, daisy decor, 7.75" d. $25-$50.

Plate 162. Cream/covered sugar set, Mold OM 14, decor OT 22, sugar, 3" h. $50-$100.

Plate 163. Pitcher, Mold OM 14, decor OT 18, 4" h. $25-$50.

Plate 160. Berry bowl, Mold OM 14, decor OT 22, 10.5" d. $50-$100.

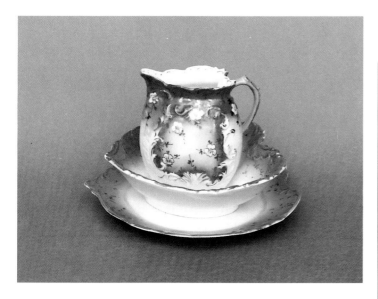

Plate 164. Mush or bread/milk set, Mold OM 14, daisy decor, pitcher 4" h. $100-$200.

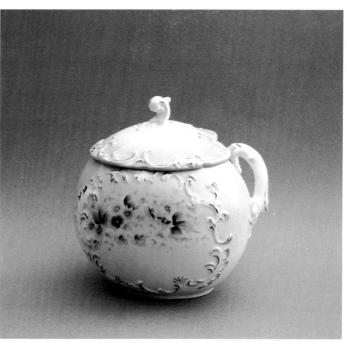

Plate 167. Biscuit jar, Mold OM 14, decor OT 4, 6" h. $200-$400.

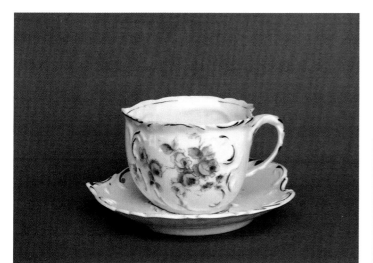

Plate 165. Coffee cup/saucer, Mold OM 14, decor OT 3. Cup 2.5" h. $50-$100.

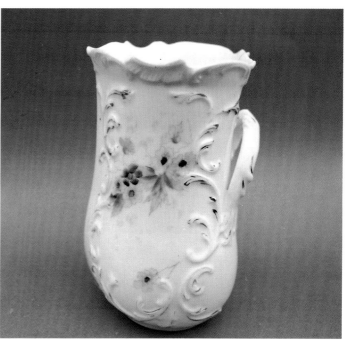

Plate 168. Celery, Mold OM 14, decor OT 4, 6" h. $100-$200.

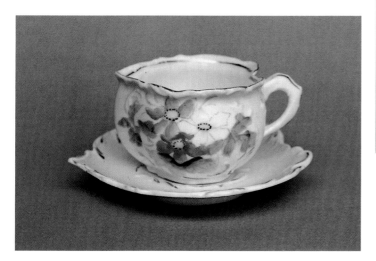

Plate 166. Cup/saucer, Mold OM 14, decor OT 4, cup 1.75" h. $50-$100.

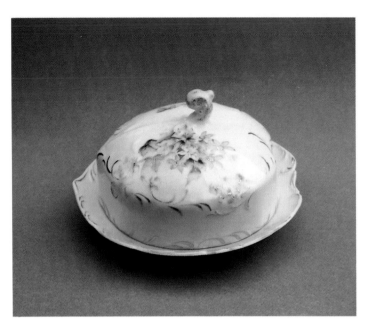

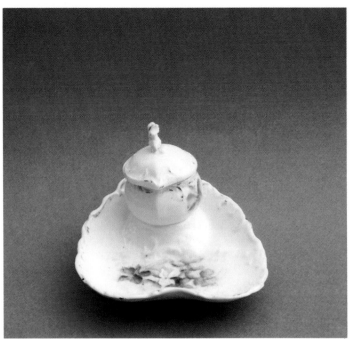

Plate 171. Inkwell and tray, Mold OM 14, decor OT 63, 3.3" h. $100-$200.

Plate 169. Covered butter, Mold OM 14, decor ST 20, 3.5" h. $100-$200.

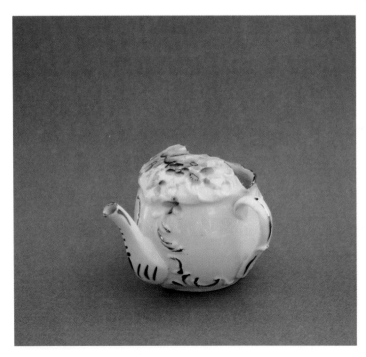

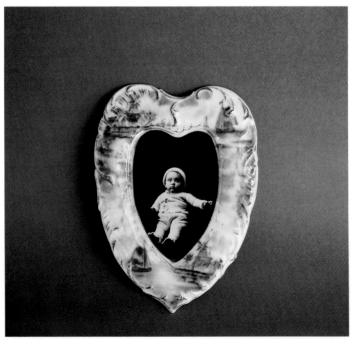

Plate 172. Picture frame, Mold OM 14, cobalt scenic decor, 6.25" h. $100-$200.

Plate 170. Invalid feeder, Mold OM 14, decor OT 4, 3" h. $200-$400.

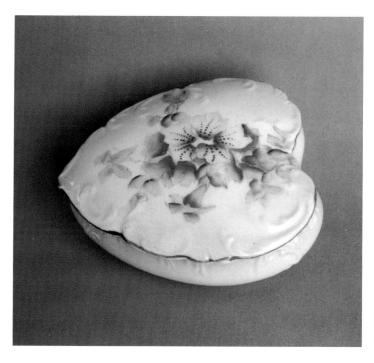

Plate 173. Box, Mold OM 14, decor OT 17, 4.5" l. $100-$200.

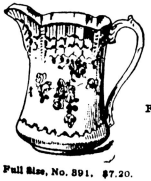

Full Size Water Pitcher
—No. 391. Fine china pitcher with hand painted decoration, holding about 1 quart; standing about 6½ in. high and measuring 5½ inches across the mouth............................

Full Size, No. 391. $7.20.

Plate 175. Illustration of No. 391 full size water pitcher in Mold OM 15 from the Fall 1896 catalog of Sommers & Co. Also shown in Sommers & Co. 1897, and in Butler Bros. 1896 catalogs. *Courtesy of Minnesota Historical Society Library.*

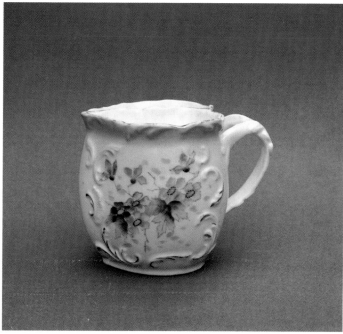

Plate 174. Shaving mug, the soap compartment is heart shaped, Mold OM 14, decor OT 4, 3.5" h. This item is listed as No. 1410 ($2.08 per dozen) in an 1896 Butler Bros. catalog. $100-$200.

Plate 176. Cream pitcher, Mold OM 15, decor OT 3, 4" h. $25-$50.

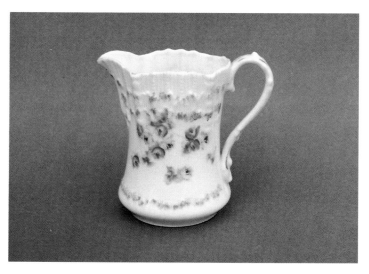

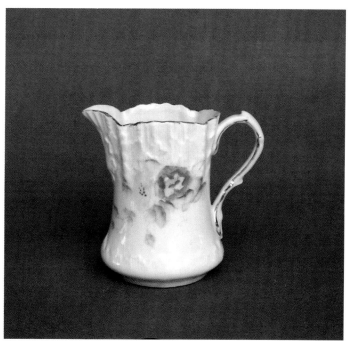

Plate 177. Cream pitcher, Mold OM 15, decor OT 1, 3" h. $25-$50.

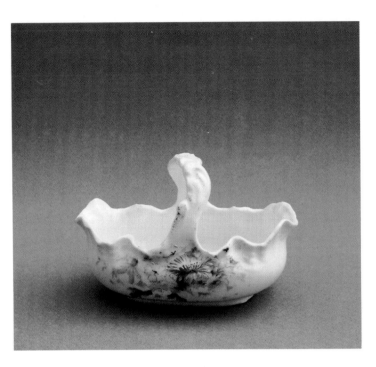

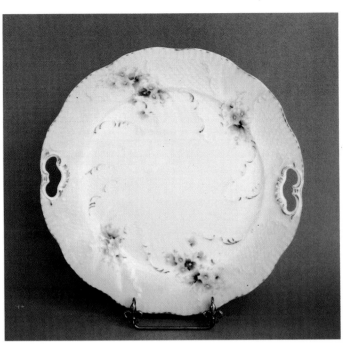

Plate 180. Cake plate, Mold OM 16, decor OT 4, 11" d. While difficult to see in photographs, there are segments in the mold with overlapping circles that resemble a fishscale pattern. $50-$100.

Plate 178. Sugar or candy basket, Mold OM 15, 3.5" h. Illustrated in 1895 Butler Bros. Fall/Holiday catalog. $50-$100.

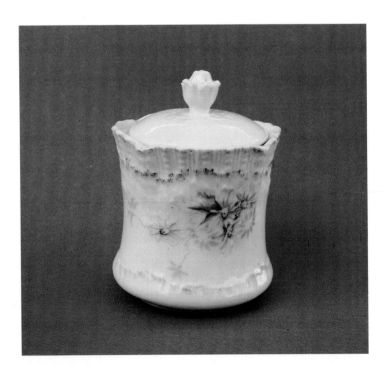

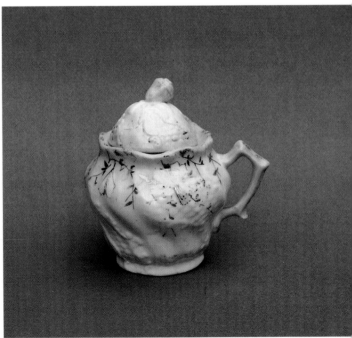

Plate 181. Mustard pot, Mold OM 16, daffodil decor, 4" h. $50-$100.

Plate 179. Cracker or biscuit jar, Mold OM 15, decor OT 48, 7" h. $100-$200.

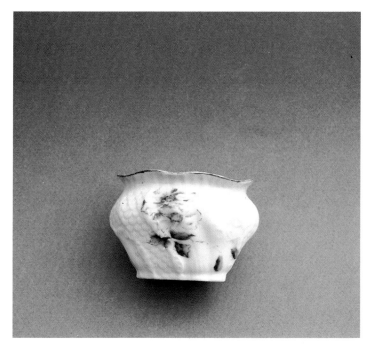

Plate 182. Open sugar, Mold OM 16, decor OT 43, 2.25" h. Under $25.

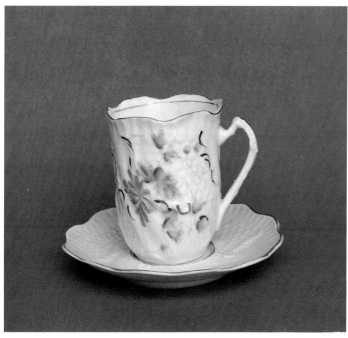

Plate 183. Chocolate cup/saucer, Mold OM 16, cup 2.8" h. $25-$50.

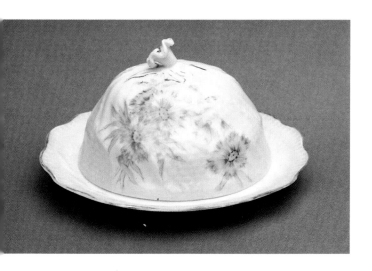

Plate 184. Covered butter, Mold OM 16, decor OT 18, 3.25" h. $100-$200.

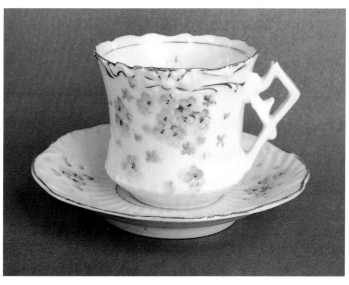

Plate 186. Cup/saucer, (Seven Handle) Mold OM 17, decor ST 25, 2.2" h., RS Wing mark. $50-$100.

New York Set, No. 539. Price complete, $2.00.

Plate 185. Illustration of No. 539 "New York" tete-a-tete set in Mold OM 17 from G. Sommers & Co. Fall 1897 Catalog. Also shown in Butler Bros. 1896 Catalog. *Courtesy of Minnesota Historical Society Library.*

The "New York" Tete-a-Tete Set, No. 539—This set is made of finest quality transparent china, consisting of a handsome china tray, teapot, sugar, cream and two cups and saucers, decorated in a very attractive manner. The cups are larger than the above. Price per set, complete............

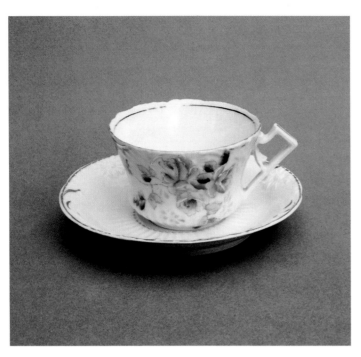

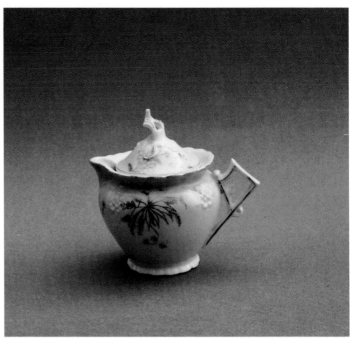

Plate 189. Syrup pitcher, Mold OM 17, palm tree decor, 3.25" h. $25-$50.

Plate 187. Coffee cup/saucer, Mold OM 17, decor OT 3, coffee 2" h. $50-$100.

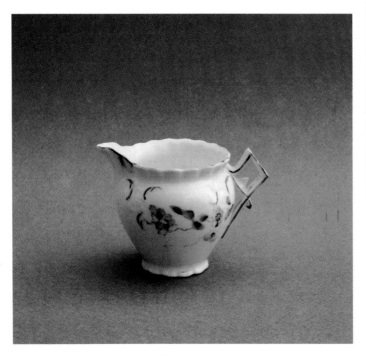

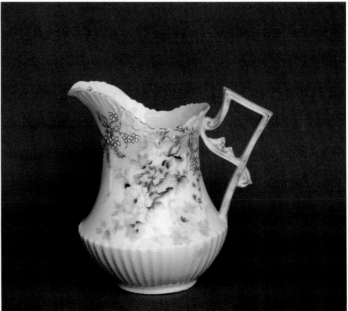

Plate 190. Pitcher, Mold OM 17, decor OT 1, 6.5" h. $100-$200.

Plate 188. Cream pitcher, Mold OM 17, 2.5" h. Under $25.

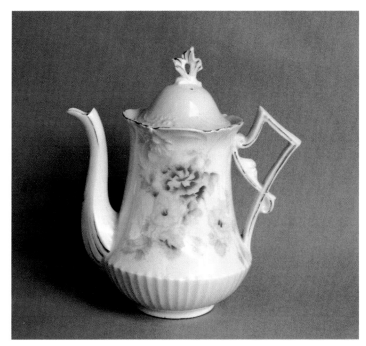

Plate 191. Coffee pot, or part of tete-a-tete set, Mold OM 17, decor OT 1, 7.5" h. $100-$200.

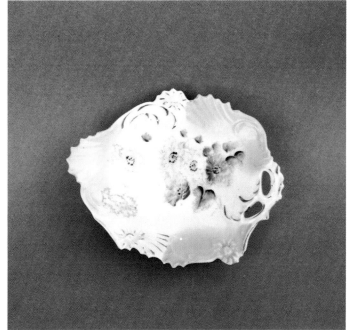

Plate 194. Bon or Tray, Mold OM 17, decor OT 7, 6" l. $50-$100.

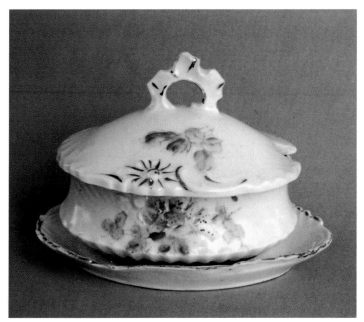

Plate 192. Mustard pot, Mold OM 17, decor OT 17A, 3.25" h. $50-$100.

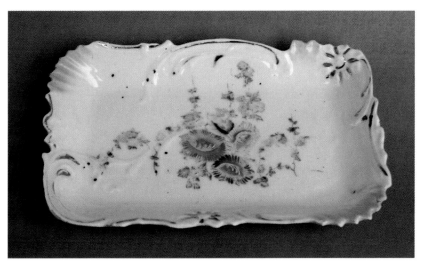

Plate 193. Pin tray, Mold OM 17, decor OT 11A, 5" l. Under $25.

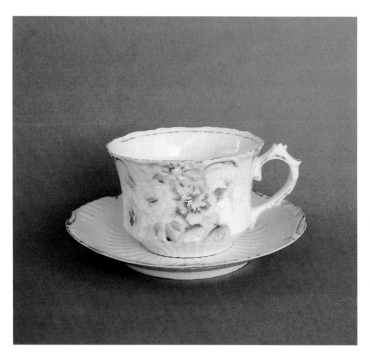

Plate 195. Tea cup/saucer, Mold OM 17A, decor OT 1. Cup 2.25" h. The mold for the body is the same as OM 17, but the handle is different. $50-$100.

Plate 198. Plate, shaded green rim, Mold OM 17C, decor OT 2, 7.5" d., RS Wing mark. $50-$100.

Plate 197. Shaving mug, Mold OM 17B, palm tree stencil decor, 3.5" h. The identical item, No. 1405, ($1.87 per dozen) is illustrated in an 1896 Butler Bros. catalog. $50-$100.

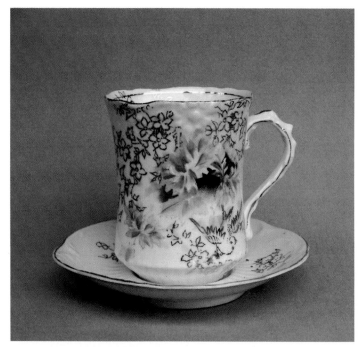

Plate 196. Chocolate cup/saucer, shaded blue edges, Mold OM 17A, decor OT 65, cup 2.75" h. $50-$100.

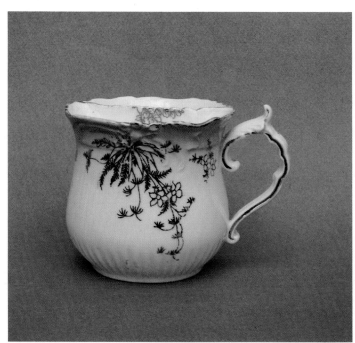

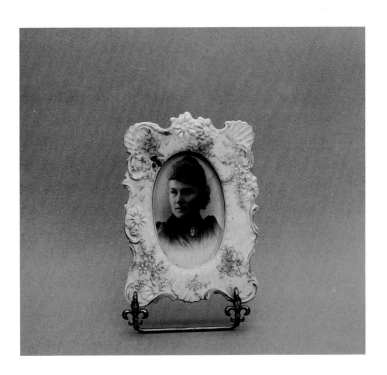

Plate 201. Picture frame, Mold OM 17C, decor OT 1, 5.75" h. $100-$200.

Plate 199. Extra size plate, shaded pink edge, Mold OM 17C, decor OT 2, 12" d. Illustrated as No. 396 "extra size plate" in G. Sommers & Co. Fall 1896 catalog. Also shown in 1896 Butler Bros. catalog. $100-$200.

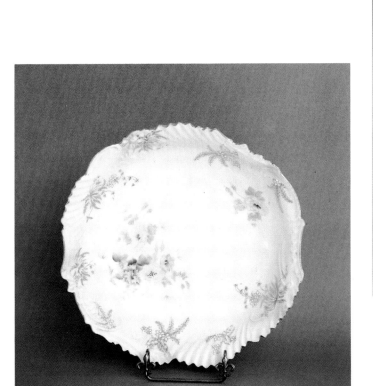

Plate 202. Napkin rings: left - Mold OM 17C, decor OT 65; right - decor OT 7, bird stencil decor on reverse of both, 2.5" w. Flower design is impressed in the rims. $25-$50. each.

Plate 200. Bowl, Mold OM 17C, decor OT 1, 10" d. $100-$200.

Plate 203. Napkin rings, Mold OM 17C, decor OT 34, 2.5" w. $25-$50. each.

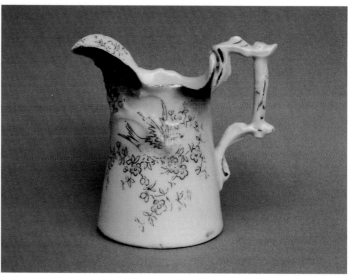

Plate 206. Cream pitcher, brown/yellow top, Mold OM 18, bird stencil decor, 3.25" h. $25-$50.

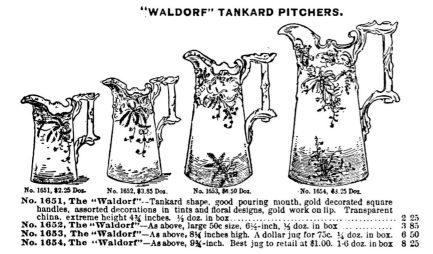

"WALDORF" TANKARD PITCHERS.

No. 1651, $2.25 Doz. No. 1652, $3.85 Doz. No. 1653, $6.50 Doz. No. 1654, $8.25 Doz.

No. 1651, The "Waldorf"--Tankard shape, good pouring mouth, gold decorated square handles, assorted decorations in tints and floral designs, gold work on lip. Transparent china, extreme height 4¾ inches. ½ doz. in box.. 2 25
No. 1652, The "Waldorf"—As above, large 50c size, 6½-inch. ⅓ doz. in box 3 85
No. 1653, The "Waldorf"—As above, 8¼ inches high. A dollar jug for 75c. ¼ doz. in box. 6 50
No. 1654, The "Waldorf"—As above, 9¾-inch. Best jug to retail at $1.00. 1-6 doz. in box 8 25

Plate 204. Illustration of Nos. 1651-1654 "Waldorf" pitchers in four sizes in Mold OM 18 from the Fall 1896 Butler Bros. catalog. *Courtesy of the Strong Museum Library.*

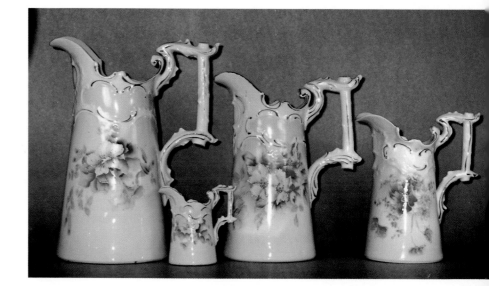

Plate 205. Pitchers, Mold OM 18, large, decor OT 17, 9.75" h., $200-$400.; medium, decor OT 5, 8.25" h., $200-$400.; small, decor OT 34, 6.5" h., $100-$200.; cream, decor OT 17, 3.25" h., $50-$100.

Plate 207. Illustration of the "Carnation Cake Plate", Mold OM 20 and decor OT 8 from the 1898 Falker and Stern Fall catalog. This mold also illustrated in G. Sommers & Co. 1896-99, Falker and Stern 1899, and Webb-Freyschlag 1903 catalogs. *Courtesy of Amador Trade Catalog Collections, Rio Grande Historical Collections, New Mexico State University Library.*

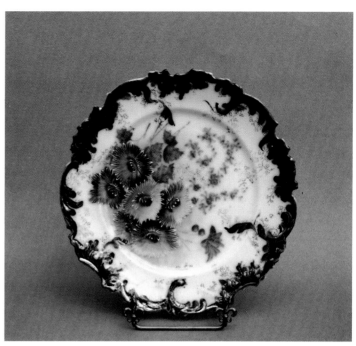

Plate 208. Plate, (Solar Flare) Mold OM 20, decor OT 11, 8.4" d. Marked underglaze with crown and "Germany". $100-$200.

Plate 209. Underglaze mark used on Plate 208. Examples marked with the RS Steeple Prussia (green) are known.

Plate 211. Plate, cobalt band, Mold OM 20, decor P 2, 8.4" d. $50-$100.

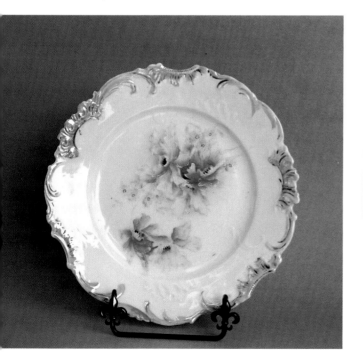

Plate 210. Plate, Mold OM 20, decor OT 31, 7.75" d. $50-$100.

Plate 212. Cake plate, shaded brown edge, Mold OM 20, decor OT 25, 10" d. $100-$200.

Plate 214. Cake plate, green, Mold OM 20, hand painted castle decor, 10" d. $100-$200.

Plate 213. Cake plate, purple edge, Mold OM 20, decor OT 29, 10" d. $100-$200.

Plate 215. Plate, Mold OM 20, freeform iris decor, 7.75" d. $50-$100.

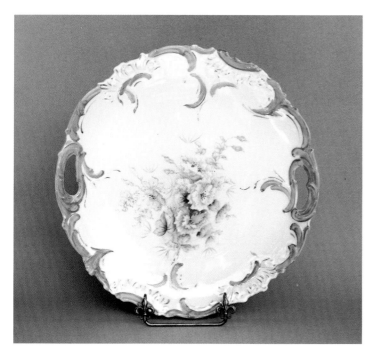

Plate 216. Cake plate, green edge, Mold OM 20, decor OT 44, 11"
d. $100-$200.

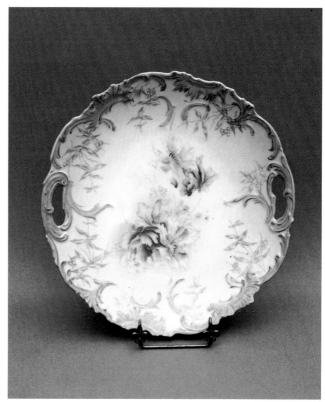

Plate 218. Charger, shaded lavender edge, Mold OM 20, decor OT
31, 12" d. $200-$400.

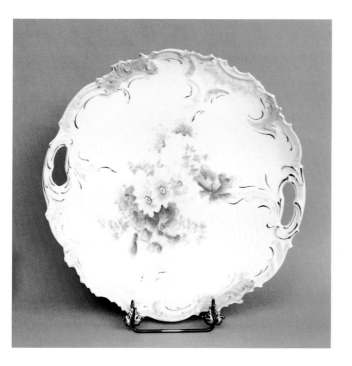

Plate 217. Cake plate, yellow/lavender edge, Mold OM 20, decor
OT 34, 11" d. $100-$200.

Plate 219. Individual berry bowl, Mold OM 20, decor OT 9, 5.25"
d. $25-$50.

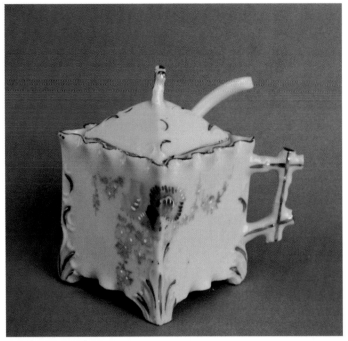

Plate 220. Mustard pot, Mold OM 29 (square mold), decor OT 11A, 3" h. This mold pattern was offered only in the Fall 1897 catalog of G. Sommers & Co. $50-$100.

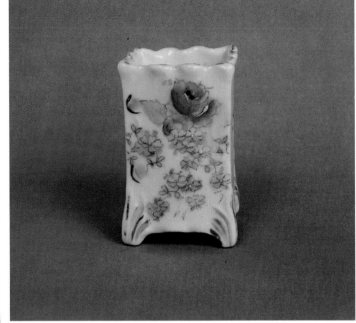

Plate 223. Toothpick holder, Mold OM 29, decor OT 40, 2.5" h. $25-$50.

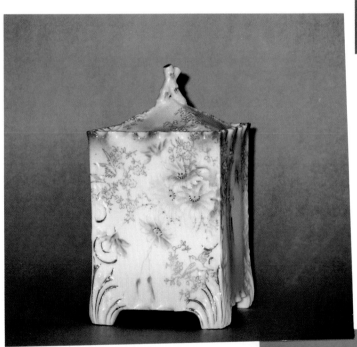

Plate 221. Cracker jar, Mold OM 29, decor OT 21, 8" h. $100-$200.

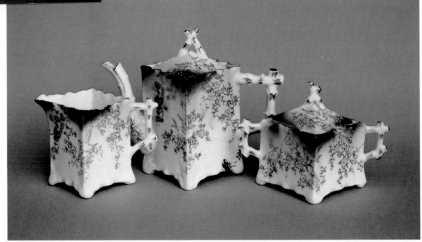

Plate 222. Tete-a-tete set (partial), shaded brown edges, Mold OM 29, bird stencil decor. Pot 4.75" h. $100-$200.

Plate 224. Illustration of No. 519 "Eiffel" shape tea set in Mold OM 30 from Falker and Stern Fall 1898 catalog. *Courtesy of Minnesota Historical Society Library.*

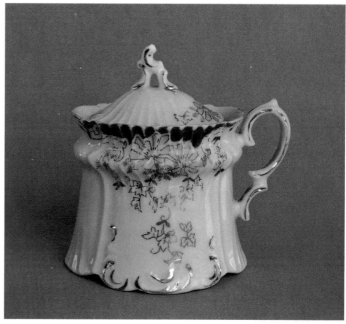

Plate 227. Mustard pot, Mold OM 30, gold daisy stencil decor, 3.5" h. $50-$100.

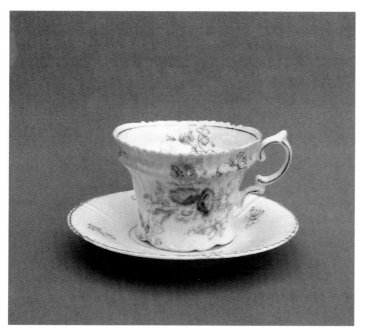

Plate 225. Cup/saucer, buff/yellow edges, Mold OM 30 (corrugated mold), decor OT 11A + bee stencil decor, cup 2.5" h. $50-$100.

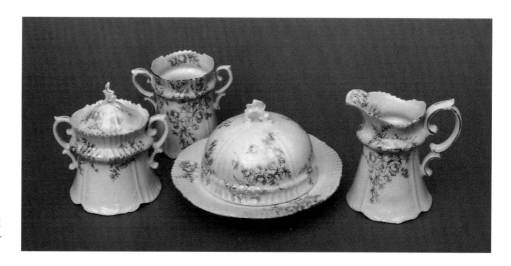

Plate 226. Four piece table set, Mold OM 30, rose stencil decor, sugar 5.5" h. $100-$200.

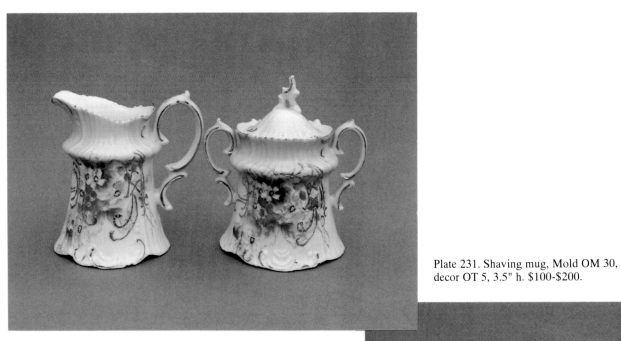

Plate 228. Cream/covered sugar, buff/blue top, Mold OM 30, decor OT 14, sugar 4.5" h. $50-$100.

Plate 231. Shaving mug, Mold OM 30, decor OT 5, 3.5" h. $100-$200.

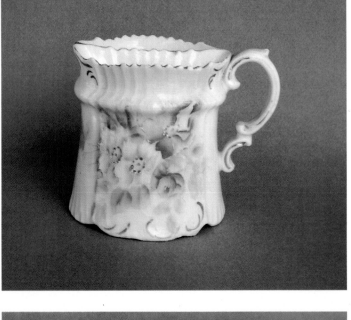

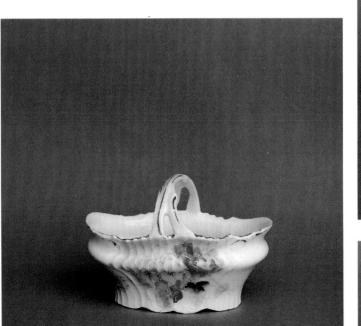

Plate 229. Candy or sugar basket, Mold OM 30, decor OT 7, 3.25" h. $50-$100.

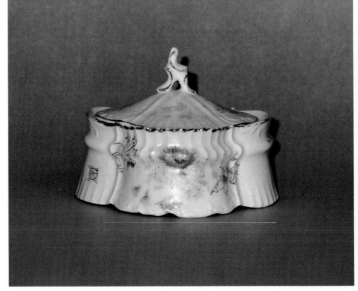

Plate 230. Covered box, Mold OM 30, decor OT 11A, 3.5" h. $50-$100.

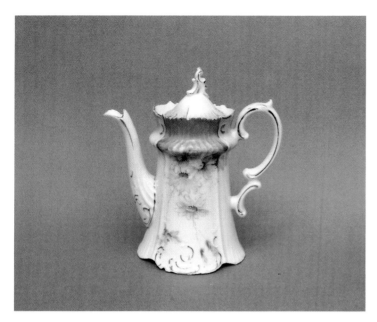

Plate 232. Demitasse pot, blue/tan top, Mold OM 30, decor OT 21, 6" h. $50-$100.

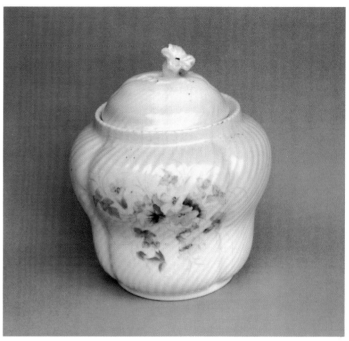

Plate 234. Biscuit jar, shaded pink top, Mold OM 33, decor OT 24, 7" h. $100-$200.

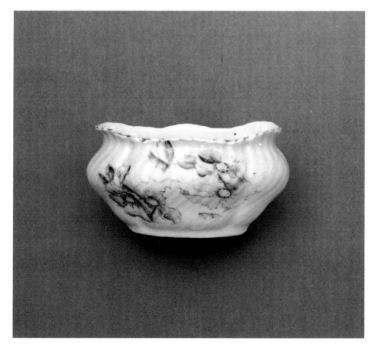

Plate 233. Open sugar, Mold OM 33, decor OT 39, 1.75" h. Swirl pattern over four major lobes. RS Wing marked examples are known. Under $25.

" **Wildwood** " **Tete-a-Tete Set**—Elegant in design, graceful in shape, background in white and green, decoration, green flowers, leaves and flowers in filagree gold, scattered over the surface. The creamer has a capacity of ½ pint. 1 set in pkg.

Per doz. sets. ..,....................$12 50

Plate 235. Illustration of "Wildwood" tete-a-tete set in Mold OM 37 from Falker and Stern Fall 1898 catalog. This mold was also illustrated in G. Sommers & Co. and Webb-Freyschlag 1898 catalogs. *Courtesy of Amador Collections, Rio Grande Historical Collections, New Mexico State University Library.*

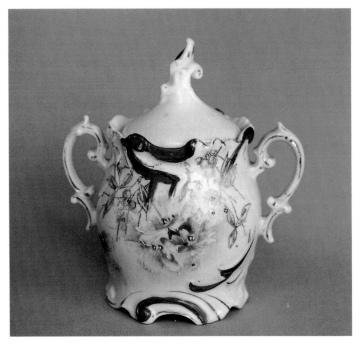

Plate 236. Covered sugar, (Scroll) Mold OM 35, decor OT 31, 5" h. $25-$50.

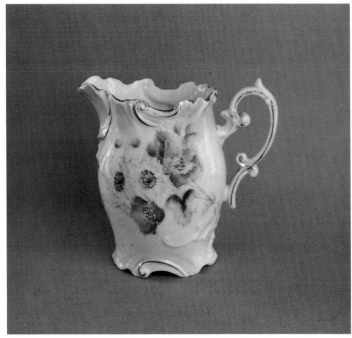

Plate 238. Cream pitcher, pink top/bottom, Mold OM 35, decor OT 7, 4.25" h. $25-$50.

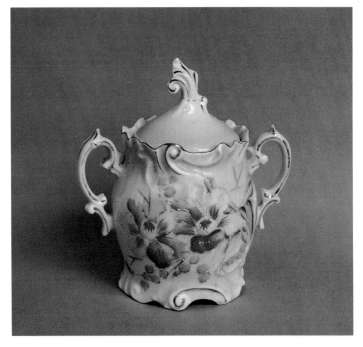

Plate 237. Covered sugar, Mold OM 35, decor OT 10, 5" h. $25-$50.

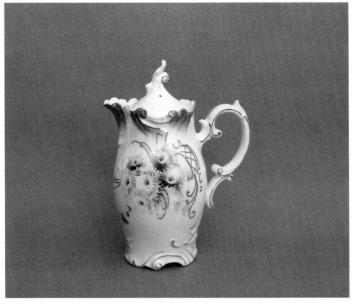

Plate 239. Chocolate pot, green top, Mold OM 35, decor OT 11, 8.5" h. $100-$200.

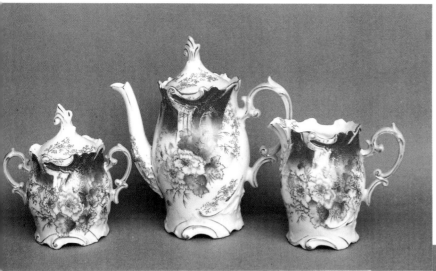

Plate 240. Demitasse pot, cream pitcher and covered sugar, red top edges, Mold OM 35, decor OT 7, 6.75" h. $200-$400.

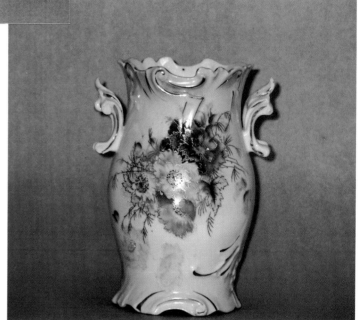

Plate 242. Spooner, Mold OM 35, decor OT 7, 5" h. $100-$200.

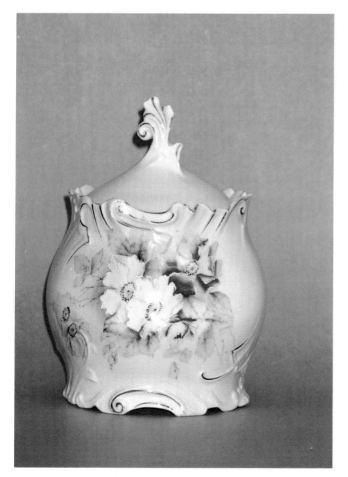

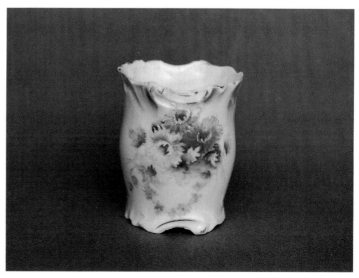

Plate 243. Toothpick holder, Mold OM 35, decor OT 11, 2.25" h. $50-$100.

Plate 241. Biscuit jar, Mold OM 35, decor OT 5, 7" h. $100-$200.

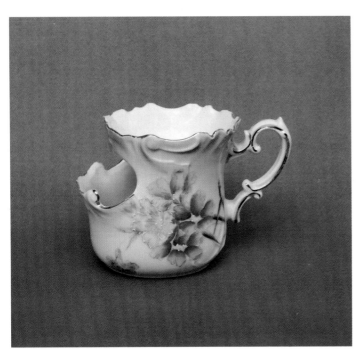

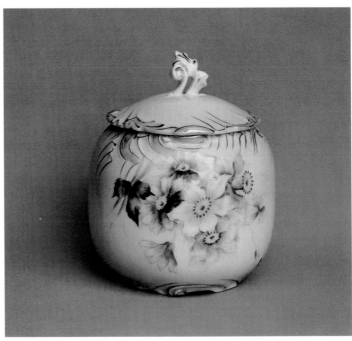

Plate 246. Humidor, shaded buff edges, Mold OM 35, decor OT 49, 7" h. $200-$400.

Plate 244. Scuttle or Military shaving mug, green/buff, Mold OM 35, decor OT 30, 3.25" h. $100-$200.

No. 2091 — A fancy shaped plate: rich raised decorations in colors and gold; measures about 11 x 11 inches 12.00

No. 2091. $12.00.

Plate 247. Illustration of fancy shape plate No. 2091 in Mold OM 36, from G. Sommers & Co. Fall 1898 catalog. *Courtesy of Minnesota Historical Society Library.*

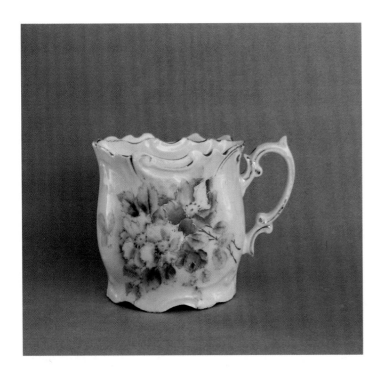

Plate 245. Shaving mug, light pink, Mold OM 35, decor OT 5, 3.3" h. $100-$200.

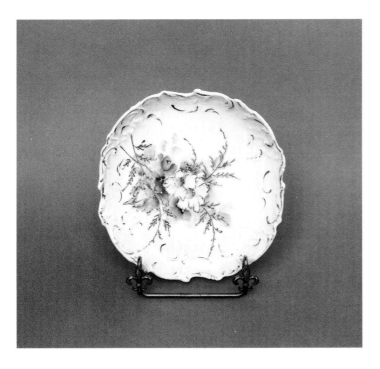

Plate 248. Plate, blue/yellow panels, Mold OM 36, decor OT 5, 6" d. $25-$50.

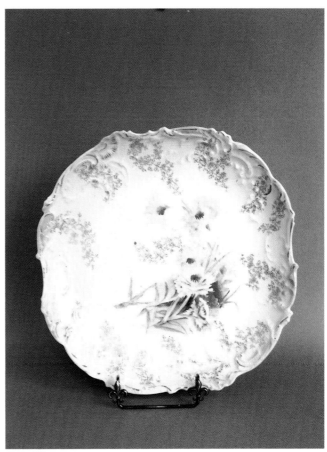

Plate 250. Charger, shaded peach/green rim, Mold OM 36, decor OT 8, 10.5" d. $100-$200.

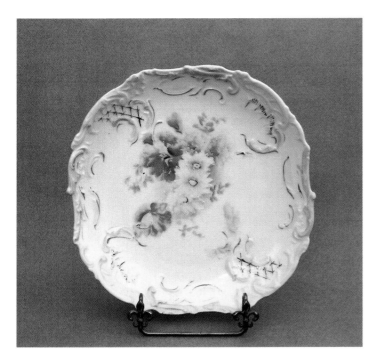

Plate 249. Plate, pink/yellow edge, Mold OM 36, decor OT 34, 7.75" d. $25-$50.

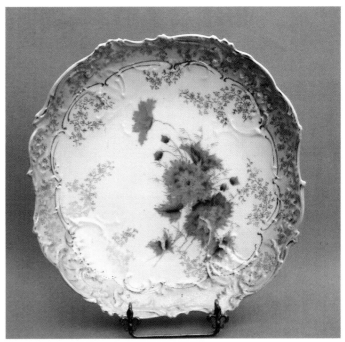

Plate 251. Charger, pink/yellow rim, Mold OM 36, decor OT 57, 10.5" w. $100-$200.

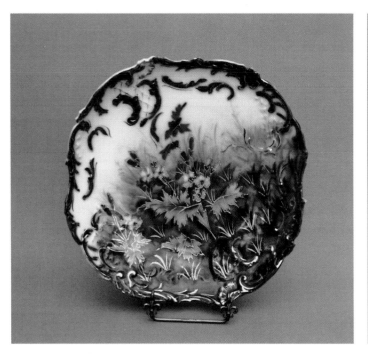

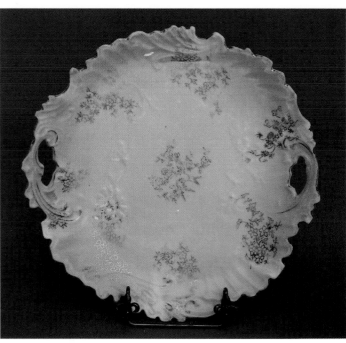

Plate 252. Charger, cobalt on white, Mold OM 36, Steeple FD O decor, 11" d., RS Steeple Prussia, (red) overglaze. $200-$400.

Plate 255. Cake plate, shaded pink edge, Mold OM 37, bird stencil decor, 10" d. Also known with shaded blue edge. $50-$100.

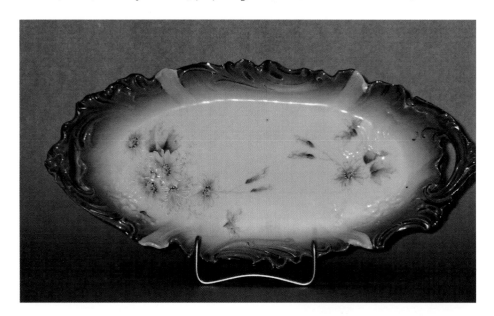

Plate 253. Celery tray, blue edge, Mold OM 37, decor OT 21, 12.5" l. This mold is illustrated in Sommers & Co. 1898-1900 catalogs. Gesetzlich geschützt Made in Germany mark. $50-$100.

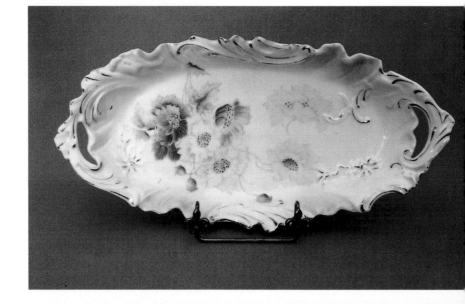

Plate 254. Celery tray, pink edge, Mold OM 37, decor OT 7, 12.5" l. $50-$100.

Plate 256. Illustration of "Helga" fruit set in Mold OM 38 from Falker and Stern Fall 1898 catalog. Falker and Stern show the identical illustration in their 1906 catalog, now identified as K6-120 "Bavarian trade-marked china" at almost one-half the price. This is one of several early R.S. Prussia patterns that apparently did not sell well, and were re-offered at a much lower price to close out stock. Also shown is the "Flavia" fruit set in Mold OM 40. *Courtesy of Amador Collections, Rio Grande Historical Collections, New Mexico State University Library.*

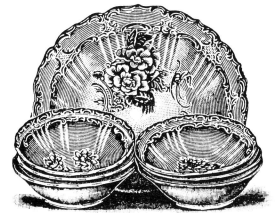

"HELGA" FRUIT SET.

One of the handsomest we have seen, the borders being tinted in two shades, lavender or pink or sea-green, and beautifully gold traced and the centers decorated with a bunch of large hand-painted flowers in rarest of colorings and raised gold tracing; diameter of bowl 10½ inches; 7 pieces to a set.

Price, per set $2 00

"FLAVIA" FRUIT SET.

Finest china, in the most fashionable color of the day-maroon; near the center is a deep rich border of maroon, gradually growing lighter towards the edge; in the center are hand-painted white and pink roses, surrounded by net-work of gold; fine gold foliage is scattered around the border and the scroll-work is all gold traced. A set comprises 7 pieces.

Price, per set........$2 50

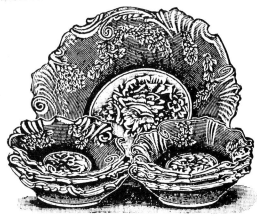

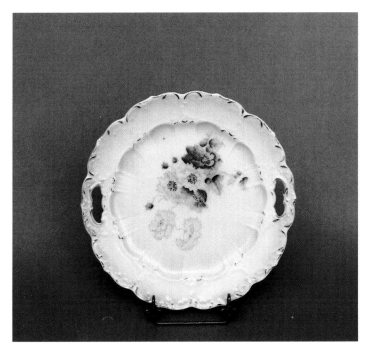

Plate 257. Cake plate, Mold OM 38, decor OT 7, 9.25" d. $50-$100.

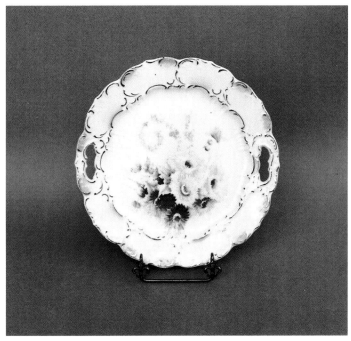

Plate 258. Cake plate, shaded lavender rim, Mold OM 38, decor OT 11, 9.25" d. $100-$200.

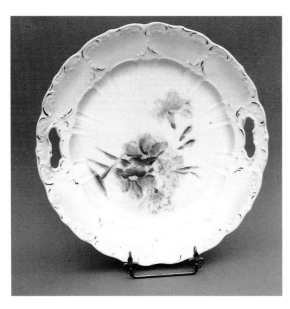

Plate 259. Cake plate, shaded blue rim, Mold OM 38, decor OT 30, 10" d. This mold was revived somewhere in 1905-06 period, and decorated with the legally protected R.S. Prussia "spring" season decor. $100-$200.

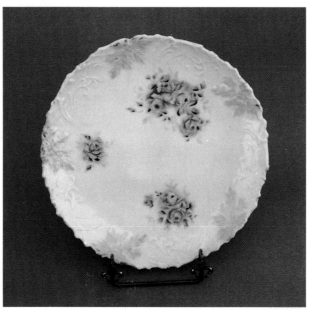

Plate 260. Plate, Mold OM 39 (embossed leaves in the rim), decor OT 3, 8.5" d. $50-$100.

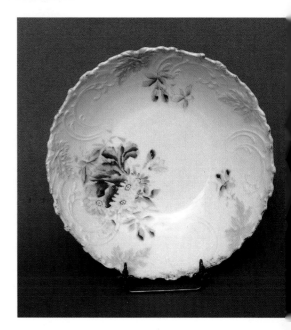

Plate 261. Bowl, Mold OM 39, decor OT 16, 10" d. $50-$100.

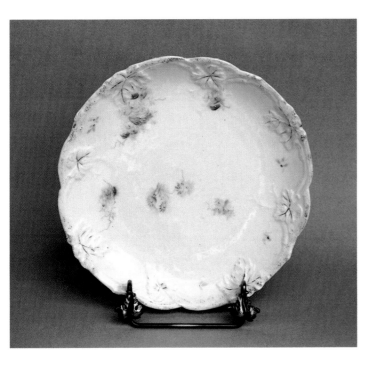

Plate 262. Plate, Mold OM 39A (slight difference in leaf patterns), decor ST 3, 7.5" d. $50-$100.

Plate 263. Plate, Mold OM 39A, decor OT 48, 8" d. $50-$100.

Plate 264. Bowl, green/white edge, Mold OM 40, decor OT 7, 10" d. This is also known as Mold 401 (Gaston 1982). $100-$200.

Plate 265 Bowl, cobalt and white, Mold OM 40, decor OT 11, 11" d. $200-$400.

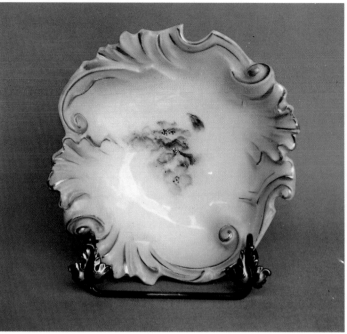

Plate 268. Individual berry bowl, Mold OM 40A, decor OT 42, 5.5" d. Under $25.

Plate 266. Individual berry bowl, Mold OM 40A, decor P 2, 5.5" d. Marked "Royal Coburg" in black script. Each size in mold OM 40 appears to incorporate a slightly different arrangement of the same pattern elements in the rim. Under $25.

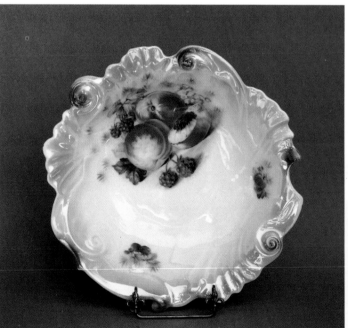

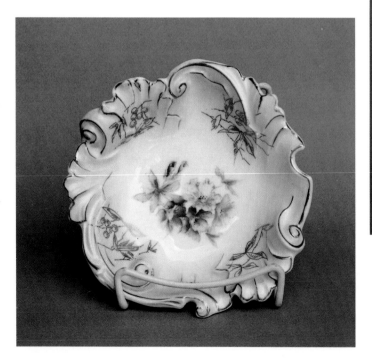

Plate 269. Large berry bowl, decor with fruit, 10.5" d. A good "look alike" mold similar to Mold OM 40A, probably from a competitor. The scrolls are within the rim in this item, while the scrolls in Mold OM 40A are tilted out of the plane of the rim. $50-$100.

Plate 267. Individual berry bowl, Mold OM 40A, decor OT 29, 5.5" d. Under $25.

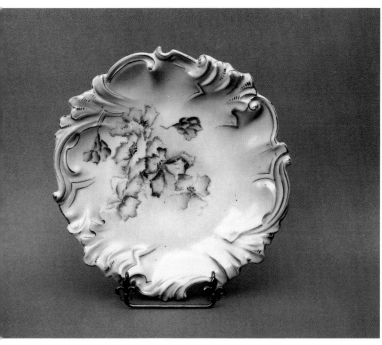

Plate 270. Bowl, red/buff rim, Mold OM 40B, decor OT 29, 9.25" d. $50-$100.

Plate 271. Plate, light green/buff rim, Mold OM 40B, decor OT 42, 9.25" d. $25-$50.

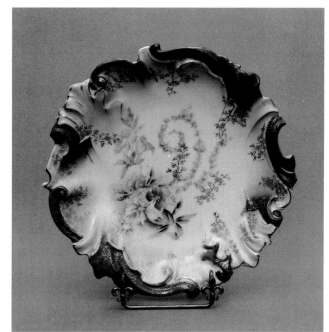

Plate 272. Plate, red/buff rim, Mold OM 40C, decor OT 8, 7.5" d. Marked "Old Vienna Germany" in gold. $50-$100.

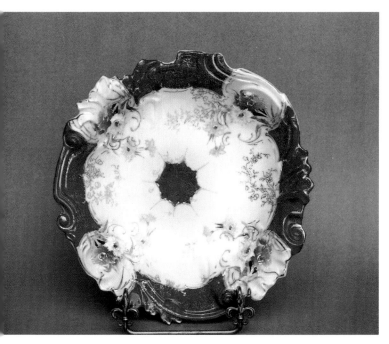

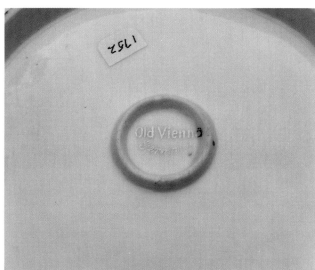

Plate 273. Old Vienna Germany mark on Plate 272.

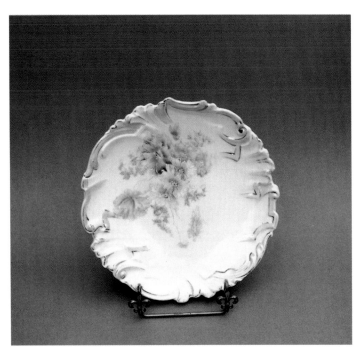

Plate 274. Plate, Mold OM 40D, decor OT 34, 7.5" d. $25-$50.

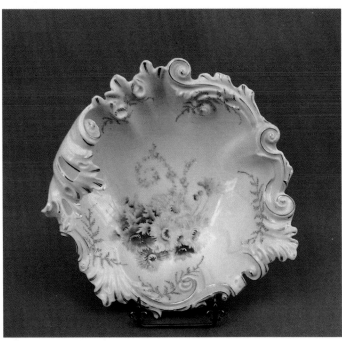

Plate 276. Bowl with fold over rim, shaded buff/blue, Mold OM 40E, decor OT 11, 11" d. The identical mold pattern is illustrated in Butler Bros. Fall 1900 catalog. Over $400.

"COUNTESS" SET.

This set combines every desirable feature—large capacity, handsome shape, pretty decoration, popular price. It is delicately tinted, edges gold traced, and the decorations exquisitely hand-painted in rich colors; butter 7½ inches in diameter. One set in package.

Price, per doz............$16 00

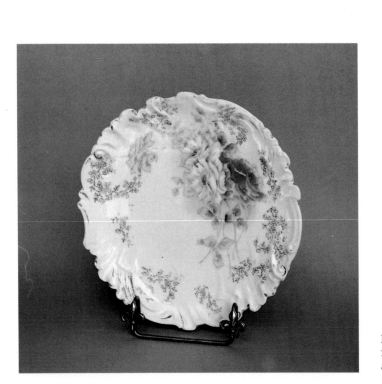

Plate 275. Plate, Mold OM 40D, decor OT 45, 7.5" d. This pattern is called the "Eulaline" pattern in the Fall and Spring 1898 Falker and Stern catalogs. $25-$50.

Plate 277. Illustration of the "Countess" table set in Mold OM 41 from a Falker and Stern 1898 catalog. *Courtesy of Amador Collections, Rio Grande Historical Collections, New Mexico State University Library.*

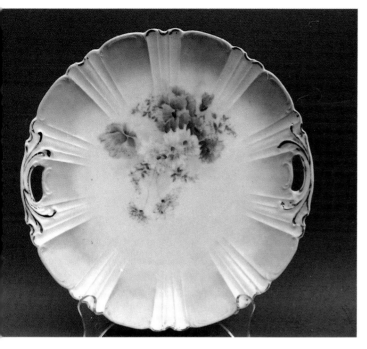

Plate 278. Cake plate, green/buff panels, Mold OM 41, decor OT 34, 10" d. $50-$100.

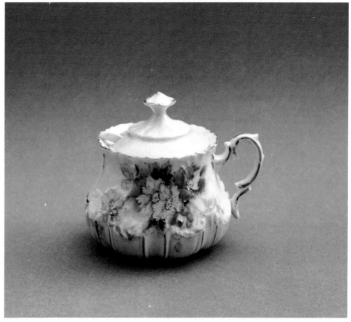

Plate 280. Mustard pot, Mold OM 41, decor OT 5, 3.5" h. $100-$200.

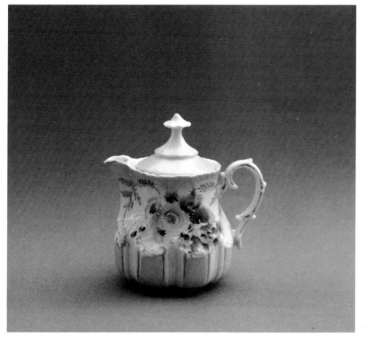

Plate 279. Syrup jug, Mold OM 41, decor OT 11A, 4.5" h. $100-$200.

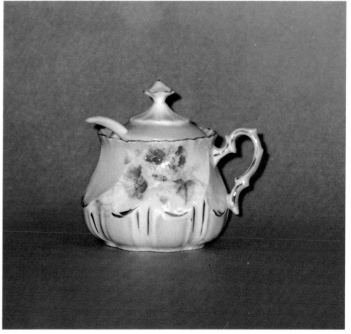

Plate 281. Mustard pot, Mold OM 41, decor OT 20, 3.5" h. $100-$200.

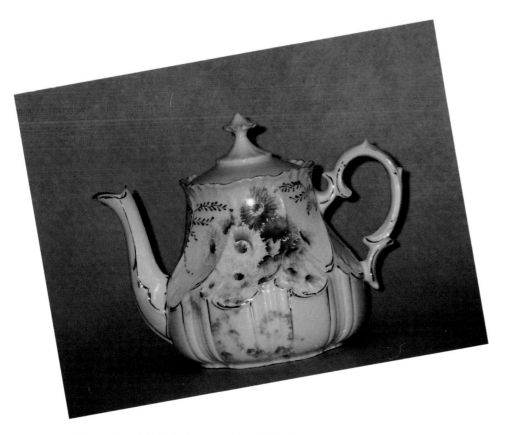

Plate 282. Teapot, Mold OM 41, decor OT 11A, 5.5" h. $100-$200.

Plate 283. Covered sugar bowl, Mold OM 41, decor OT 26, 4" h. $50-$100.

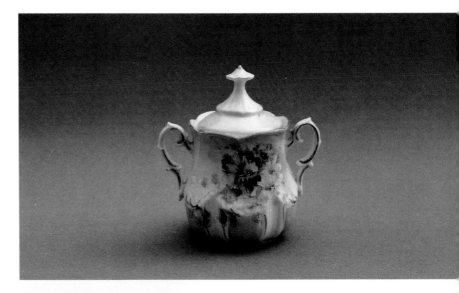

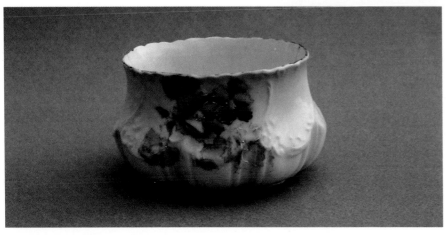

Plate 284. Open sugar bowl, Mold OM 41, 2" h. $25-$50.

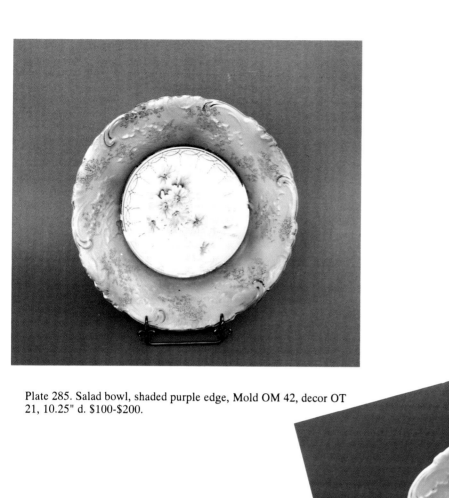

Plate 285. Salad bowl, shaded purple edge, Mold OM 42, decor OT 21, 10.25" d. $100-$200.

Plate 287. Salad bowl, Mold OM 42, decor OT 17, 10.25" d. $50-$100.

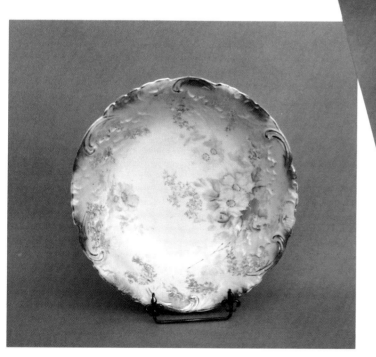

Plate 286. Salad bowl, shaded green edge, Mold OM 42, decor OT 5, 10.25" d. $100-$200.

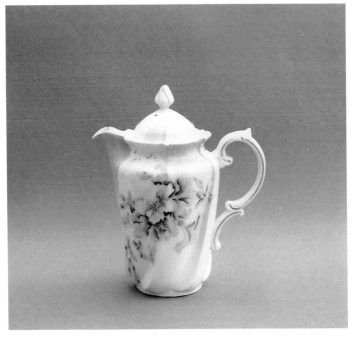

Plate 288. Chocolate pot, Mold OM 43, decor OT 17, 9" h. $100-
$200.

Plate 290. Mustard pot, Mold OM 43, decor OT 17, 3" h. $50-$100.

Plate 289. Child's open sugar/cream set, Mold OM 43, decor OT 5,
sugar 2" h. $50-$100.

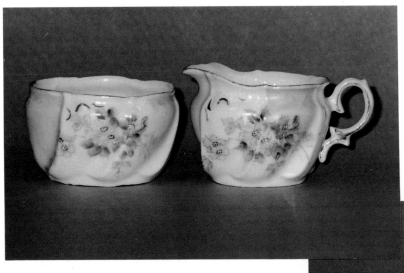

Plate 291. Dresser tray, Mold OM 44,
decor OT 7, 11.5" l. $50-$100.

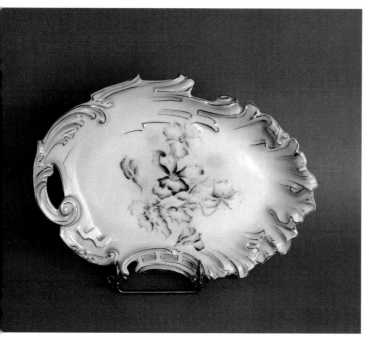

Plate 292. Dresser tray, Mold OM 44, decor OT 42, 11.5" l. $50-$100.

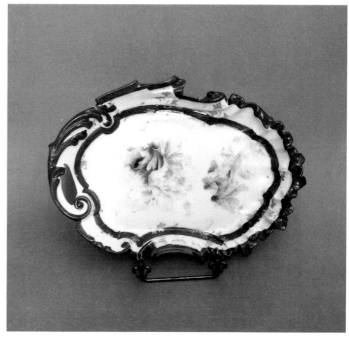

Plate 293. Dresser tray, Mold OM 44, decor OT 31, 11.5" l. $100-$200.

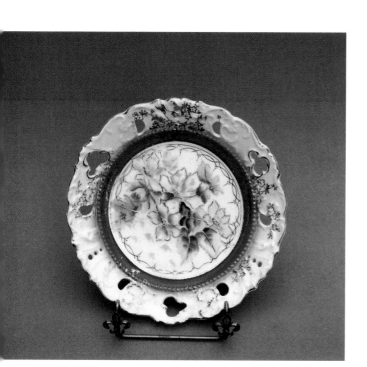

Plate 295. Plate, red band, openwork edge, Mold OM 45, decor OT 9, 6.75" d. $25-$50.

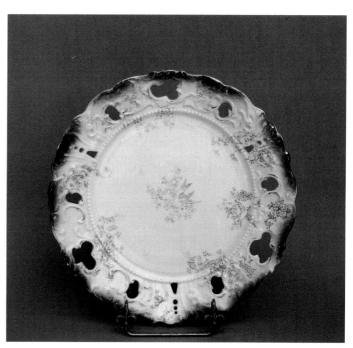

Plate 294. Plate, openwork edge, Mold OM 45, bird stencil decor, 9" d. $25-$50.

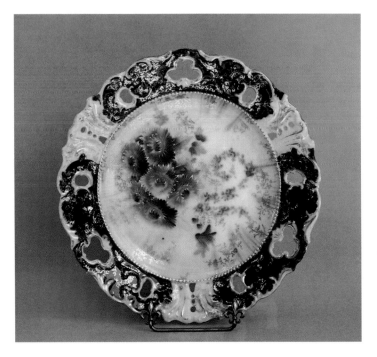

Plate 296. Plate, openwork edge, cobalt and tan, Mold OM 45, decor OT 11, 10.5" d. $200-$400.

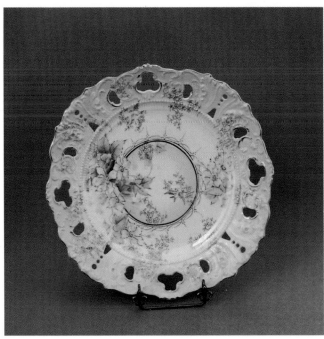

Plate 297. Charger, openwork edge, shaded lavender rim, Mold OM 45, decor OT 5, 11.25" d. $200-$400.

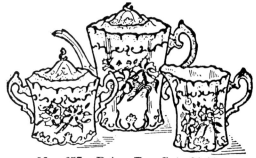

No. 657. Price Per Set, $1.10.

No. 657—A new shape set; a large panel shaped tea pot; beautiful colored decorations; fancy crimped edges and foot; covered sugar bowl and panel-shaped creamer to match; all with crimped edges, scroll bottom; fancy stippled handles; the whole forming an unusual, striking set. Price per set complete **1.10**

Plate 298. Illustration of No. 657 three piece tea set in Mold OM 47 from the 1899 G. Sommers & Co. Fall catalog. Broken finial on pot. Also illustrated in the Sommers & Co. 1900-01, Falker and Stern 1901-03, and Butler Bros. 1902-05 catalogs. Later catalogs show two finial changes, probably made to minimize breakage during shipment. *Courtesy of Minnesota Historical Society Library.*

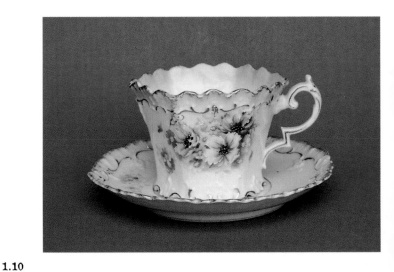

Plate 299. Coffee cup/saucer, pink edges, (Hexagon) Mold OM 47, cup 2.8" h. $50-$100.

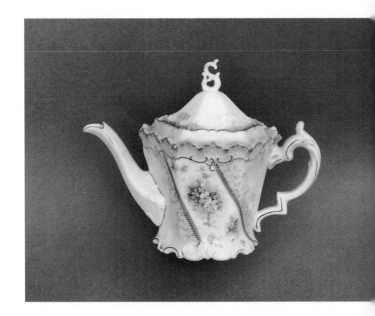

Plate 300. Teapot, pink edges, Mold OM 47, decor P 3, 5.5" h. $100-$200.

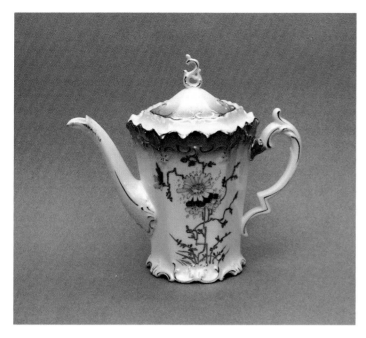

Plate 301. Coffee pot, purple edge, Mold OM 47, freeform daisy decor, 6.75" h. $100-$200.

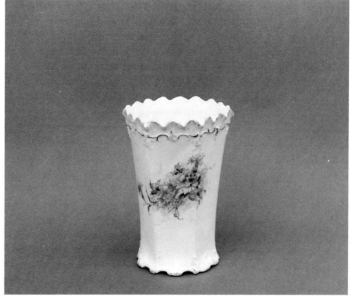

Plate 303 Spooner, blue edge, Mold OM 47, 4.5" h. $100-$200.

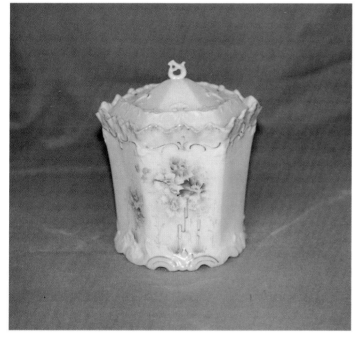

Plate 302. Biscuit jar, Mold OM 47, freeform decor, 7" h. $100-$200.

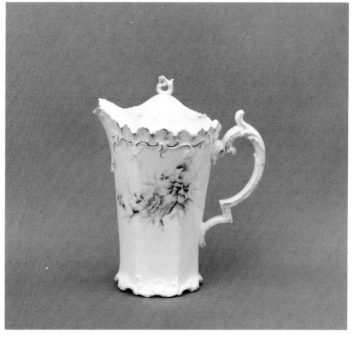

Plate 304. Chocolate pot, pink/green edge, Mold OM 47, 8.25" h. $100-$200.

CHINA CELERY TRAYS.

RS228—CELERY TRAY. *Eclipses anything ever offered by other houses at such a price!* Fine china, beautifully formed and hand-painted with flowers in rich colors. Has raised border of leaf and scroll-work, outlined in gold, tinted in pink and green and blue. Length 13⅜ in. ¼ doz. assorted in package. **Per doz., $7.00**

ES12 — CEL-

Plate 305. Illustration of RS 228 celery tray in Mold OM 48 from the 1901 Falker and Stern Spring catalog. This mold pattern also illustrated in the 1899 G. Sommers & Co. Fall catalog. *Courtesy Amador Collections, Rio Grande Historical Collections, New Mexico State University Library.*

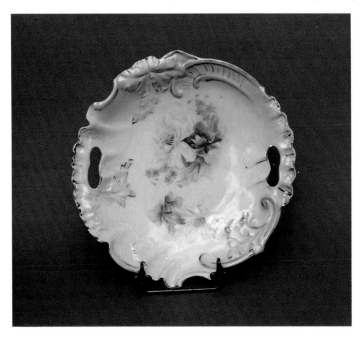

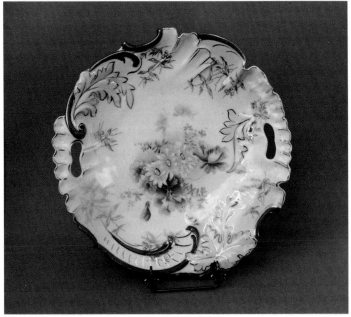

Plate 306. Cake plate, Mold OM 48, decor OT 31, 9.5" d. This mold with decor FD M is known to be marked with the RS Steeple Germany (green) underglaze mark. $100-$200.

Plate 307. Cake plate, Mold OM 48, decor OT 34, 11.25" d. $200-$400.

Plate 308. Dresser tray, Mold OM 48, decor OT 31, 11.5" l. $100-$200.

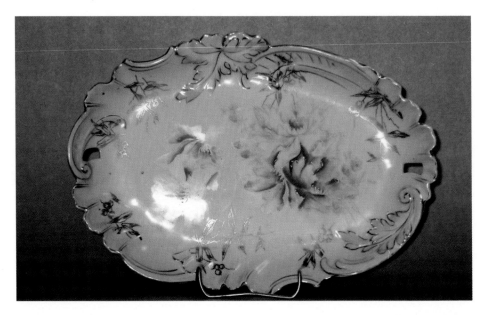

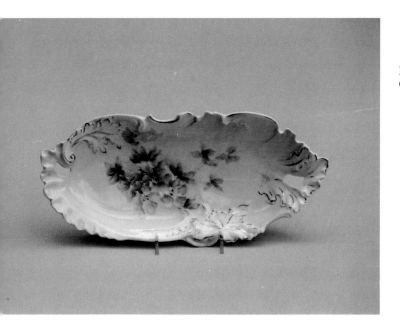

Plate 309. Celery tray, Mold OM 48, decor
OT 34, 11.5" l. $100-$200.

A37, $1.50 per set.

A37. Fancy Shell Design. Light
china, embossed in fancy shell
design with light green tinted
and white panels all around
flange, outlined with heavy
gold, center decorated with
large hand painted spray of
natural colored flowers, over
tinted ground, petals and flow-
ers outlined in raised enamel.
$2.25 would be considered cheap for this. Bowl 10¼ inches in diameter, extra deep,
six 5¾ inch berry dishes decorated to match; price per set......... 1.50

Plate 310. Illustration of No. A 37 sauce or berry set with a master
bowl (only) in Mold OM 49 from the Webb-Freyschlag Oct. 1900
catalog. *Courtesy of Amador Collections, Rio Grande Historical
Collections, New Mexico State University Library.*

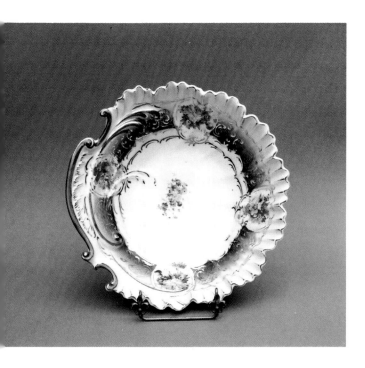

Plate 311. Berry bowl, green inner band, Mold OM 49, decor P 2,
10" d. $100-$200.

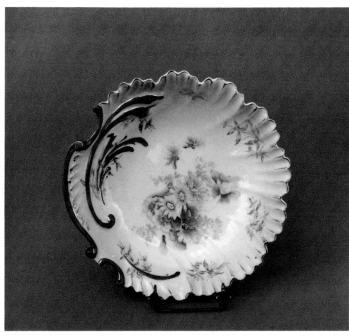

Plate 312. Berry bowl, shaded buff/pink edge, Mold OM 49, decor
OT 34, 10" d. $100-$200.

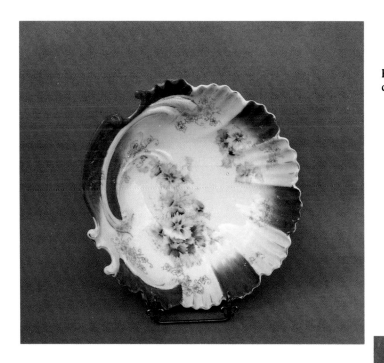

Plate 313. Berry bowl, buff/red rim, Mold OM 49, decor OT 33, 10" d. $200-$400.

Plate 314. Berry bowl, green/buff rim, Mold OM 49, decor OT 31, 10" d. $100-$200.

Plate 315. Open sugar/cream set, Mold OM 50, decor OT 17. Sugar 2" h. $50-$100.

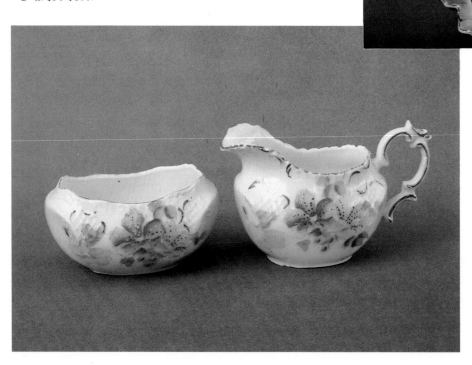

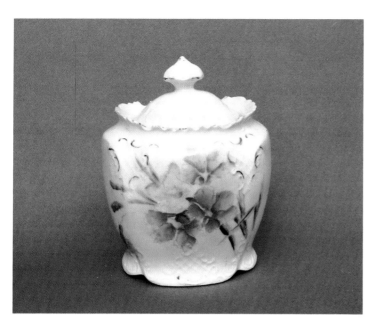

Plate 316. Biscuit jar, Mold OM 50, decor OT 30, 7" h. $100-$200.

Plate 317. Illustration of No. 412 and No. 426 "Prize Shaving Mug" in Mold OM 51 from Webb-Freyschlag 1898 Oct. catalog. Also shown is No. 414 in Mold OM 30, and another mug No. 416 in a rarely decorated mold pattern which may or may not be R.S. Prussia. *Courtesy of Amador Collections, Rio Grande Historical Collections, New Mexico State University Library.*

412, $2.00 doz. 414, $2.25 doz.

426, $2.25 doz. 416, $2.50 doz.

412. Panel Shaving Mug. Decorated with bright colored enamel flowers in beautiful effect, fancy gold traced edges and handle. partition with holes, size 3¼x3¼. ¼ dozen in package; per doz.............. 2.00

414. 35 Cent Shaving Mug. Wide base tapering towards bulging top, divided in four panels, decorated with hand-painted ox-heart daisies, which are enameled with tinted centers and gold tracing, scalloped gold traced edges and fancy handle, very artistic, partition with holes, size 3¼x3½, ¼ dozen in package; per doz.................... 2.25

426. Prize Shaving Mug. Embossed twist panel design decorated with bright colored enamel flowers, partition with holes and aperture for brush, gold traced edges and handle, size 3¼x3⅝, ¼ dozen in package; per doz........ 2.25

416. Footed Bottom Mug. Fancy embossed panel design on base, with heavy gold outlines, fancy scalloped gold stippled edge, handsome hand-painted floral decorations, gold stippled handle, partition with holes, size 3⅝x3½, ¼ dozen in package; per doz... 2.50

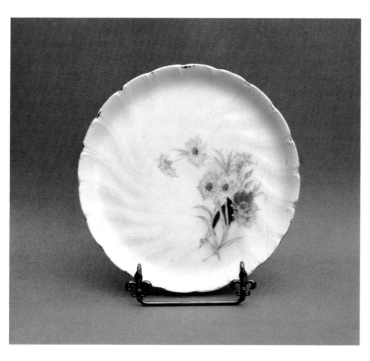

Plate 318. Small tray, probably for condiments, Mold OM 51, decor OT 8, 7.25" d. $25-$50.

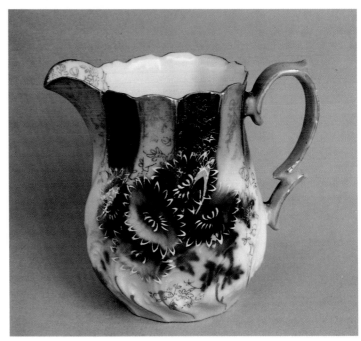

Plate 320. Milk pitcher, cobalt and tan, Mold OM 51, decor OT 11, 4" h. $100-$200.

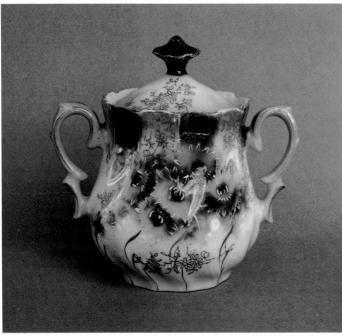

Plate 319. Covered sugar, cobalt and tan, Mold OM 51, decor OT 11, 4.5" h. $100-$200.

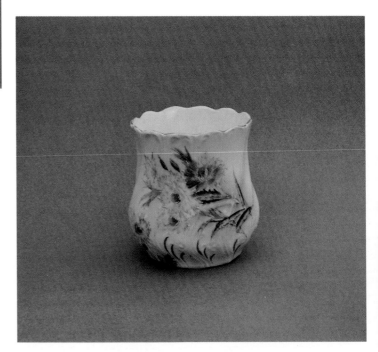

Plate 321. Spooner, Mold OM 51, decor OT 8, 3.5" h. $50-$100.

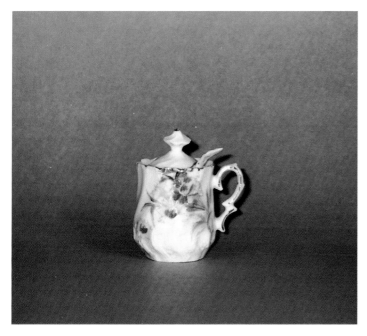

Plate 322. Mustard pot, Mold OM 51, decor OT 8, 4" h. $50-$100.

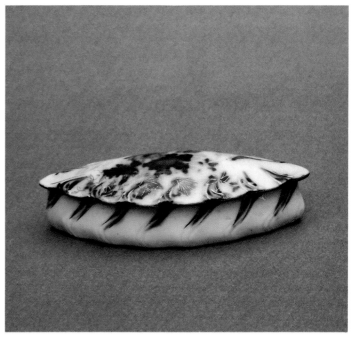

Plate 324. Pin box, cobalt and white, Mold OM 51, decor FD M, 4" l. RS Steeple Germany (green) mark. $100-$200.

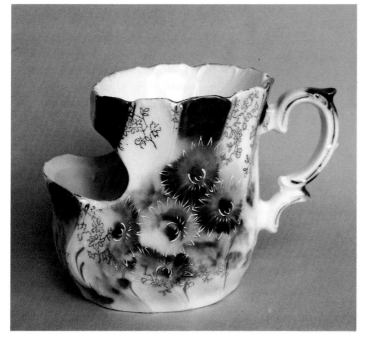

Plate 323. Scuttle mug, cobalt and white, Mold OM 51, decor OT 11, 3.75" h. $200-$400.

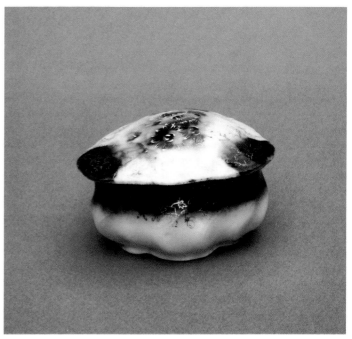

Plate 325. Trinket box, cobalt and white, Mold OM 51, decor OT 11, 3.25" w. $100-$200.

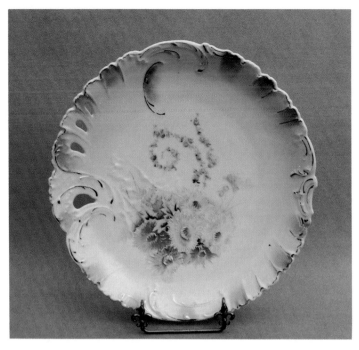

Plate 326. Cake plate, Mold OM 52, decor OT 11, 10.75" d. $100-$200.

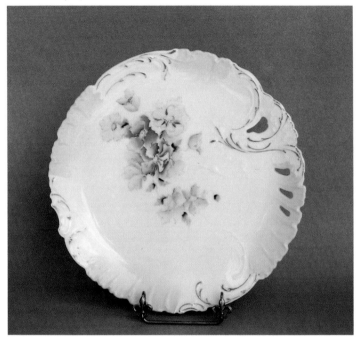

Plate 328. Cake plate, Mold OM 52, decor OT 33, 10.75" d. $100-$200.

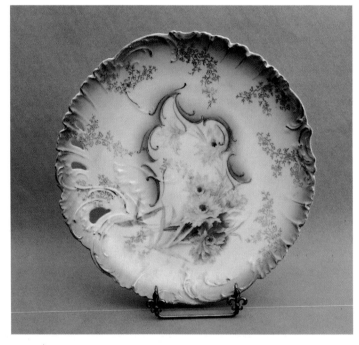

Plate 327. Cake plate, green rim, Mold OM 52, decor OT 8, 10.75" d. $100-$200.

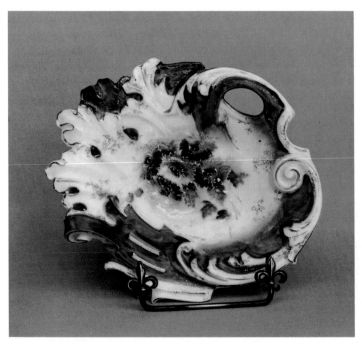

Plate 329. Tray, cobalt and white, Mold OM 53, decor OT 11, 7.5" l. $100-$200.

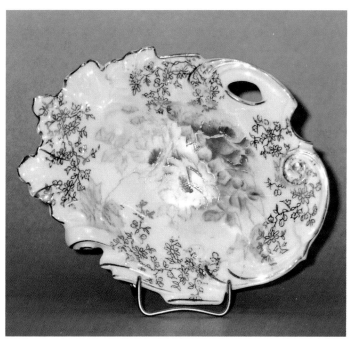

Plate 332. Tray, Mold OM 53, decor OT 45, 6" l. $50-$100.

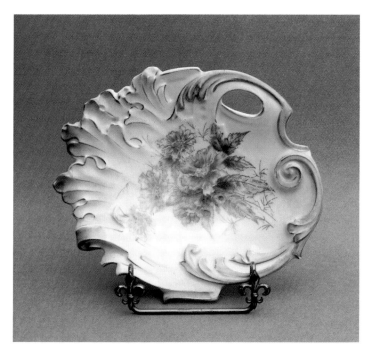

Plate 330. Tray, buff edge, Mold OM 53, decor OT 36, 7.5" l. Illustrated in 1900 Butler Bros. spring catalog. $50-$100.

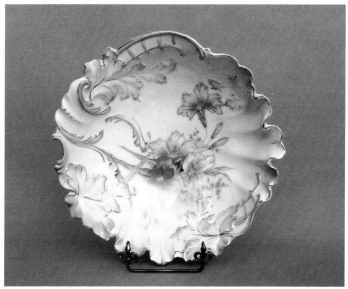

Plate 333. Berry bowl, Mold OM 54, decor OT 30, 10.25" d. This mold is easily confused with Mold OM 48, but may be distinguished by the "railroad track" pattern which expands here in a clockwise direction. Royal Coburg Germany + crown, (red) overglaze mark. $100-$200.

Plate 334. Royal Coburg Germany (overglaze) mark used on Plate 333.

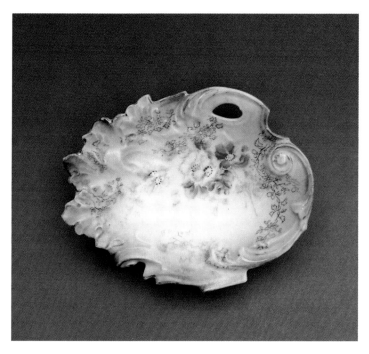

Plate 331. Tray, Mold OM 53, decor OT 5, 6" l. $50-$100.

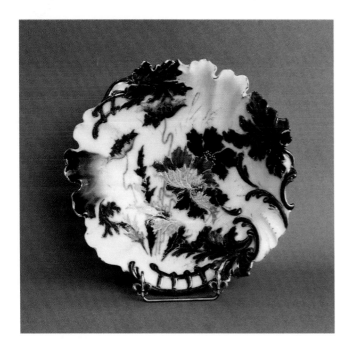

Plate 335. Berry bowl, cobalt and white, Mold OM 54, decor Steeple FD P, 10.25" d. RS Steeple Prussia (blue) underglaze mark. $200-$400.

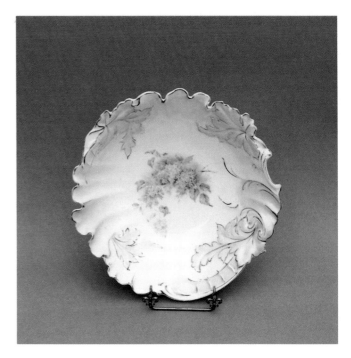

Plate 337. Berry bowl, pink/buff rim, Mold OM 54, decor P 4, 10.25" d. $100-$200.

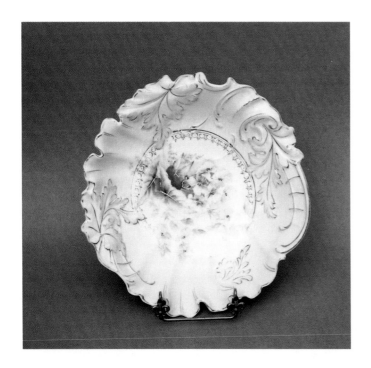

Plate 336. Berry bowl, pink/buff rim, Mold OM 54, decor OT 37, 10.25" d. $100-$200.

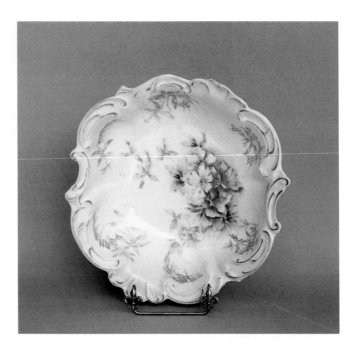

Plate 338. Bowl, shaded pink rim, Mold OM 55, decor OT 29, 10" d. $50-$100.

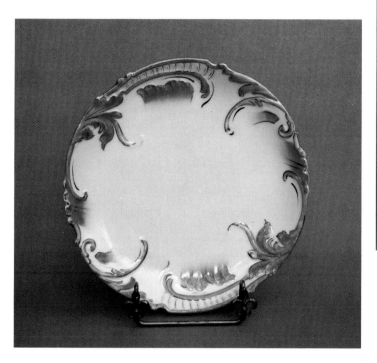

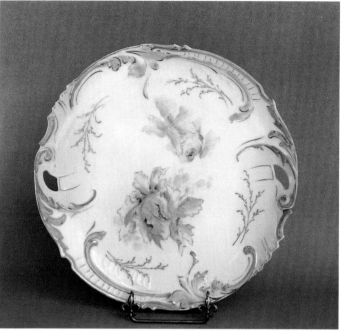

Plate 341. Cake plate, Mold OM 57, decor OT 31, 11.25" d. $100-
$200.

Plate 339. Plate, Mold OM 57, 7.5" d. This mold is different from
OM 54 in that there is a symmetrical arrangement of pattern
elements. Royal Coburg Germany, (red) overglaze mark. Under
$25.

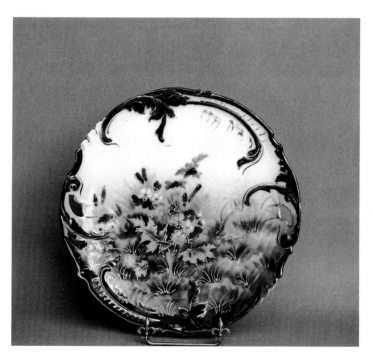

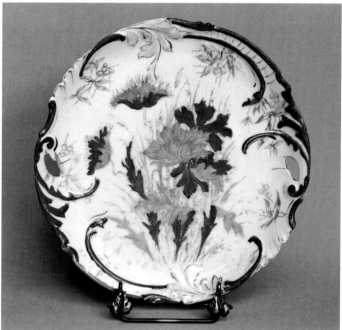

Plate 342. Cake plate, Mold OM 57, decor FD P, 12" d. $100-$200.

Plate 340. Cake plate, Mold OM 57, decor Steeple FD P, 9.5" d., RS
Steeple Prussia, (red) overglaze mark. $200-$400.

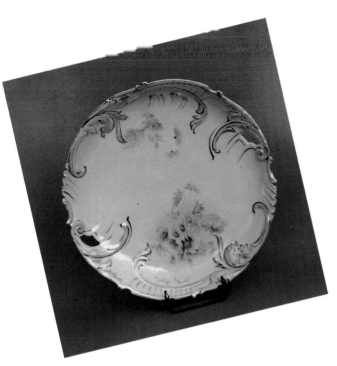

Plate 343. Charger, Mold OM 57, decor OT 34, 12.5" d. $100-$200.

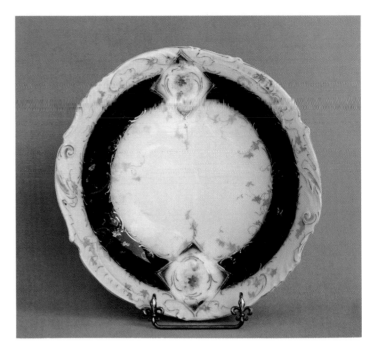

Plate 345. Plate, cobalt inner rim, Mold OM 57, decor P 2, 10.25" d. $25-$50.

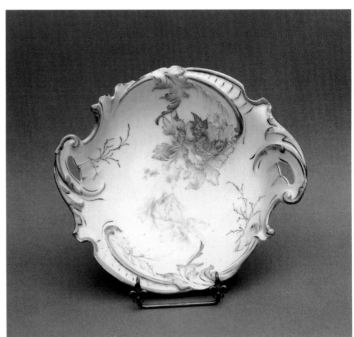

Plate 346. Open handle bowl, Mold OM 57, decor OT 31, 10.75" l. $100-$200.

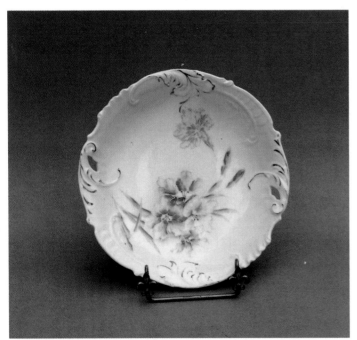

Plate 344. Bowl, Mold OM 57, decor OT 30, 7.5" d. $25-$50.

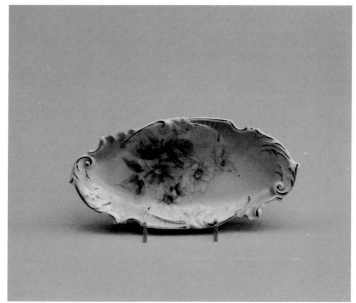

Plate 347. Tray, Mold OM 57, decor OT 26, 12.5" l. $50-$100.

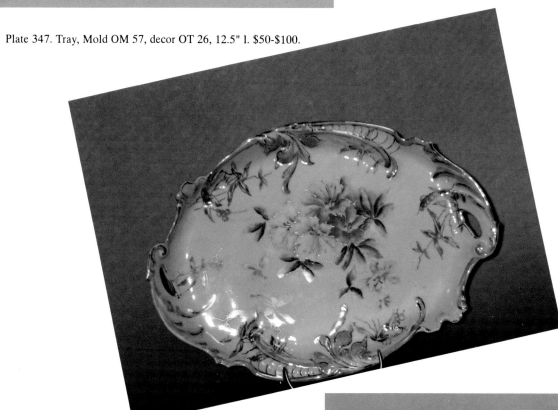

Plate 348. Dresser tray, Mold OM 57, decor OT 29, 12" l. $100-$200.

Plate 349. Tray, cobalt rim, Mold OM 57, decor P 4, 12" l. $100-$200.

Plate 350. Butter pats, cobalt and white, Mold OM 61, 3.3" d., RS Steeple Germany (green) mark. This mold is illustrated in Sommers & Co. 1900 and Falker and Stern 1903 catalogs. Each $50-$100.

Plate 352 Spooner, Mold OM 61, decor OT 34 (partial), 4.25" h. $50-$100.

Plate 353. Syrup pitcher, Mold OM 61, decor OT 70, 4.25" h. $50-$100.

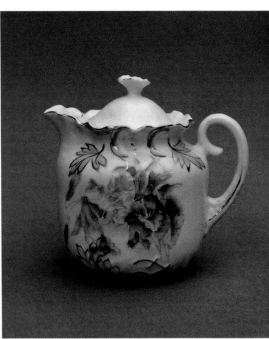

Plate 351. Covered sugar/cream set, Mold OM 61, decor OT 30, sugar 4.5" h. $50-$100.

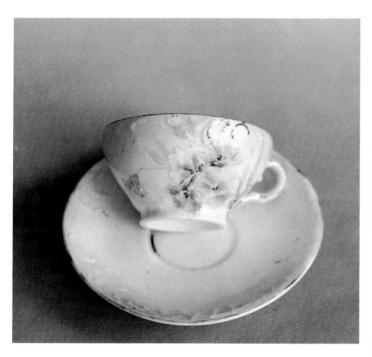

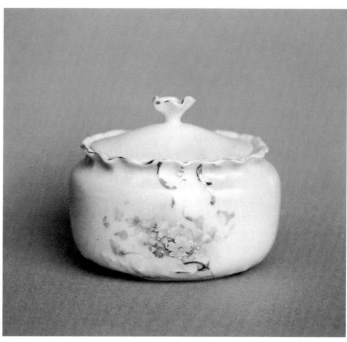

Plate 356. Oval box or small sugar bowl, Mold OM 61, decor P 3, 2.5" h. $25-$50.

Plate 354. Cup/saucer, Mold OM 61, decor OT 30, Cup 1.5" h. $25-$50.

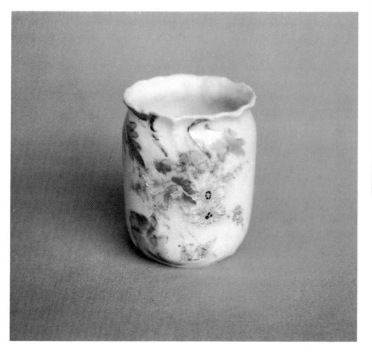

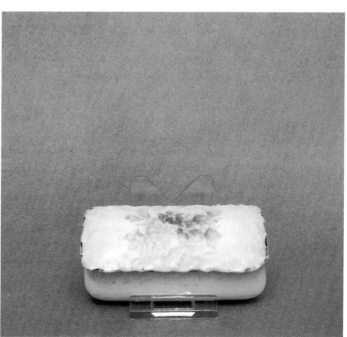

Plate 357. Box, rectangular, Mold OM 61, decor OT 28, 3.5" l. $50-$100.

Plate 355. Toothpick holder, Mold OM 61, decor OT 26, 2.4" h. $50-$100.

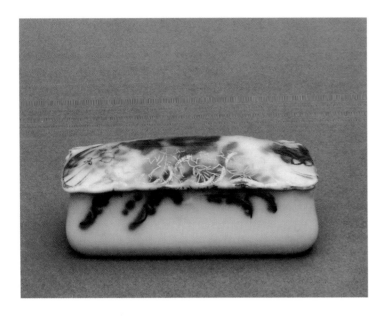

Plate 358. Box, rectangular, Mold OM 61, decor FD M, 3.5" l., RS Steeple Prussia (green) mark. $100-$200.

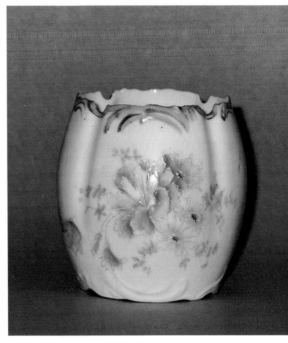

Plate 361. Spooner, Mold OM 62, decor OT 34, 3.5" h. This mold known to be marked with crown with "Germany" below in green (Capers mark RS 5.3G 5.) $50-$100.

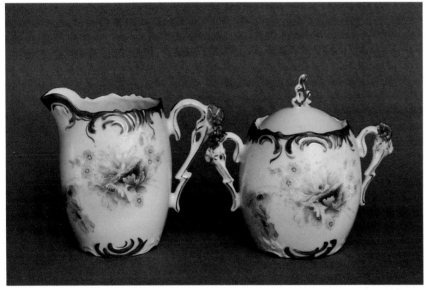

Plate 359. Cream and covered sugar, Mold OM 62, decor OT 31. sugar 4.6" h. $50-$100.

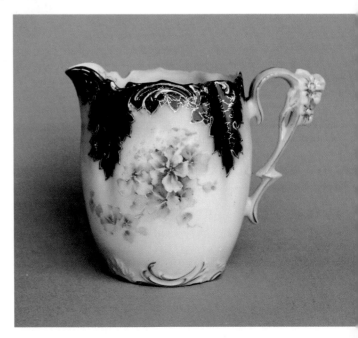

Plate 360. Milk pitcher, cobalt rim, Mold OM 62, decor OT 26, 4.5" h. $100-$200.

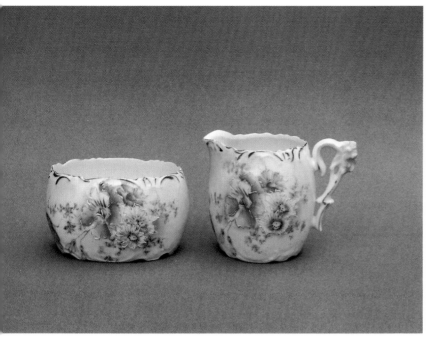

Plate 362. Open sugar/cream set, Mold OM 62, decor OT 34, pitcher 3" h. $50-$100.

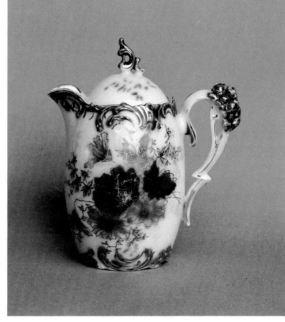

Plate 365. Tall syrup can, Mold OM 62, decor FD M, 6" h., RS Steeple Prussia (green) mark. The teapot in this mold/decor combination is known to be marked with a Royal Vienna type crown and "Germany" in green (Capers 1996). $200-$400.

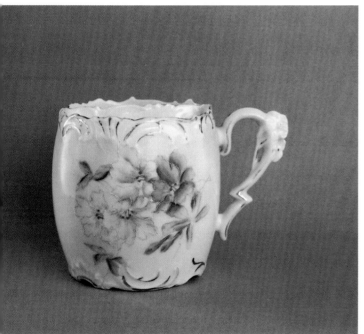

Plate 363. Shaving mug, light pink ground, Mold OM 62, decor OT 29, 3.6" h. $100-$200.

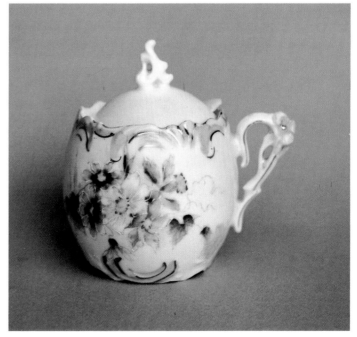

Plate 364. Mustard pot, Mold OM 62, decor OT 47, 3.5" h. Illustrated in 1900 Butler Bros. Spring catalog. $50-$100.

1 0 0 5—2 fancy shapes, open handles with gold traced openings, luster green tinted scroll, embossed flange, gold traced, elaborate gold colored floral decorations all over. 2 shapes and 2 decorations in pkg. of ⅙ doz.. 8 90

Plate 368. Illustration of Mold OM 64 in the Butler Bros. Spring 1900 catalog.

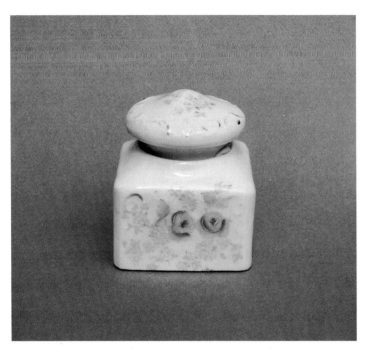

Plate 366. Inkwell, Mold OM 62A, decor OT 40, 2.75" h. $50-$100.

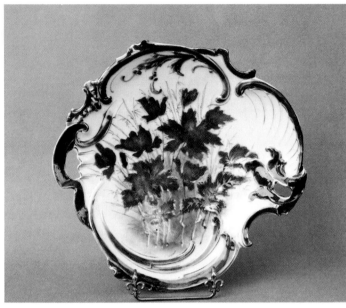

Plate 369. Tray, green and white, Mold OM 64, decor OT 67, 11" w., RS Steeple Prussia, (green) mark. $100-$200.

Plate 370. Tray, green edge, Mold OM 64, decor OT 29, 11" w. $100-$200.

Plate 367. Blotter holder, Mold OM 62A, decor OT 40, 5.25" l. $50-$100.

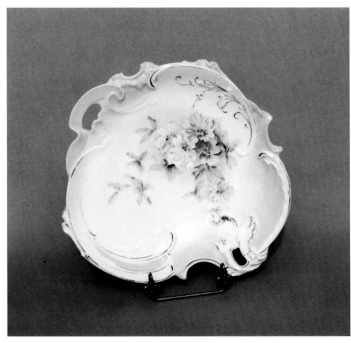

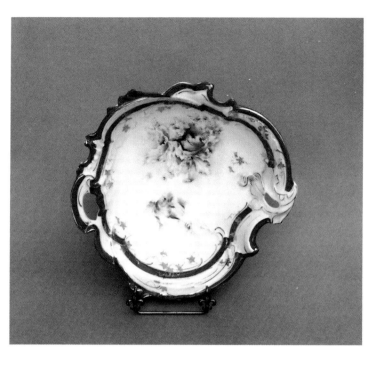

Plate 371. Tray, red and white, Mold OM 64, decor OT 31, 11" w. $100-$200.

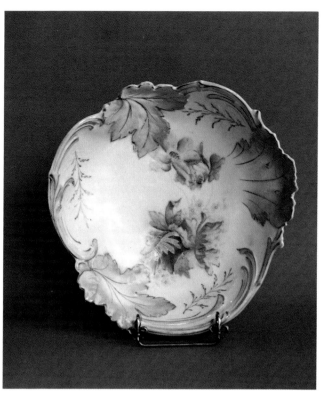

Plate 373. Salad bowl, buff/lavender edge, Mold OM 67, decor OT 31, 10" w. $100-$200.

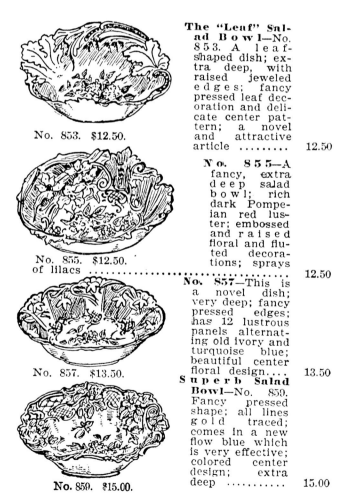

No. 853. $12.50.

No. 855. $12.50.

No. 857. $13.50.

No. 859. $15.00.

The "Leaf" Salad Bowl—No. 853. A leaf-shaped dish; extra deep, with raised jeweled edges; fancy pressed leaf decoration and delicate center pattern; a novel and attractive article 12.50

No. 855—A fancy, extra deep salad bowl; rich dark Pompeian red luster; embossed and raised floral and fluted decorations; sprays of lilacs 12.50

No. 857—This is a novel dish; very deep; fancy pressed edges; has 12 lustrous panels alternating old ivory and turquoise blue; beautiful center floral design.... 13.50

Superb Salad Bowl—No. 859. Fancy pressed shape; all lines gold traced; comes in a new flow blue which is very effective; colored center design; extra deep 15.00

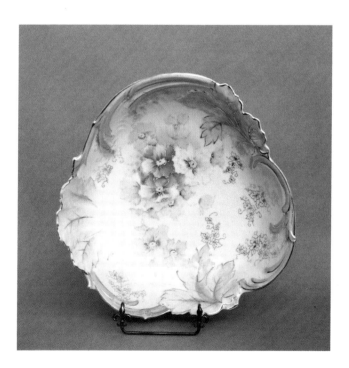

Plate 374. Salad bowl, tan/green edge, Mold OM 67, decor OT 33, 10" w. $100-$200.

Plate 372. Illustration of the "Leaf" salad bowl No. 853 in Mold OM 67. Also shown are Molds OM 65 (#855), OM 69 (#857), and OM 70 (#859) from the G. Sommers & Co. Fall 1900 catalog. *Courtesy of Minnesota Historical Society Library.*

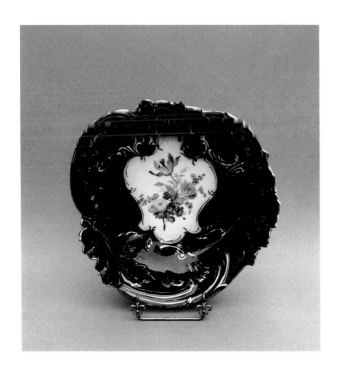

Plate 375. Salad bowl, cobalt with white center, Mold OM 67, printed decor, 10" w. $200-$400.

Plate 377. Cake plate, Mold OM 69, decor P 4, 11" d. $50-$100.

Plate 376. Plate, green edge, Mold OM 69, decor OT 26, 8" d. Shown in the G. Sommers & Co. 1900-1901 catalogs, and in the Spring Falker and Stern 1901 catalog. $25-$50.

Plate 378. Bowl, Mold OM 69, decor OT 44, 8" d. $50-$100.

Plate 379. Cake plate, pink/lavender flowers in rim, Mold OM 72, decor OT 27, 11" d. $100-$200.

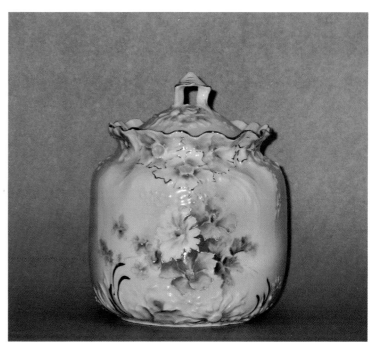

Plate 382. Biscuit jar, lavender flowers in rim, Mold OM 72, decor OT 71, 6.5" h. $200-$400.

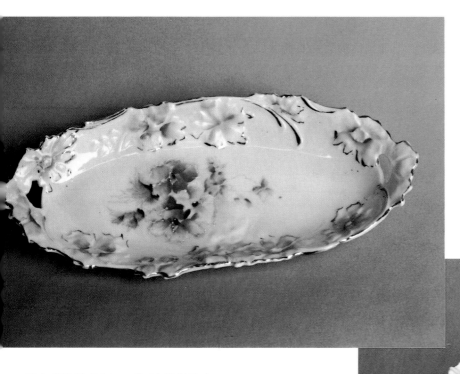

Plate 380. Relish tray, Mold OM 72, decor OT 71, 8.5" l. $50-$100.

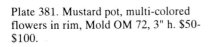

Plate 381. Mustard pot, multi-colored flowers in rim, Mold OM 72, 3" h. $50-$100.

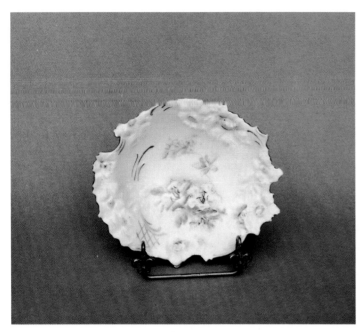

Plate 383. Tray, Mold OM 72, decor OT 71, 6.5" l. $50-$100.

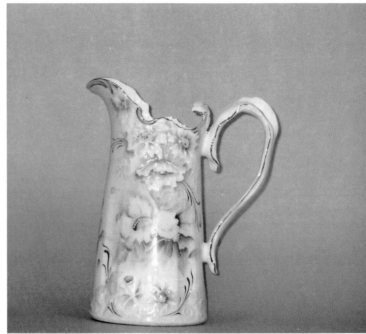

Plate 385. Tankard shape pitcher, Mold OM 72, decor OT 31A, 8" h. $200-$400.

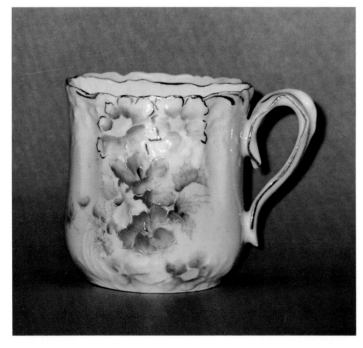

Plate 384. Shaving mug, Mold OM 72, decor OT 71, 3.5" h. $100-$200.

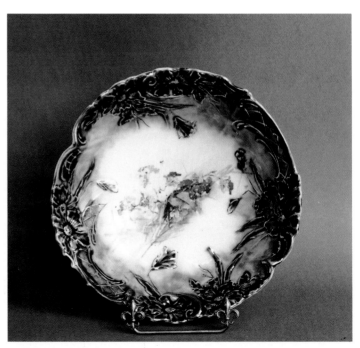

Plate 386. Bowl, cobalt and white, Mold OM 73, decor HI 10, 9.25" d., marked RS Steeple Prussia, green. $200-$400.

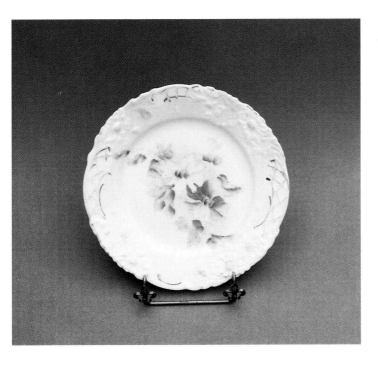

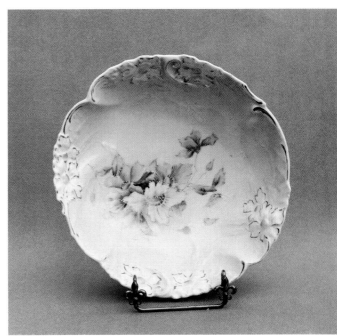

Plate 387. Plate, Mold OM 73, 7.5" d. $25-$50.

Plate 389. Bowl, Mold OM 73, decor OT 31A, 9" d. $50-$100.

Plate 388. Cake plate, shaded green edge, Mold OM 73, decor OT 34, 12" d. $100-$200.

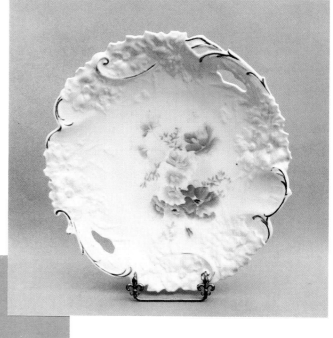

Plate 390. Bun tray, Mold OM 73, decor OT 71, 12.5" l. This object in cobalt/white and Queen Louise decor is known to be marked with the RS Steeple Prussia (red) mark (Capers 1996). $100-$200.

Chapter 7
Mold Patterns with Small Transfer Decoration

Objects with small decorative patterns, both outline and printed transfer, are illustrated in this section. Normally, these patterns are composed of three flowers or less, with and without small leaves. In contrast with large transfers, small transfers do not appear to have been widely used until 1898. In addition, the molds decorated with many of the small transfers are largely different from those decorated with large transfers. About 1900, however, both large and small outline transfers were phased out and largely, but not entirely, replaced with printed color transfers.

The extent of overlap in the small transfer array is considerably less than in the large transfer array. In fact, the overlap barely meets the minimum requirement for many of the molds. Many of the small transfers, prefixed by ST, were used on small, incidental items. Apparently, there was a large variety of transfers, and parts thereof, to use on these objects.

Illustrations in Chapter 7 begin with RS Celebrate and RS Wing mark mold patterns. The decoration on Molds OM 102-105 is very plain, but characteristic of the period. Mold OM 120 is one where objects without decoration appear in a 1896 Butler Bros. catalog, but objects with sparse decoration appear in much later in Webb-Freyschlag and G. Sommers & Co. catalogs. For a long time we could not find a catalog reference to the "Scallop Bottom" Mold OM 130. Close examination of the cup and mug sections of an 1898 Webb-Freyschlag catalog finally provided the date for this pattern.

Unlike other wholesale firms, accessory items were a staple to Webb-Freyschlag. Items in Molds OM 130-131 are illustrated in 1898 and 1899 catalogs. Apparently, some of these objects remained in production for some time, as we have seen an inkwell in Mold OM 131 marked with the classic RS Prussia Wreath. Other unusual and one-of-a-kind objects carried by this firm are illustrated in Chapter 8.

Beginning 1899, G. Sommers & Co. carried three mold patterns decorated almost exclusively with small transfers. One of these, Mold OM 140, is known to be marked "Royal Tillowitz" (Plate 452), as well as with the classic RS Wreath. Mold patterns OM 150-150A were either produced for a long time, or once inventoried, did not move off their shelves. They may have not been alone with this problem, as Butler Bros. illustrate the same molds in their 1905 and 1906 catalogs.

Finally, we illustrate Mold OM 162, a pattern widely used for accessory items. Our link to R.S. Prussia is provided by the small printed transfers used later on many known R.S. Prussia mold patterns.

While there are many examples we would have liked to include in this Chapter, we could not do so owing to an insufficient number of objects. Hopefully, the reader will find the illustrations of help in the identification of their unmarked items, and useful in their quest for examples of early R.S. Prussia.

Plate 391. Tankard shape pitcher, Mold OM 101, 9" h., RS Celebrate mark. $100-$200.

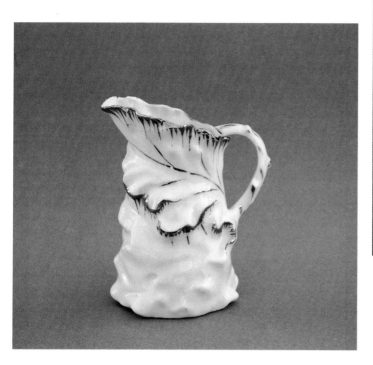

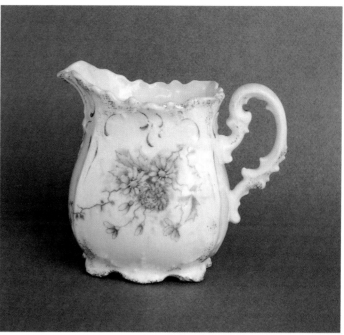

Plate 394. Cream pitcher, Mold OM 102, decor ST 15, 3.75" h., RS Wing mark. $25-$50.

Plate 392. Cream pitcher, tankard shape, Mold OM 101, 4" h. $25-$50.

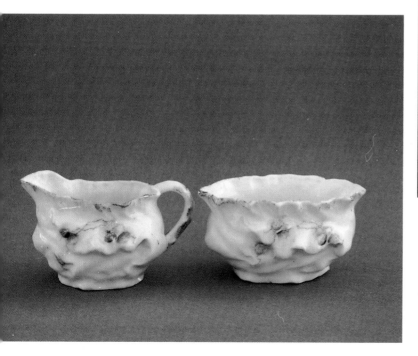

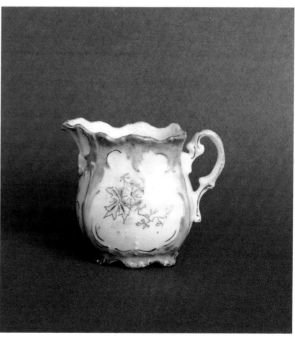

Plate 395. Cream pitcher, Mold OM 102, 2.5" h. Under $25.

Plate 393. Cream/open sugar set, Mold OM 101, 3" h. $25-$50.

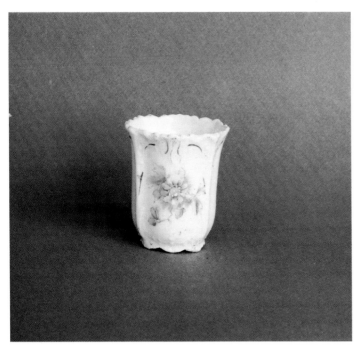

Plate 396. Toothpick holder, Mold OM 102, decor ST 15, 2" h., RS Wing mark. $50-$100.

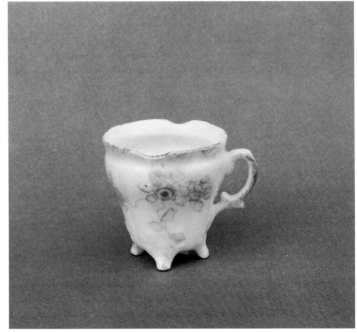

Plate 398. Cup, Mold OM 103, 1.75" h., RS Wing mark. $25-$50.

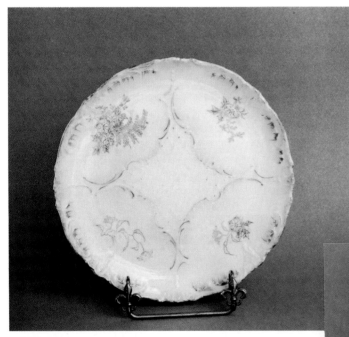

Plate 397. Plate, Mold OM 102, 7.75" d. $25-$50.

Plate 399. Three piece tea set, Mold OM 103, pot 5" h. $100-$200.

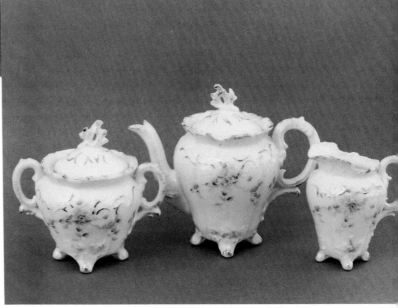

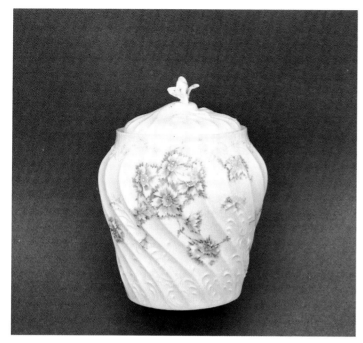

Plate 400. Biscuit jar, Mold OM 104, 7" h. $100-$200.

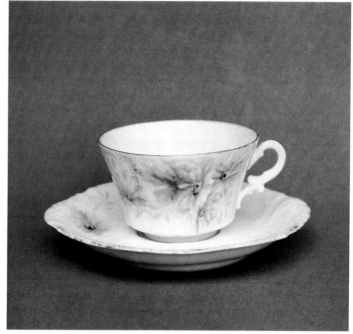

Plate 402. Cup/saucer, Mold OM 105, decor OT 48, 2.25" h., RS Wing mark. $50-$100.

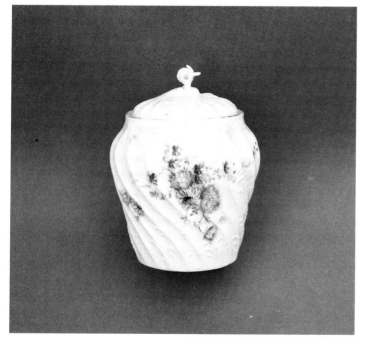

Plate 401. Biscuit jar, Mold OM 104, 7" h. $100-$200.

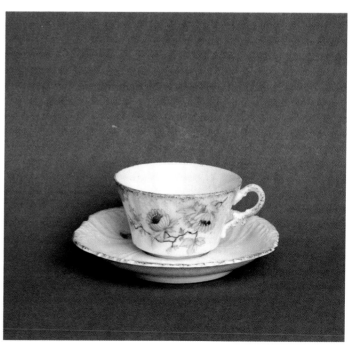

Plate 403. Cup/saucer, Mold OM 105, 2.25" h. $50-$100.

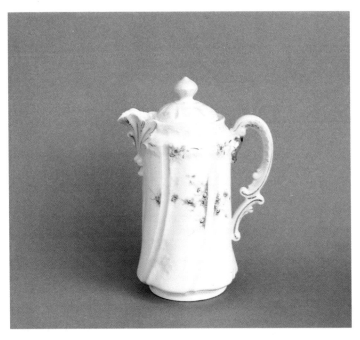

Plate 404. Chocolate pot, Mold OM 105, 8.5" h. $50-$100.

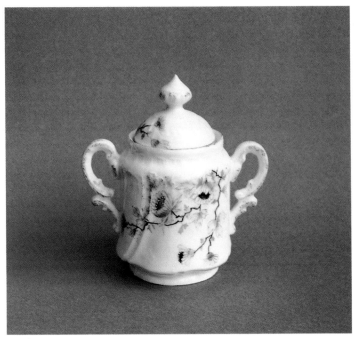

Plate 406. Covered sugar, Mold OM 105, 4" h. $25-$50.

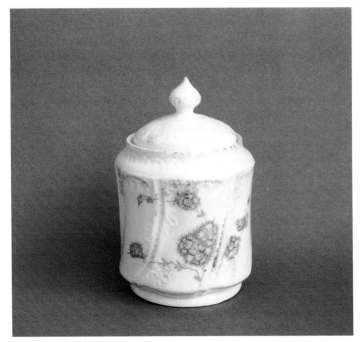

Plate 405. Biscuit jar, Mold OM 105, 7.5" h. $50-$100.

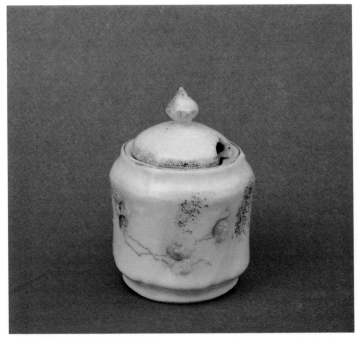

Plate 407. Mustard pot, Mold OM 105, 3.25" h. $25-$50.

No. 1627, $4.00 Doz.

No. 1627, Assorted Celery Holders—Regular size, 6½ inches high and 4 in diame
handsome scroll designs, gold clouds, gold lines and colored work. ¼ doz. in pkg...

Plate 408. Illustration of No. 1627 tall celery in Mold OM 120 with no transfer decor from the 1896 Butler Bros. catalog. This mold also shown in the Webb-Freyschlag 1898 catalog, and in the G. Sommers & Co. 1900-01 catalogs. *Courtesy of the Strong Museum Library*

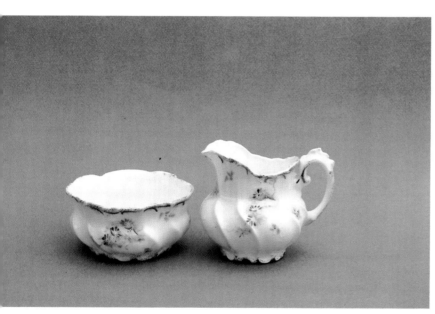

Plate 409. Open sugar/cream set, Mold OM 120, decor ST 3, sugar 1.75" h. $50-$100.

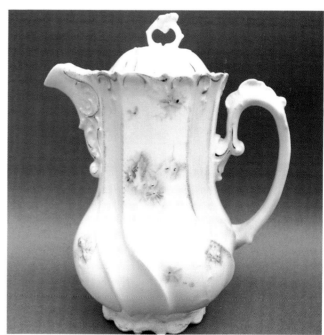

Plate 411. Mustard pot, Mold OM 120, decor OT 53, 3.25" h. $25-$50.

Plate 410. Chocolate pot, Mold OM 120, decor ST 3, 8.5" h. $100-$200.

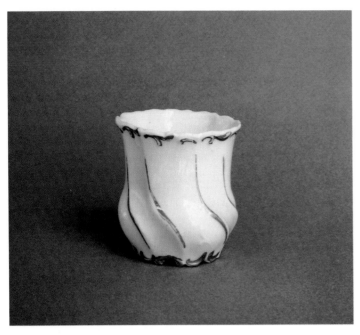

Plate 412. Toothpick holder, Mold OM 120, 2" h. $25-$50.

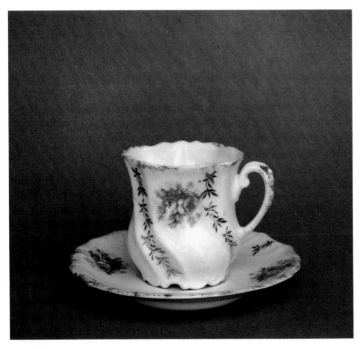

Plate 413. Demitasse cup/saucer, Mold OM 120, small printed transfer, 2" h. $25-$50.

Plate 414. Teapot, Mold OM 120, decor ST 19, 5.5" h. $100-$200.

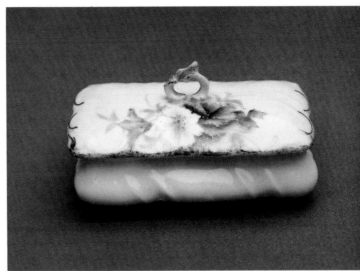

Plate 415. Covered box, Mold OM 120, decor ST 21, 3.75" l. $50-$100.

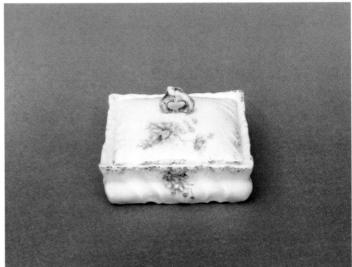

Plate 416. Covered box, square, Mold OM 120, 3" w. $50-$100.

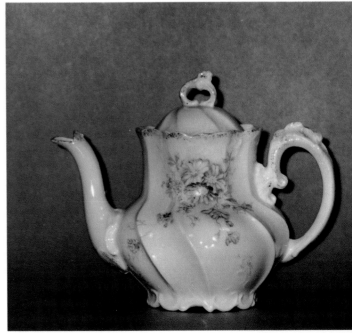

Plate 417. Pitcher, Mold OM 121, 3.5" h. $25-$50.

Plate 419. Mustard pot, Mold OM 121, 3.25" h. $25-$50.

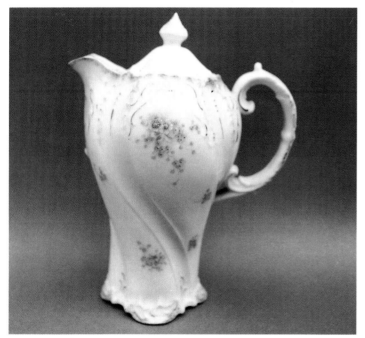

Plate 418. Chocolate pot, Mold OM 121, 8.5" h. $100-$200.

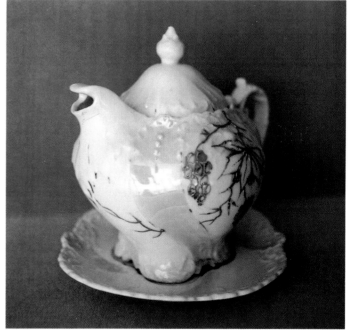

Plate 420. Syrup pitcher and underplate, Mold OM 121, weed decor, pitcher 4" h. $50-$100.

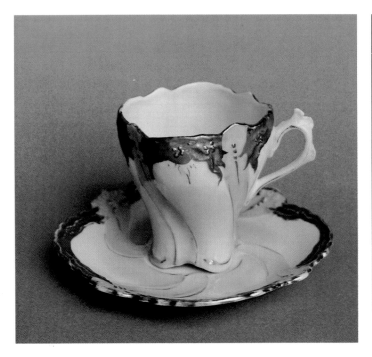

Plate 421. Demitasse cup/saucer, Mold OM 121A, cup 1.75" h. $50-$100.

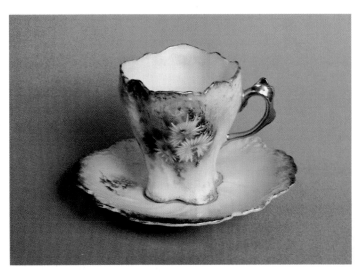

Plate 422. Demitasse cup and saucer, Mold OM 121A, printed decor P 6, cup 2.25" h. $50-$100.

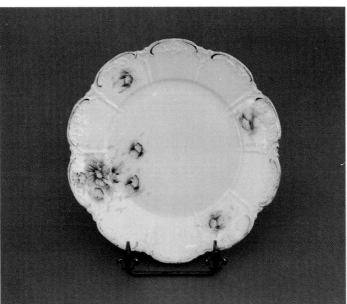

Plate 424. Plate, Mold OM 130, 8" d. $25-$50.

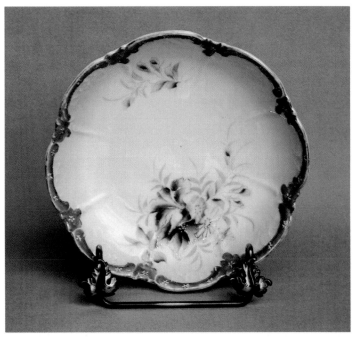

Plate 425. Small berry bowl, Mold OM 130, 6" d. Under $25.

Plate 426. Open sugar, Mold OM 130, 1.25" h. Under $25.

342, $3.85 doz.

342. A Rich 50 Cent Offering. Fine quality transparent china, fancy footed, base and rim encircled with beautiful scroll of green outlined in raised gold, all-over hand-painted flower and spray decorations in Dresden effect, narrow band of gold on inner rim. Extra fine both in china and decoration, size 3x3⅜, ½ dozen in package; per doz.............. 3.85

Plate 423. Illustration of No. 342 fancy shape mug in mold OM 130 from the Webb-Freyschlag 1898 Spring catalog. This mold also illustrated in the G. Sommers & Co. 1898 catalog. *Courtesy of Amador Collections, Rio Grande Historical Collections, New Mexico State University Library.*

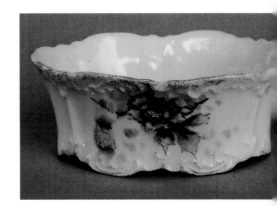

116

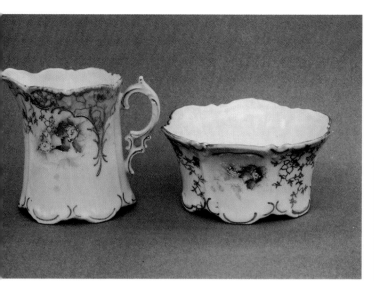

Plate 427. Cream/open sugar set, Mold OM 130, sugar 2" h. $50-$100.

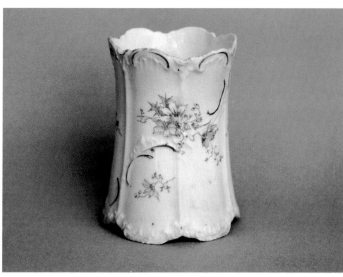

Plate 430. Spooner, Mold OM 130, 4.5" h. $50-$100.

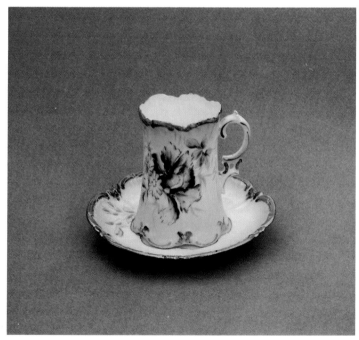

Plate 428. Chocolate cup/saucer, Mold OM 130, decor OT 16, cup 3" h. $50-$100.

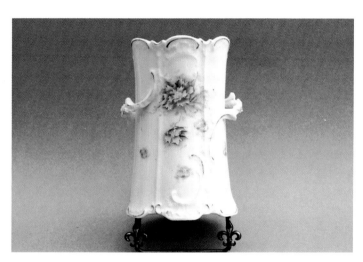

Plate 431. Handled celery, Mold OM 130, decor ST 1, 7" h. $50-$100.

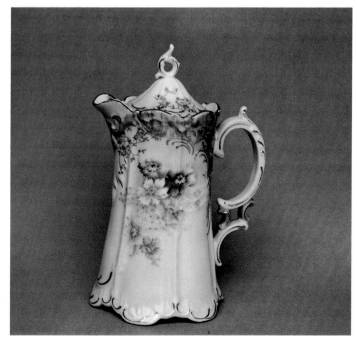

Plate 429. Chocolate pot, Mold OM 130, 8" h. There is a six point star molded into the bottom of the pot. $100-$200.

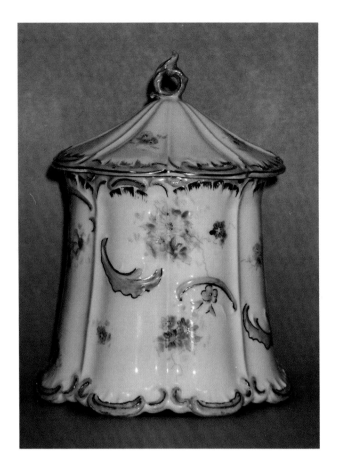

Plate 432. Biscuit jar, Mold OM 130, decor ST 3, 6.75" h. $100-$200.

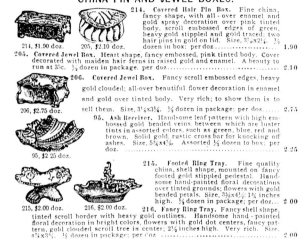

Plate 435. Chamber stick, Mold OM 130, decor ST 1A, 2" h. $100-$200.

CHINA PIN AND JEWEL BOXES.

214. Covered Hair Pin Box. Fine china, fancy shape, with all-over enamel and gold spray decoration over pink tinted body, scroll embossed edges of green, heavy gold stippled and gold traced; two hair pins in gold on lid. Size, 3½x2¼. ½ dozen in box; per doz......... 1.90

214, $1.90 doz. 205, $2.10 doz.

205. Covered Jewel Box. Heart shape, fancy embossed, pink tinted body. Cover decorated with maiden hair ferns in raised gold and enamel. A beauty to run at 35c. ½ dozen in package, per doz......... 2.10

206. Covered Jewel Box. Fancy scroll embossed edges, heavy gold clouded; all-over beautiful flower decoration in enamel and gold over tinted body. Very rich; to show them is to sell them. Size, 3¼x3¼. ½ dozen in package, per doz......... 2.75

206, $2.75 doz.

95. Ash Receiver. Handsome leaf pattern with high embossed gold beaded veins between which are luster tints in assorted colors, such as green, blue, red and brown. Solid gold, rustic cross bar for knocking off ashes. Size, 5¾x4⅞. Assorted ½ dozen to box; per doz......... 2.25

95, $2.25 doz.

215. Footed Ring Tray. Fine quality china, shell shape, mounted on fancy footed gold stippled pedestal. Handsome hand-painted floral decorations over tinted grounds; flowers with gold beaded petals. Size, 3⅜x4½; 1¾ inches high. ½ dozen in package; per doz...... 2 00

215, $2.00 doz. 216, $2.00 doz.

216. Fancy Ring Tray. Fancy shell shape, tinted scroll border with heavy gold outlines. Handsome hand-painted floral decoration in bright colors, flowers with gold dot centers, fancy pattern, gold clouded scroll tree in center; 2½ inches high. Very rich. Size, 4⅝x3⅞. ½ dozen in package; per doz......... 2 00

Plate 436. Illustration of square box No. 206, Mold OM 131, 3.25" w., illustrated in the Webb-Freyschlag Oct 1898 catalog. Later objects in this mold are known to be trademarked with the classic RS Prussia Wreath. *Courtesy of Amador Collections, Rio Grande Historical Collections, New Mexico State University Library.*

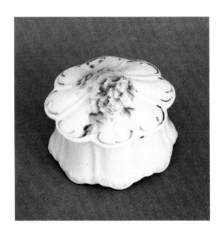

Plate 433. Round box, Mold OM 130, 3.25" h. $25-$50.

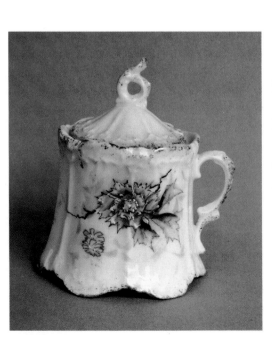

Plate 434. Mustard pot, Mold OM 130, decor ST 1A, 3" h. $50-$100.

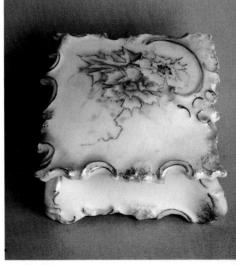

Plate 437. Square box, Mold OM 131, decor ST 1, 3.25" w. $100-$200.

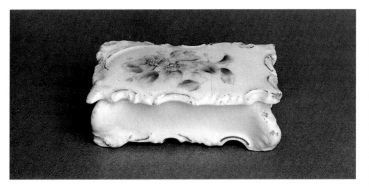

Plate 438. Rectangular box, Mold OM 131, decor ST 13, 4" l. $100-$200.

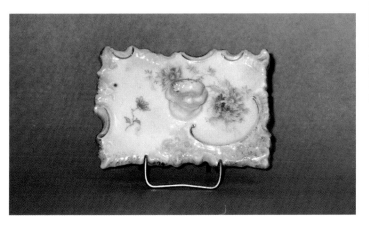

Plate 439. Desk blotter, Mold OM 131, decor ST 6, 4" l. $100-$200.

Plate 440. Match holder with striker, Mold OM 131, 2.4" h. $50-$100.

Plate 441. Cup/elongated saucer, pink edge, Mold OM 132, 5.25" l. This mold is illustrated in the Webb-Freyschlag 1898 and G. Sommers & Co. 1899-1900 catalogs. The extension of the saucer was meant to hold a piece of cake or some similar sweet. $100-$200.

Plate 442. Tray, Mold OM 132, 5.25" l. $25-$50.

Plate 443. Candle holder, Mold OM 132, decor ST 6A, 4.5" l. Probably a desk item used for melting sealing wax. $100-$200.

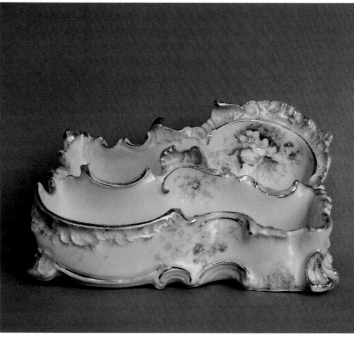

Plate 446. Letter tray, pink edges, Mold OM 132, decor ST 5, 6" l. $200-$400.

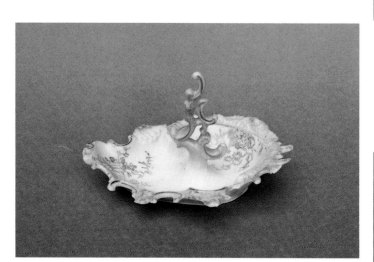

Plate 444. Ring tray, Mold OM 132, 5.75" l. Sold as a fancy ring tray No. 216 for $2 per dozen by Webb-Freyschlag in 1898. $50-$100.

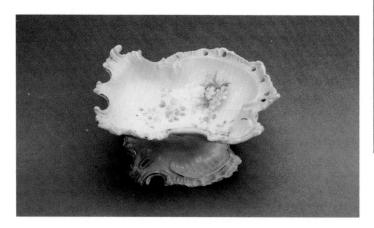

Plate 445. Ring tray (catalog description), blue base, Mold OM 132, decor ST 5, 5.75" l. $50-$100.

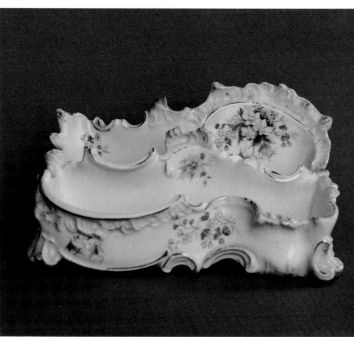

Plate 447. Letter tray, blue edges, Mold OM 132, decor ST 5, 7.25" l. $200-$400.

Plate 448. Rectangular match box, striker under lid, pink edges, Mold OM 133, decor ST 7, 4.25" l. $100-$200.

Plate 450. Square card box, blue/buff edges, Mold OM 133, decor ST 12, 3" h. $100-$200.

Plate 449. Rectangular box, hairpin molded into top, blue/buff edges, Mold OM 133, 4.25" l. $100-$200.

Plate 452. Toothpick holder, Mold OM 140, decor P 3, 2.25" h., Royal Tillowitz mark. $100-$200.

No. 661. Per Set, $1.50.

No. 661. An unusually large 3-piece set, con- sisting of an extra sized tea pot, covered sugar bowl and cream pitcher, in a very at- tractive bisque finish; alternate panels of pale green and pink with apple blossom dec- orations. Price per set complete............. 1.50

Plate 451. Illustration of No. 661, a three piece tea set in Mold OM 140 from the G. Sommers & Co. Fall 1899 catalog. *Courtesy of Minnesota Historical Society Library.*

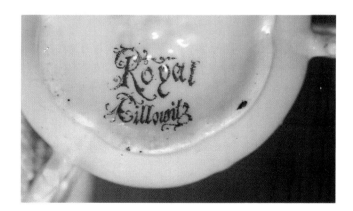

Plate 453. Royal Tillowitz (red) mark on the toothpick holder in Plate 452.

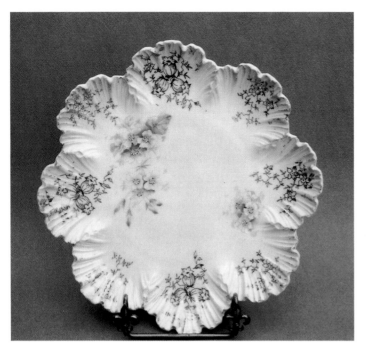

Plate 454. Plate, buff/blue edge, Mold OM 140, decor ST 2, 8.5" d. $50-$100.

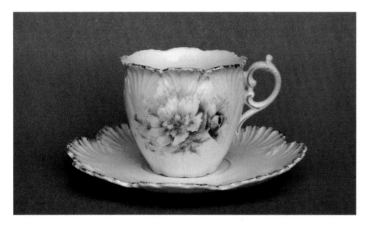

Plate 455. Tea cup/saucer, Mold OM 140, decor ST 2A, 2.75" h. $50-$100.

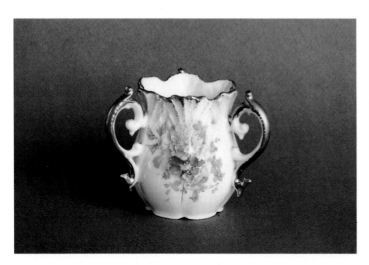

Plate 456. Three handled toothpick holder, Mold OM 140, decor ST 11, 2" h. $100-$200.

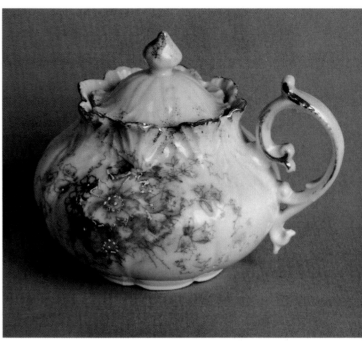

Plate 457. Mustard pot, Mold OM 140, 3" h. $50-$100.

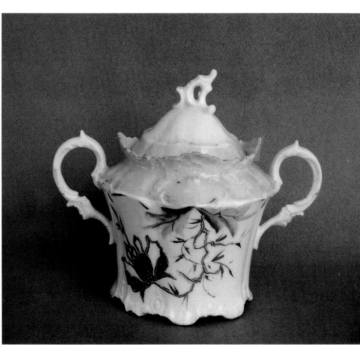

Plate 458. Covered sugar bowl, Mold OM 150, weed decor, 5" h. This mold generally has a 12 point star in the bottom of containers. $25-$50.

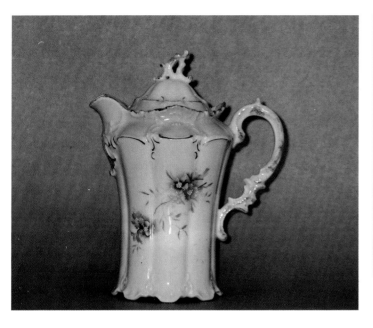

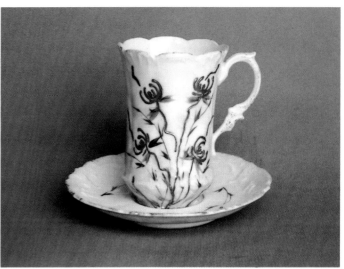

Plate 462. Chocolate cup/saucer, Mold OM 150A, weed decor, 3.2" h. $25-$50.

Plate 459. Chocolate pot, Mold OM 150, 7.25" h. $100-$200.

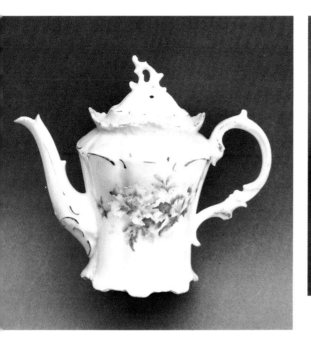

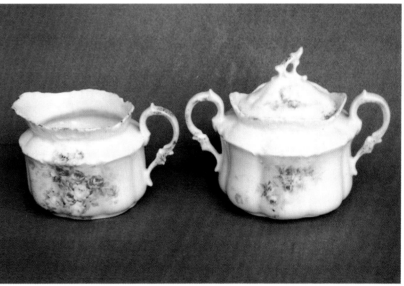

Plate 463. Cream/covered sugar set, Mold OM 150A, printed transfer, sugar 4" h. $50-$100.

Plate 460. Teapot, Mold OM 150, 6" h. $100-$200.

Plate 461. Illustration of No. 405 cracker jar in Mold OM 150A from the G. Sommers & Co. Fall 1900 catalog. This mold is also illustrated in the Butler Bros. 1905-06, and the Falker and Stern 1901-03 catalogs. *Courtesy of Minnesota Historical Society Library.*

Plate 464. Tea cup/saucer, Mold OM 150A, weed decor, 2.25" h. $50-$100.

No. 405. $4.40.

No. 405—An extra size footed jar, 8 inches high; swell shape; rich tinted; stippled gold and colored decorations 4.40

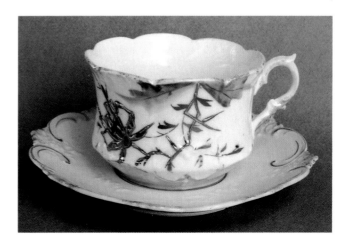

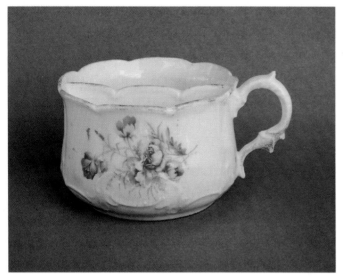

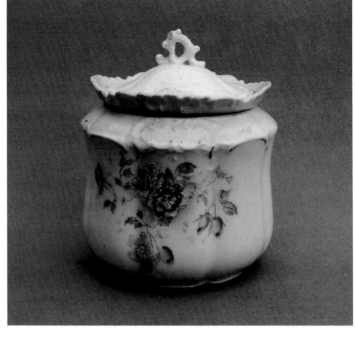

Plate 465. Shaving mug, Mold OM 150A, printed decor, 2.25" h. $50-$100.

Plate 466. Humidor, Mold OM 150A, decor ST 2, 5.5" h. $200-$400.

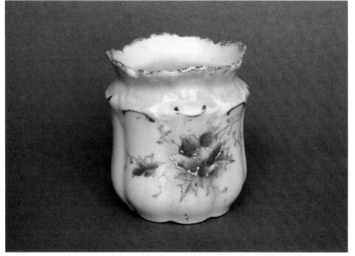

Plate 467. Toothpick holder, Mold OM 150A, decor OT 50, 2" h. $25-$50.

Plate 468. Mug, Mold OM 151, decor OT 49, 3.5" h. These mugs were always offered with saucers in wholesale catalogs. This mold is illustrated in the Fall 1899 Sommers & Co., the 1901 Spring Falker and Stern, and the 1898 Webb-Freyschlag catalogs. $25-$50.

Plate 469. Mustache cup/saucer, Mold OM 151, weed decor, 3.5" h. The bridge does not show in this picture. $50-$100.

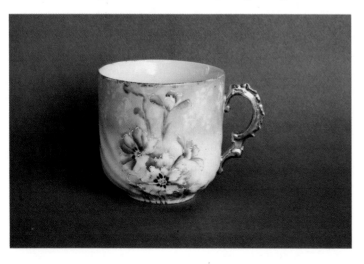

Plate 470. Mustache cup/saucer, Mold OM 151, 3.5" h. $50-$100.

Plate 473. Syrup pitcher, Mold OM 152, 4" h. $50-$100.

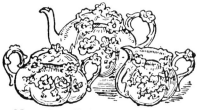

No. 501. Price 80c per Set.

Each Set.

No. 501—A large, handsome set of fine Carls-bad china; the squat melon shape with raised decorations and delicate floral hand painting. The set consists of a tea pot, covered sugar bowl and pitcher. Price each set80

Plate 471. Illustration of No. 501 tea set in Mold OM 152 from the G. Sommers & Co. 1900 Christmas Edition. This mold is also illustrated in the G. Sommers & Co. 1901, the Falker and Stern Fall 1903, and the Butler Bros. Fall 1902-05 catalogs. *Courtesy of Minnesota Historical Society Library.*

Plate 472. Cake plate, Mold OM 152, decor P 3, 9.75" d. Arriving so late in the period, most items in this mold were decorated with printed transfers. $50-$100.

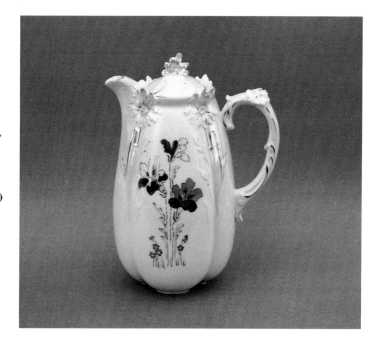

Plate 474. Chocolate pot, Mold OM 152, weed decor, 9" h. $100-$200.

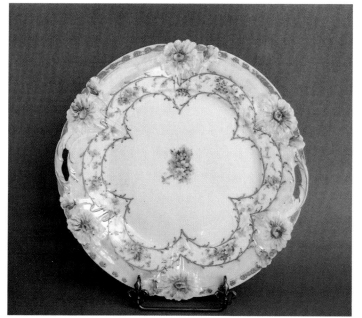

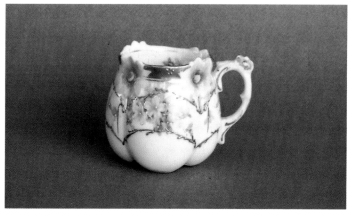

Plate 475. Demitasse Cup, Mold OM 152, decor P 3, 1.75" h. With saucer $50-$100.

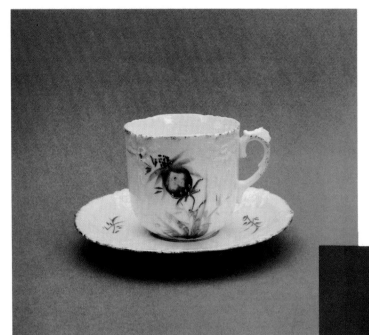

Plate 476. Cup/saucer, Mold OM 152, weed decor, cup 2.5" h. $25-$50.

Plate 477. Three piece tea set, pot, cream, and sugar, Mold OM 152, printed decor, pot 4.75" h. $100-$200.

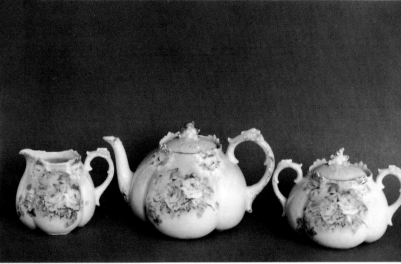

Plate 478. Three piece tea set, pot, cream, and sugar, Mold OM 152, printed decor, pot 4" h. $100-$200.

Plate 479. Souvenir plate, Mold OM 160, 6" d. $25-$50.

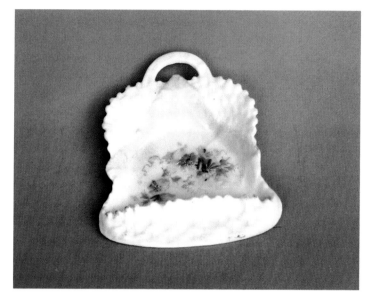

Plate 480. Tray, Mold OM 160, decor ST 8, 3.5" l. $50-$100.

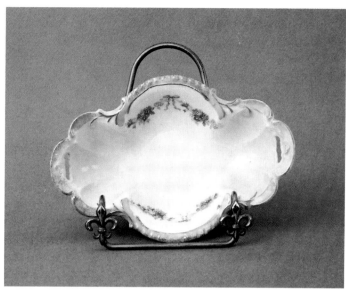

Plate 483. Oval dish, pink/buff edge, Mold OM 161, printed decor, 6.2" l. $25-$50.

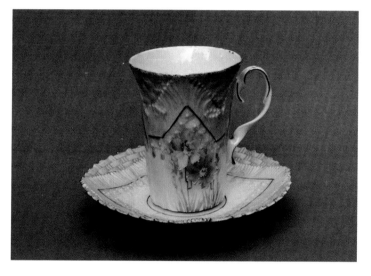

Plate 481. Chocolate cup/saucer, Mold OM 160, 3.5" h. $50-$100.

Plate 484. Square box, Mold OM 162, decor HI-14, 3" l. $50-$100.

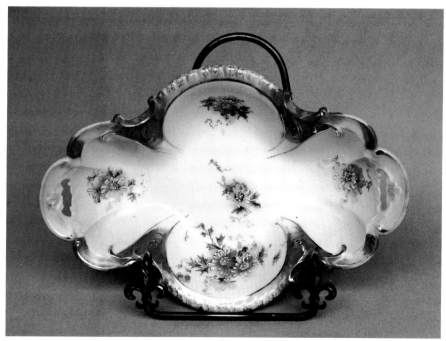

Plate 482. Oval dish, red/pink edge, Mold OM 161, decor ST 8, 7.25" l. This dish is shown as part of assortment in the Butler Bros. Fall 1902-1905 catalogs. $25-$50.

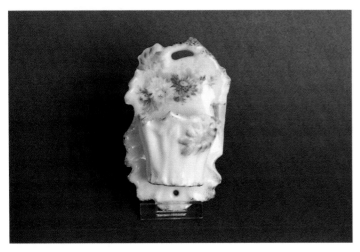

Plate 485. Match safe, Mold OM 162, decor P 5, 4.25" l. $50-$100.

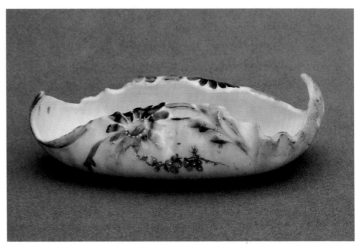

Plate 488. Tray or small bowl, green edge, Mold OM 162, 5" l. Under $25.

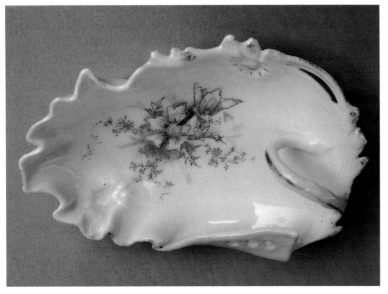

Plate 486. Handled tray, Mold OM 162, 4.5" l. $25-$50.

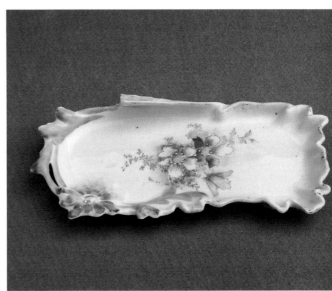

Plate 489. Tray, Mold OM 162, 5" l. $25-$50.

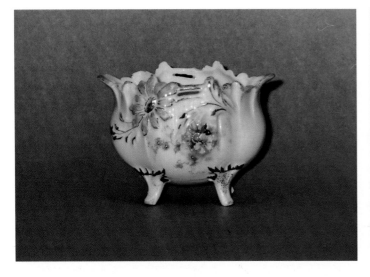

Plate 487. Open sugar bowl with feet, Mold OM 162, 3.5" l. $25-$50.

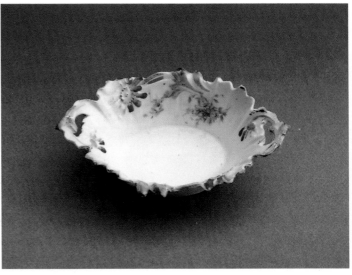

Plate 490. Bowl, Mold OM 162, 5.5" l. Under $25.

Chapter 8
Mold Patterns with One Identified Transfer Decoration

The reconstruction of events of a hundred years ago will never be complete. Although we have searched extensively, some mold patterns can not be located with more than a single, identified R.S. Prussia decoration. Many of the objects in these mold patterns are among the more interesting to be found. Some are even described as R.S. products in post-1900 wholesale catalog descriptions. On average, wholesale firms offered many of the smaller items for a longer time than common tableware. Yet, we seem to find fewer examples.

There is a remote possibility for some objects in this section to have been made by other German manufacturers. We have made a serious effort to exclude those items whose origin can be challenged. On the other hand, we find it hard to imagine we have been 100% accurate. However, should later information show we have erred, the offending illustration(s) will have served a useful purpose.

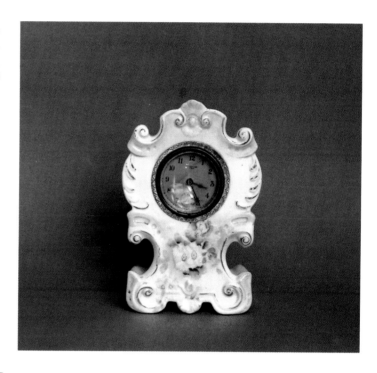

Plate 492. Clock, decor OT 5, 6.5" h., New Haven works. $100-$200.

Plate 493. Clock, decor ST 15, 4.75" h. $100-$200.

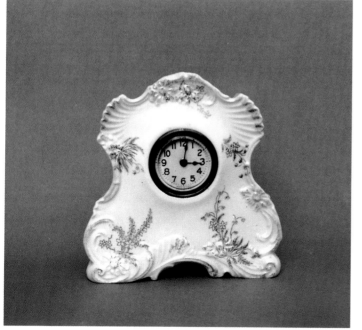

Plate 491. Clock, blue edges, palm tree decor, 5" h., "Patented 16. July 1895." on back. $100-$200.

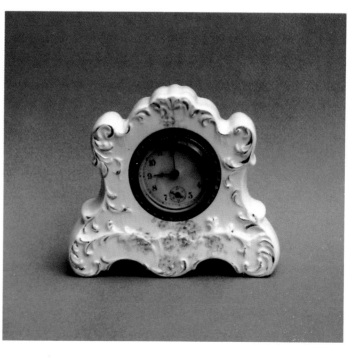

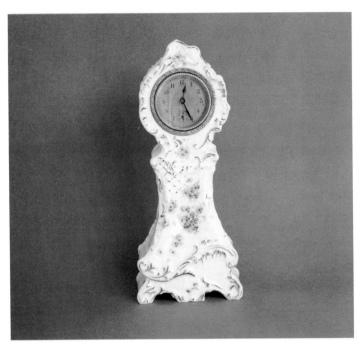

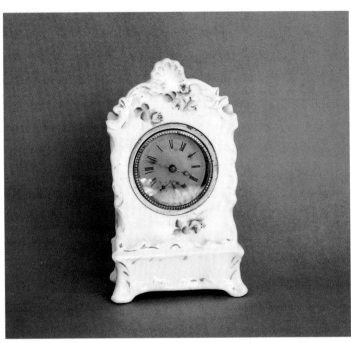

Plate 494. Clock, decor ST 15, 10" h., "Patented 16. July 1895." on back. Original works replaced (?) with older Cruckshank clock dated 7/10/80. $200-$400.

Plate 496. Clock, decor OT 3, 6.75" h. $100-$200.

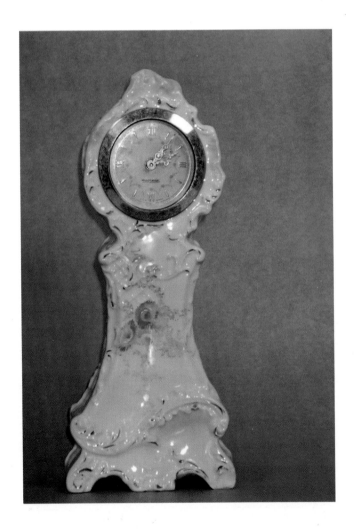

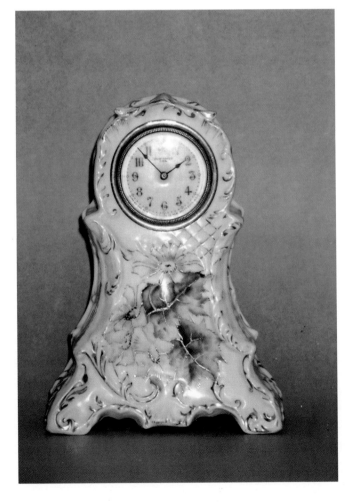

Plate 495. Clock, decor OT 11A, 10" h., "Patented 16. July 1895." on back. $200-$400.

Plate 497. Clock, decor OT 19, 7.25" h., patent applied for. (red) mark, New Haven works. $200-$400.

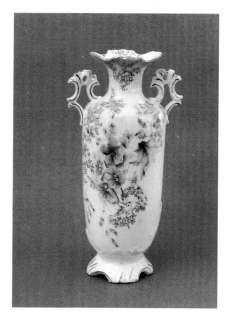

Plate 498. Vase, bird stencil decor, 7.5" h. $100-$200.

Plate 499. Ewer, pink top, decor OT 1, 7.5" h. $50-$100.

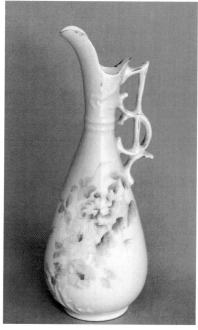

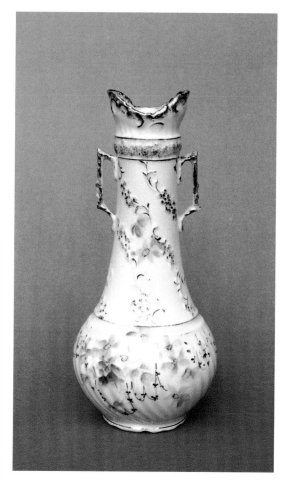

Plate 501. Handled vase, decor OT 4, 9.25" h. $200-$400.

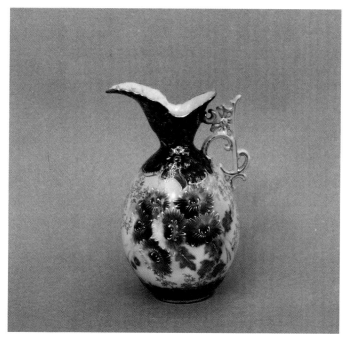

Plate 500. Vase, pink underglaze painting, similar to OT 38. RS Steeple Prussia (green) mark. $200-$400.

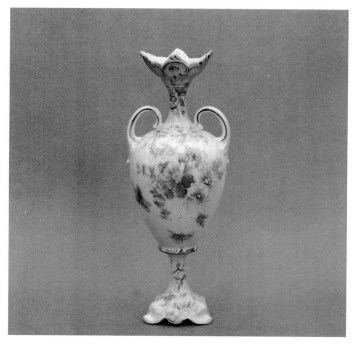

Plate 502. Vase, blue top/bottom, decor OT 26, 9.75" h. $100-$200.

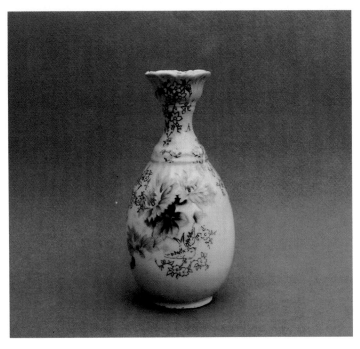

Plate 503. Vase, blue top/bottom, decor OT 65, 6.4" h. $50-$100.

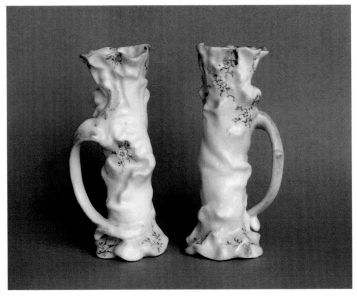

Plate 505. Handled vase (pair), pink top/bottom, daisy chain decor, 6" h. This item is illustrated as No. 538 ($1.75 per 6) in a 1896 Butler Bros. catalog. Each $25-$50.

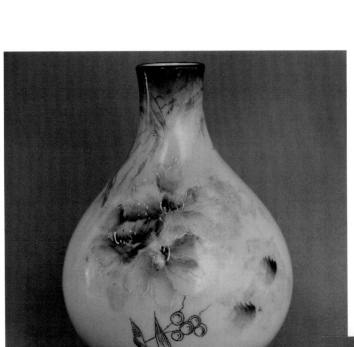

Plate 504. Vase, green top, decor OT 31, 4.5" h. $50-$100.

Plate 506. Celery tray, buff edges, decor OT 18, 11" l., RS Wing mark. $50-$100.

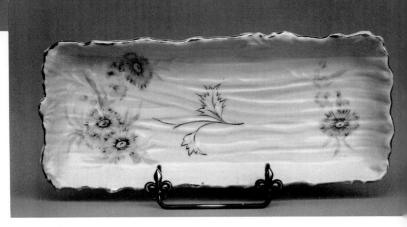

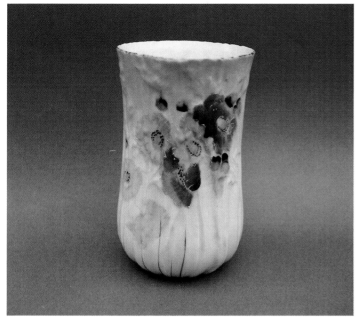

Plate 507. Celery jar, decor OT 7, 6" h. $50-$100.

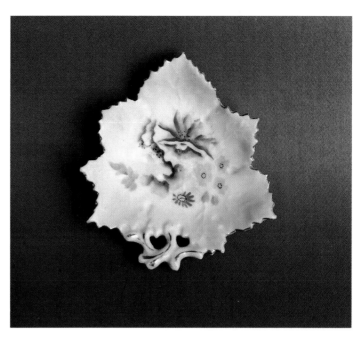

Plate 510. Tray, decor OT 2, 5.25" l., RS Wing mark. $25-$50.

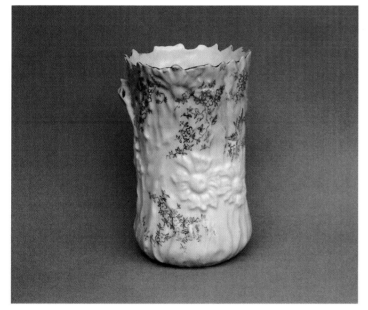

Plate 508. Handled celery jar, decor with bird stencil decor, 6.25" h. $50-$100.

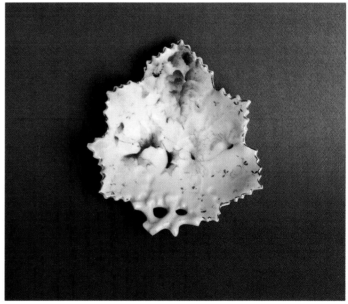

Plate 511. Tray, decor OT 19, 5.25" l. Under $25.

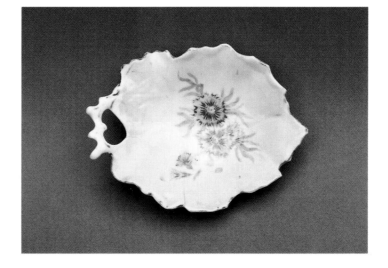

Plate 509. Tray, decor OT 18, 6" l. $25-$50.

Plate 512. Handled, divided tray, decor OT 63, 7.75" w. $50-$100.

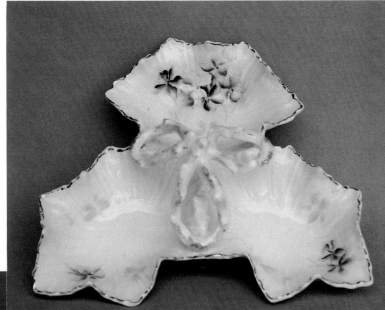

Plate 513. Tray, decor ST 6, 6.7" l. $25-$50.

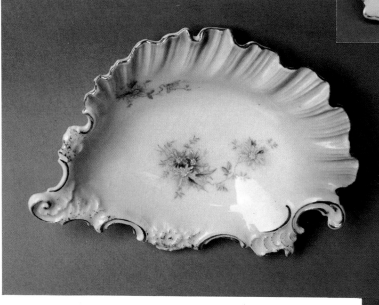

Plate 514. Tray, decor ST 13, 5.75" l. $25-$50.

Plate 515. Illustration of No. 104, handled olive dish from 1898 Webb-Freyschlag catalog. *Courtesy of Amador Collections, Rio Grande Historical Collections, New Mexico State University Library.*

HANDLED ALMOND OR OLIVE DISHES.

104, $1.75 per doz.

104. Fancy Leaf Shape. Good quality china, heavy gold clouded edges, profuse gold spray decoration all around edge over pink and green tinted background; fancy gold clouded rustic handle. 25c goods of exceptional value. Size, 3¼x4¼ inches. ½ dozen in package; per doz...... 1.75

106. Handled Olive Dish. Fancy leaf shape, with tinted gold clouded handle and edges; handsome hand-painted floral decoration, flowers with gold beaded petals. A most beautiful 50c offering. Size, 5½x6¼ inches. ½ dozen in package; per doz.................. 3.85

109¼, $2.75 per doz.

109½. Olive Dish. Fine china embossed leaf pattern with heavy gold traced edges and gold traced arch handle. Decorated with flowers and vines in natural colors. Size, 7¼x5 inches. An ornament to mantle or table. ½ dozen in package; per doz.......... 2.75

Plate 516. Handled olive tray, decor ST 13, 7.4" l. $25-$50.

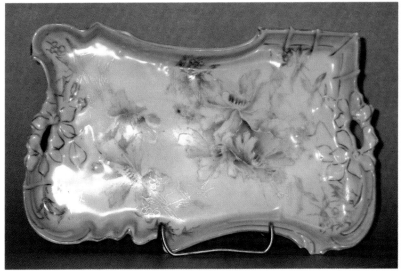

Plate 519. Rectangular tray, decor OT 31, 10" l. $100-$200.

Plate 517. Handled olive tray, 5.4" l. $25-$50.

Plate 520. Tray, cobalt and white, decor FD M, 6.5" l., RS Steeple Germany (green) mark. $100-$200.

Plate 521. Pin tray, 4.5" l., designated as "RS" in a 1901 Falker and Stern catalog. $25-$50.

Plate 518. Rectangular tray, decor OT 29, 9.6" l. $50-$100.

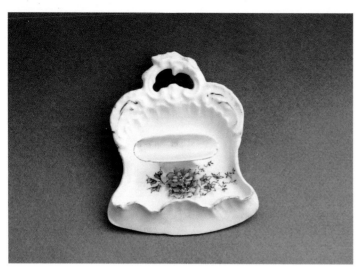

Plate 522. Pin tray base with cigar rest, decor ST 14, 4.5" l. $25-$50.

Plate 525. Tray, with lip-over edge, decor ST 10, 4.75" l. $50-$100.

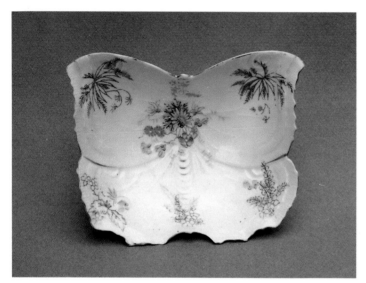

Plate 523. Deep tray, butterfly shape, decor ST 23, 5.75" l. $50-$100.

Plate 524. Tray, green/white edges, decor 29, 4.5" l. $50-$100.

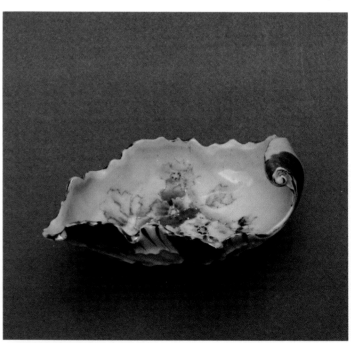

Plate 526. Tray, shell shape, decor OT 33, 5" l. $50-$100.

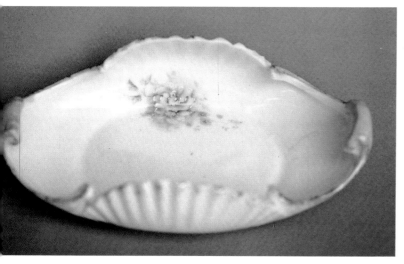

Plate 527. Tray, with lip-over ends, decor ST 11, 5.75" l. Under $25.

Plate 530. Illustration of No. 1011 open basket in Mold OM 134 illustrated in G. Sommers & Co. Fall-Holiday 1900 catalog. *Courtesy of Minnesota Historical Society Library.*

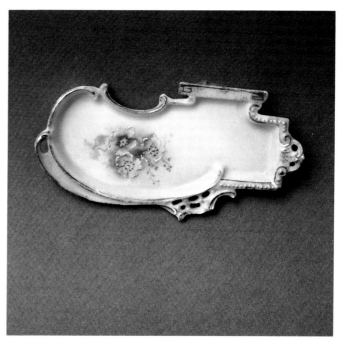

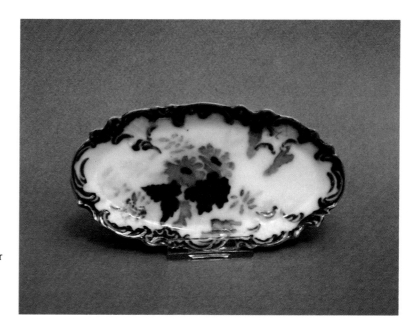

Plate 528. Tray, open handled, decor ST 8, 5.25" l. $25-$50.

Plate 531. Tray, green/pink edge, Mold OM 134, 5" l. $100-$200.

Plate 529. Pin tray, cobalt and white, decor FD M, 5" l., RS Germany Steeple (green) mark. $50-$100.

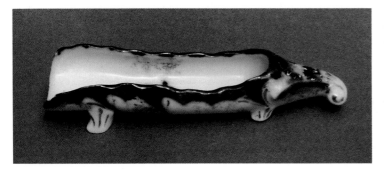

Plate 532. Lay down hatpin tray, cobalt and white, decor OT 11A, 5" l. $100-$200.

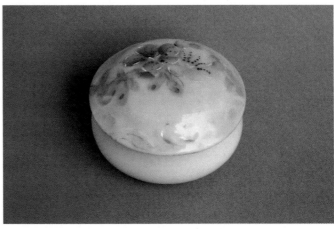

Plate 536. Pomade box, decor OT 17A, 2" d. Under $25.

No. 05, $6.75 per doz.

29. Manicure Sets. Consisting of porcelain tray, 2 pomade boxes, cuticle knife and chamois covered nail polisher with china handle, light-weight china in delicate blue and pink tints, elaborately decorated with embossed scroll pattern traced in gold and small gold fern leaf designs; size of salver, 8⅜x5¼ inches. Price each **1.25**

Plate 533. Illustration of No. 29 manicure set from Webb-Freyschlag 1900 catalog. *Courtesy of Amador Collections, Rio Grande Historical Collections, New Mexico State University Library.*

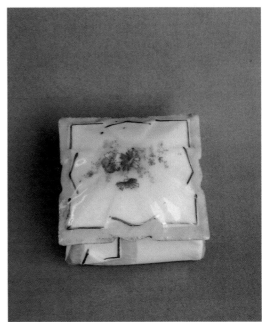

Plate 537. Square box, decor ST 10, 2.25" w. $25-$50.

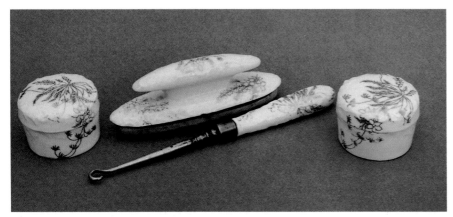

Plate 534. Manicure set, button hook, nail buff, and two pomade boxes. Gold palm tree stencil decor, Box 2", Buff 4.5" l., Hook 6.5" l. $100-$200.

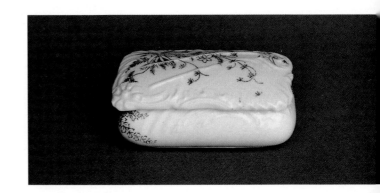

Plate 535. Rectangular box, gold palm tree stencil decor, 3.6" l., RS Wing mark. $100-$200.

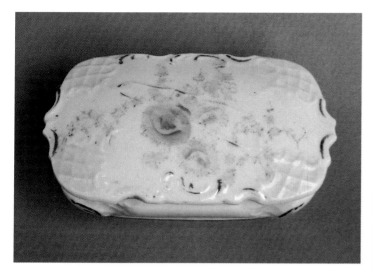

Plate 538. Rectangular box, decor OT 11A, 4" l. $50-$100.

Plate 539. Rectangular box, pink edges, decor OT 7, 4" l. $50-$100.

Plate 540. Rectangular stamp box, decor OT 31, 4.25" l. $100-$200.

Plate 541. Rectangular stamp box, decor P 2, 4.25" l. $100-$200.

Plate 542. Freeform box, 5.5" l. This box was in production for several years and is known with a "Tilly" printed transfer. $100-$200.

Plate 543. Freeform box, 5.5" l. $100-$200.

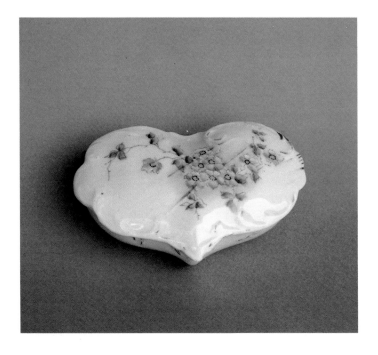

Plate 544. Heart shape box, 3.4" w., RS Wing mark. Boxes in this mold pattern are known to be marked with RS Prussia Wreath, and with RS Germany (green) Wreath. $100-$200.

Plate 545. Wide heart shape box, 4.5" l. A box in this mold pattern is shown in Gaston IV with the RS Wing mark. This item is illustrated as No. 1565 ($1.25 per dozen) in the 1896 Butler Bros. catalog. $100-$200.

Plate 546. Wide heart shape box, Decor OT 1, 4.25" l. $100-$200.

Plate 547. Fan shape bonbonier, yellow edges, decor OT 26, 5.25" w. This item is illustrated as No. 348 ($1.82 per dozen) in the 1896 Butler Bros. catalog. $100-$200.

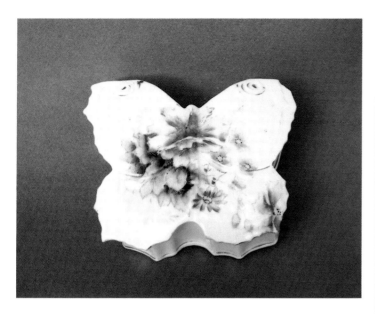

Plate 548. Butterfly shape box, decor OT 2, 4.75" w. $100-$200.

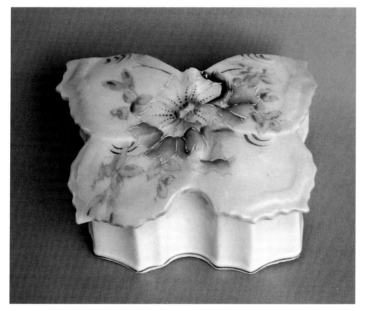

Plate 549. Butterfly shape box, decor OT 17, 4.75" w. $100-$200.

Plate 550. Butterfly shape box, palm tree stencil decor, 3.75" w. $50-$100.

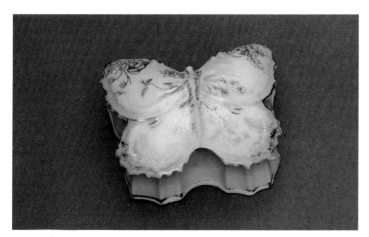

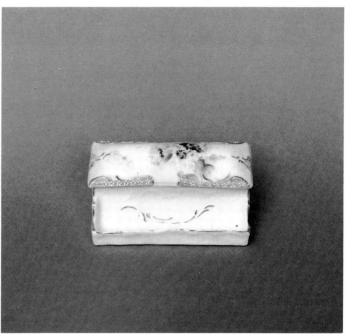

Plate 551. Combination tray with match box, green edges, decor OT 7, 4" w. $100-$200.

Plate 552. Slipper shape wall pocket, decor OT 26, 6.5" l. This mold pattern is illustrated in an 1896 Butler Bros. catalog. $200-$400.

Plate 556. Wall match safe, the striker is on the bottom of the box, decor OT 17, 4" l. $50-$100.

Plate 553. Wall sconce, decor OT 31, 7.5" l. $200-$400.

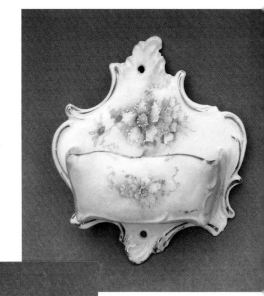

220, $2.00 doz.

220. Double Match Holder. Good china, fancy shape, all-over gold and enamel flower work on pink tinted body, edges of green, heavy gold traced, hole at top and base for fastening scratcher on base of box. Size, 4¾x4. ⅙ dozen in package; per doz.......................... 2.0

Plate 557. Illustration of No. 220 double match holder in Webb-Freyschlage 1898 catalog. *Courtesy of Amador Collections, Rio Grande Historical Collections, New Mexico State University Library.*

Plate 554. Bird shape wall pocket, decor OT 21, 5.75" l. $200-$400.

Plate 558. Double match holder, the striker is on the base, pink, 4.75" l. $100-$200.

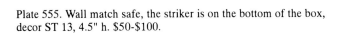

Plate 555. Wall match safe, the striker is on the bottom of the box, decor ST 13, 4.5" h. $50-$100.

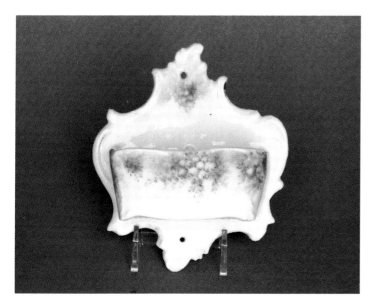

Plate 559. Double match holder, the striker is on the base, small printed transfer decor used later on RS Prussia marked ware. $100-$200.

Plate 560. Rectangular card box, pink/white edges, four suits on sides, decor ST 11, 4.5" l. Thumbhole in bottom of box. $100-$200.

Plate 561. Rectangular card box, cards decor, 4.5" l. $200-$400.

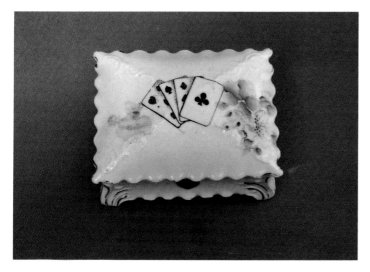

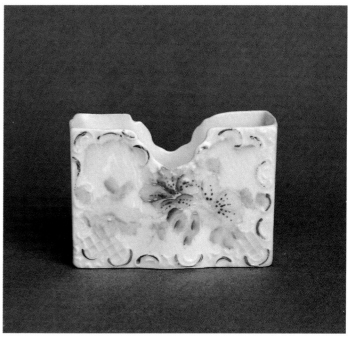

Plate 562. Upright card holder, decor 17A, 2.5" h. $50-$100.

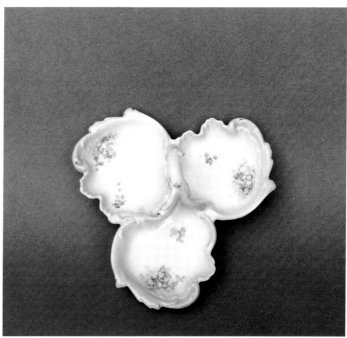

Plate 563. Divided, three compartment dish with handle, decor ST 7, 8.5" overall. $100-$200.

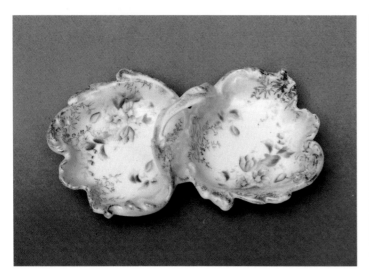

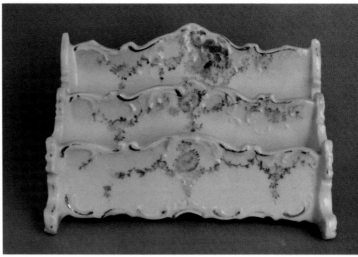

Plate 564. Divided, two compartment dish with handle, decor ST 13, 7.5" overall. $50-$100.

Plate 567. Letter holder, decor OT 11A, 3.6" h. $100-$200.

Plate 568. Letter holder, decor OT 26, 4.6" h. $100-$200.

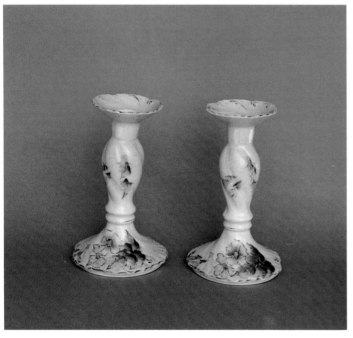

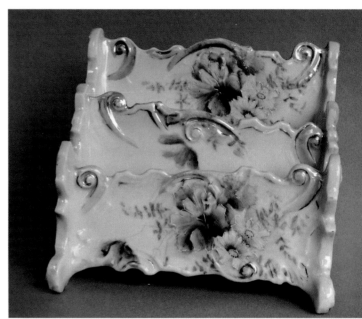

Plate 565. Candle holder (pair), decor OT 58, 6" h. $100-$200.

Plate 566. Picture frame, decor OT 18, 9" l. Offered as No. 100 "German China Photo Frame" in a 1895 Butler Bros catalog. $50-$100.

Plate 569. Calendar holder (celluloid cards missing), decor OT 30, 3.8" h. $50-$100.

Plate 572. Invalid feeder, decor OT 39, 2.25" h. $100-$200.

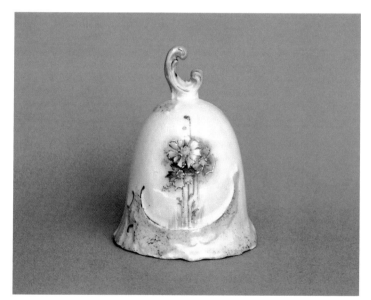

Plate 570. Bell, wood clapper, 4" h. $100-$200.

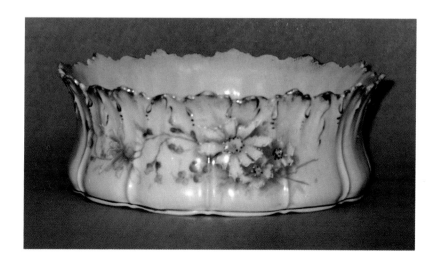

Plate 571. Ferner (without insert), 7" d., RS Wing mark. $200-$400.

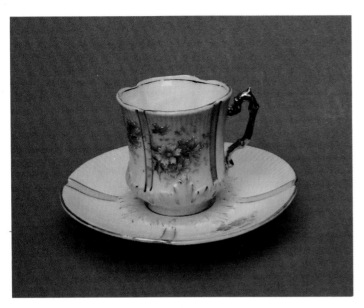

Plate 573. Demitasse cup/saucer, decor ST 10, cup 2.2" h. $50-$100.

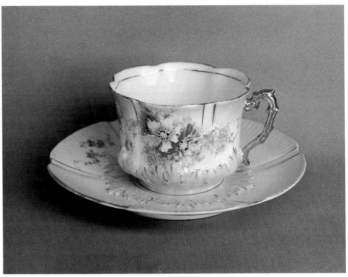

Plate 574. Coffee cup, cup 2.4" h. $50-$100.

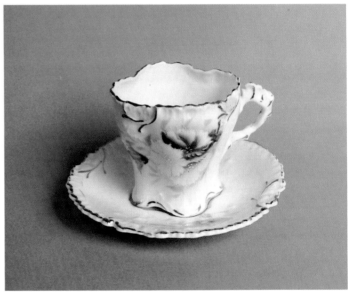

Plate 576. Demitasse cup/saucer, decor ST 21, 2.2" h. $50-$100.

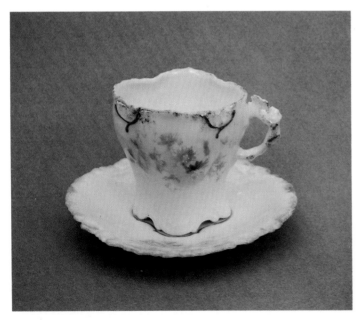

Plate 575. Demitasse cup/saucer, decor ST 8, 2.2" h. $50-$100.

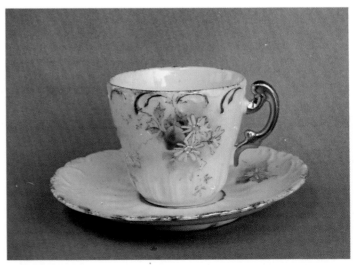

Plate 577. Demitasse cup/saucer, decor ST 9, cup 2" h. $25-$50.

146

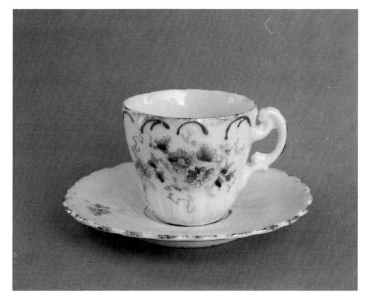

Plate 578. Demitasse cup/saucer, decor ST 8, cup 2" h. $25-$50.

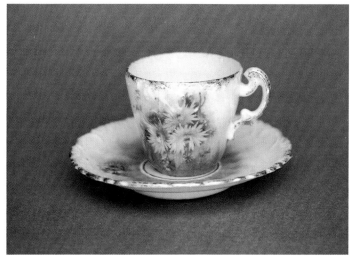

Plate 579. Demitasse cup/saucer, decor P 6, cup 2" h. $25-$50.

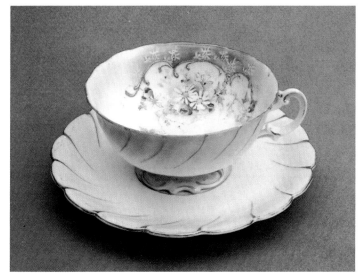

Plate 580. Tea cup/saucer, decor ST 9, cup 2.5" h. Shown in Butler Bros. Fall 1902 catalog. $50-$100.

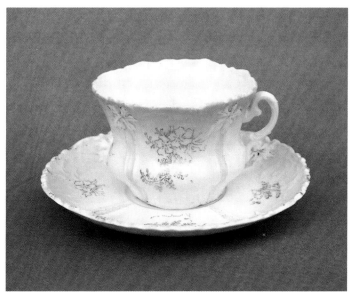

Plate 581. Coffee cup/saucer, gold stencil decor, cup 2.25" h., RS Wing mark. $50-$100.

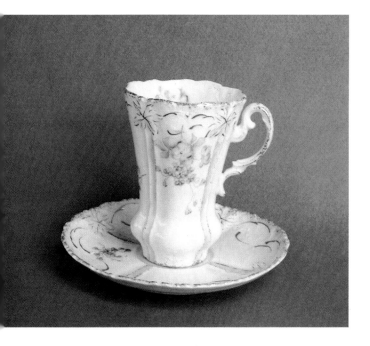

Plate 582. Chocolate cup/saucer, the mold pattern is the same as in Plate 581, cup 3.5" h. $50-$100.

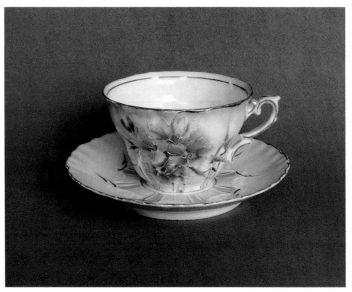

Plate 583. Tea cup/saucer, decor OT 30, cup 2.5" h. $50-$100.

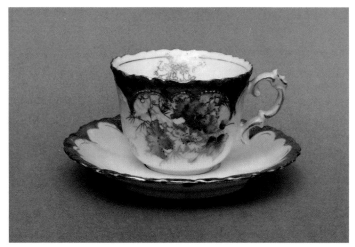

Plate 584. Tea cup/saucer, decor OT 7, cup 2.25" h. $50-$100.

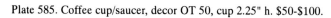

Plate 585. Coffee cup/saucer, decor OT 50, cup 2.25" h. $50-$100.

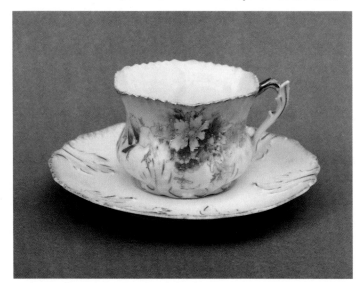

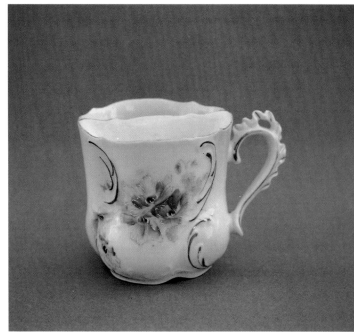

Plate 586. Shaving mug, decor OT 31, 3.25" h. $100-$200.

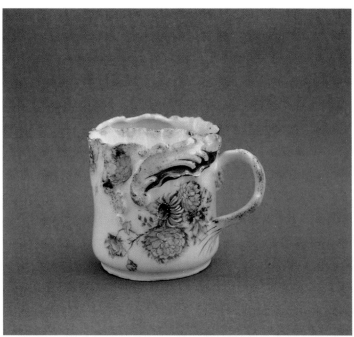

Plate 587. Shaving mug, decor OT 62, 3.25" h. $100-$200.

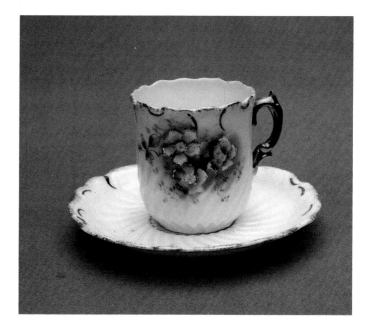

Plate 588. Souvenir cup/saucer, decor ST 7, 1.8" h. $25-$50.

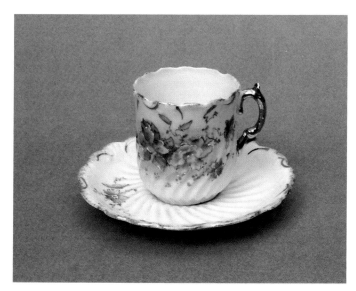

Plate 589. Souvenir cup/saucer, 1.8" h. $25-$50.

Plate 590. Souvenir cup/saucer, printed transfer decor P 6, 1.8" h. $25-$50.

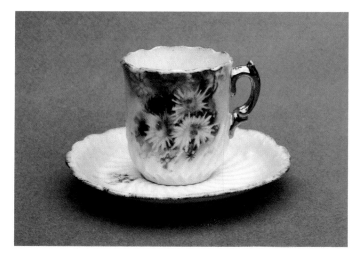

CHINA SUGAR OR CANDY BASKETS.

A82. China Sugar or Candy Basket. Light-weight china, in assorted artistic and unique shapes, twisted, fluted and embossed, gold stippled scalloped edges, fancy handles in assorted tints, delicate small hand-painted floral decorations. Per doz... 2.75

A82. $2.75 doz.

Plate 591. Illustration of A 82, china sugar or candy basket, from a 1898 Webb-Freyschlag catalog. *Courtesy of Amador Collections, Rio Grande Historical Collections, New Mexico State University Library.*

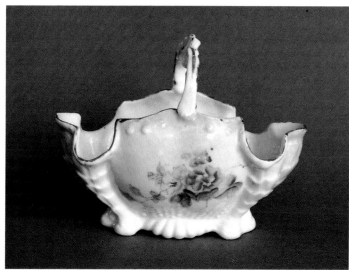

Plate 592. Candy or sugar basket, decor OT 1, 3.75" h. $50-$100.

Plate 593. Tray with open sugar, cream missing, decor OT 26, sugar 2.5" h. Entire set $100-$200.

Plate 594. Cream/open sugar set, decor OT 1, cream 2.6" h. $50-$100.

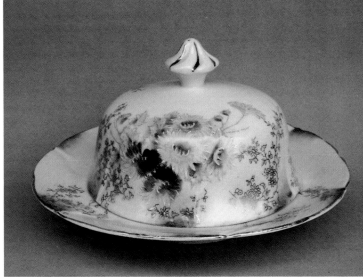

Plate 597. Covered butter, decor OT 11, lid 5" d. $100-$200.

Plate 595. Open sugar bowl, decor OT 1, sugar 2" h. Under $25.

Plate 596. Shell shape cream pitchers, decor 39, 2.5" h. Under $25.

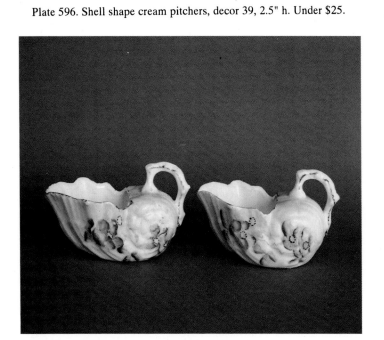

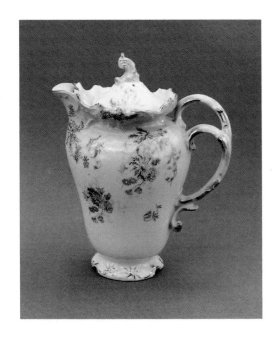

Plate 598. Chocolate pot, decor ST 14, 9.25" h. $100-$200.

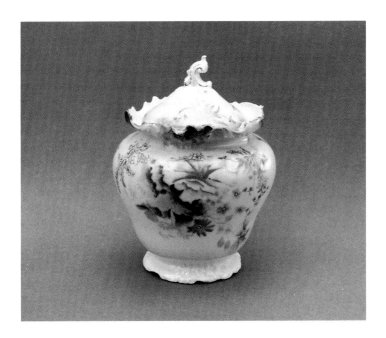

Plate 599. Biscuit jar, decor OT 2, 7" h. $100-$200.

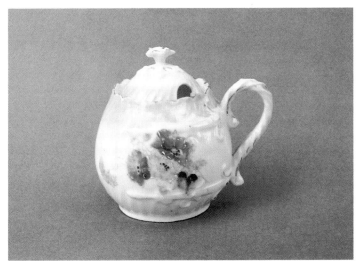

Plate 600. Mustard pot, decor OT 7, 3.5" h. $50-$100.

Plate 601. Cake plate, decor OT 45, 7.5" d. $50-$100.

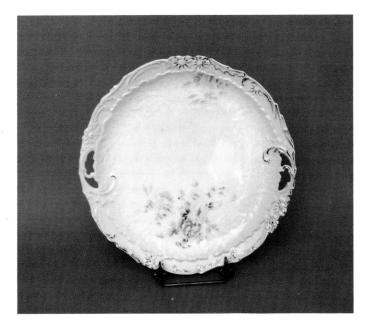

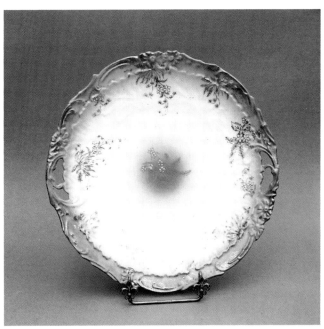

Plate 602. Cake plate, olive green rim, palm tree decor, 12" d. $50-$100.

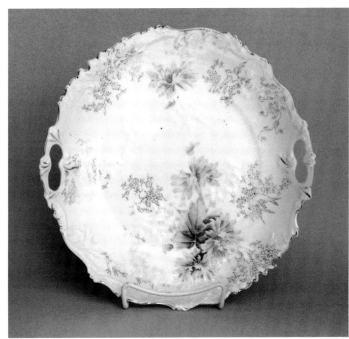

Plate 603. Cake plate, blue rim, decor OT 65, 10" d. $100-$200.

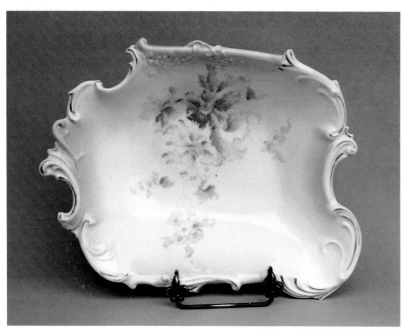

Plate 604. Salad bowl, decor OT 27, 11.5" w. $50-$100.

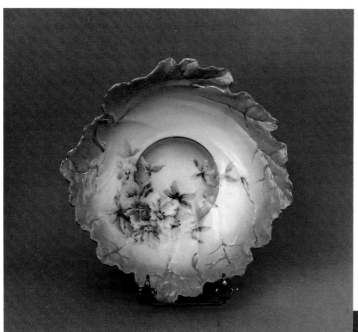

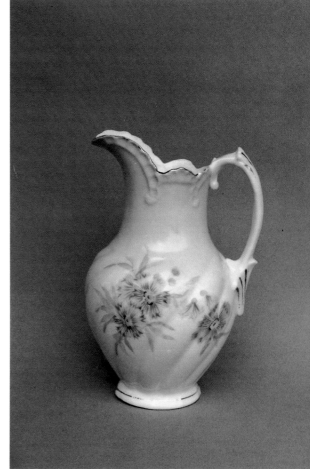

Plate 607. Child's pitcher from commode set, decor OT 18, 7" h. $50-$100.

Plate 605. Salad bowl, decor OT 29, 10" d. $200-$400.

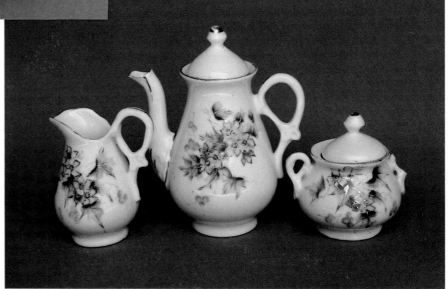

Plate 606. Partial child's tea set, decor ST 20, pot 4.75" h. $100-$200.

References

Barlock, George and Barlock, Eileen. *The Treasures of R.S. Prussia*. Parkersburg WV: Pappas Bros., 1976.

Capers, R.H. *German Source Materials --Article 4*. Int'l. Assoc. R.S. Prussia Collectors Newsletter, No. 29, 1995a.

Capers, R.H. *German Source Materials --Article 5*. Int'l. Assoc. R.S. Prussia Collectors Newsletter No. 30, 1995b.

Capers, R.H. *Translators Notes*. Int'l. Assoc. R.S. Prussia Collectors Newsletter No. 28, 1995.

Capers, R.H. *Capers Notes on the Marks of Prussia*. El Paso IL: Alphabet Printing, 1996.

Gaston, Mary. *Collectors Encyclopedia of R.S. Prussia, Second Series*. Paducah KY: Collector Books, 1986.

Gaston, Mary. *Collectors Encyclopedia of R.S. Prussia, Third Series*. Paducah KY: Collector Books, 1994.

Hartwich, Bernd. *The History of the Suhl Porcelain Factories, 1861-1937*. 1984. Translated by Int'l. Assoc. R.S. Prussia Collectors, 1996. Originally published as *Die Geschichte der Suhler Porzellanfabriken 1861 bis 1937* (Liepzig: Technical School for Museum Caretakers).

Terrell, George. *Collecting R.S. Prussia*. Florence AL: Books Americana, 1982.

Appendix 1
The Mold Pattern - Large Transfer Matrix

The matrix presented here is the current version of an ever changing record. Mold patterns are numbered in sequence according to their known introduction — or our best estimate thereof — into the American market. Some mold pattern numbers are purposely not used in order to allow for later additions. Other patterns were deleted when too few examples were found to meet the minimum criteria. Several mold patterns exhibit minor deviations, such as different handles on the same body mold. Other molds, eg. Mold OM 40, exhibit a slightly different accent of pattern elements on objects of different sizes. Finials often vary with the type of object, and appear to have been changed if breakage was a problem. All of these deviations are included with the parent in the construction of the matrix.

Large outline transfer pattern numbers, prefixed OT, were assigned in the order we could establish their origin. The transfer pattern sequence in the matrix was generated by adding new transfers as required when mold patterns were arranged in numerical order.

Key for matrix:

DSY = Daisy pattern
DAF = Daffodil pattern
PLM = Palm tree pattern
BRD = Bird gold stencil pattern
FDM,FDY,FDJ,FDO,FDP = RS Steeple patterns
(Gaston 1995)

	58	4	19	DSY	39	59	3	DAF	61	25	18	24	21	63
1/A	X	X	X	X										
2	X		X	X	X	X								
3		X				X								
4/A		X	X					X	X					
5			X							X	X	X	X	X
6		X		X							X			
7		X	X	X			X		X		X		X	X
8						X	X							
9		X	X				X		X					
10/A		X	X	X		X		X		X				
11			X											
12													X	
13										X			X	
14		X		X			X				X			X
15				X			X							
16		X						X			X			
17							X			X				X
18														
20										X				
29													X	
30				X									X	
33					X		X					X		
35														
36														
37													X	
38														
39/A						X								
40														
41														
42													X	
43														
44														
45													X	
47														
48														
49										X				
50														
51														
52														
53														
54														
57														
61														
62														
64														
67														
69														
72														
73														
	58	4	19	DSY	39	59	3	DAF	61	25	18	24	21	63

	PLM	1	6	15	68	11A	46	2	7	BRD	9	17	17A	65
1/A						X								
2														
3														
4/A		X		X										
5														
6														
7	X	X	X	X		X	X							
8	X			X				X	X					
9		X	X				X	X	X			X		
10/A	X		X		X		X					X		
11					X								X	
12										X				
13						X		X		X	X	X		X
14	X	X										X		
15		X												
16				X										
17	X	X				X		X	X	X			X	X
18	X									X		X		
20											X			
29						X				X				
30						X		X		X		X		
33														
35						X		X	X					
36									X					
37		X							X		X			
38									X					
39/A														
40						X		X	X					
41						X							X	
42												X		
43												X		
44									X					
45										X	X			X
47														
48														
49										X				
50												X		
51						X								
52														
53						X								
54						X								
57														
61														
62														
64														
67														
69														
72									X					
73														
	PLM	1	6	15	68	11A	46	2	7	BRD	9	17	17A	65

	34	11	8	27	29	31	44	FDM	P-2	30	43	FDY	P-3	16
1/A														
2														
3														
4/A														
5														
6														
7														
8														
9											X			
10/A														
11												X		
12														
13	X							X						
14														
15														
16											X			
17	X													
18	X													
20	X	X	X	X	X	X	X	X	X					
29										X				
30														
33											X			
35		X								X				
36	X		X											
37														
38		X								X				
39/A														X
40	X	X	X		X	X			X	X				
41	X													
42														
43														
44					X									
45		X												
47												X	X	
48	X				X	X		X	X					
49	X					X			X	X				
50										X				
51			X											
52		X	X											
53					X									
54						X				X	X			
57	X			X	X	X		X	X	X				
61	X				X	X		X		X			X	
62	X				X	X		X						
64					X	X		X	X					
67						X		X		X				
69							X							
72				X										
73	X													
	34	11	8	27	29	31	44	FDM	P-2	30	43	FDY	P-3	16

	P-1	5	47	FDJ	FD 0	P-4	28	42	36	37	FD-P	33	45	26	31A	56
1/A																
2																
3																
4/A																
5																
6																
7																
8																
9																
10/A		X														
11																
12																
13		X														
14																
15																
16																
17																
18		X														
20		X	X									X				
29																
30		X														
33																
35		X	X	X					X							
36		X			X					X				X		
37																
38		X														
39/A																
40						X	X	X					X			
41		X												X		
42		X														
43		X														
44								X								
45		X														
47																
48			X						X	X	X					
49	X								X				X			
50																
51																
52		X				X							X	X		
53		X						X	X					X	X	
54	X		X			X	X					X			X	
57	X				X	X	X		X	X	X	X			X	
61	X		X			X	X							X		
62	X		X				X					X		X		
64									X							
67			X			X						X				
69						X								X		X
72						X									X	
73						X									X	X
	P-1	5	47	FDJ	FD0	P-4	28	42	36	37	FD-P	33	45	26	31A	56

Appendix 2
List of Plates for Numbered Large Outline Transfers

This listing is intended as a cross-reference to aid in the identification of individual outline transfer patterns. Collectors vary in their ability to remember details. Those having difficulty in making a comparison of molds may excel in making a comparison of outline transfers. We also recognize some collectors concentrate on a given decorating pattern upon forming a collection. We hope this listing will make it unnecessary for one to cut the book apart in order to gain ready access to the most frequently used material.

Transfer Number/Examples (by Plate Number)
1: 62, 92, 96, 106, 161, 177, 190, 191, 200, 201, 499, 546, 592, 594, 595
2: 98, 107, 149, 198, 199, 510, 548, 599
3: 30, 55, 78, 94, 176, 187, 260, 496
4: 32, 42, 61, 72, 89, 91, 93, 102, 122, 158, 166, 167, 168, 170, 174, 180, 501
5: 120, 138, 141, 145, 205, 231, 241, 245, 248, 280, 286, 289, 297, 331, 492
6: 13, 35, 86
7: 27, 99, 147, 154, 194, 202, 229, 238, 240, 242, 254, 257, 264, 291, 507, 541, 551, 584, 600
8: 250, 272, 318, 321, 322, 327
9: 114, 137, 219, 295
10: 237
11: 208, 239, 243, 258, 265, 276, 296, 319, 320, 323, 325, 326, 329, 597
11A: 80, 143, 146, 155, 156, 193, 220, 225, 230, 279, 282, 495, 532, 538, 567
14: 228
16: 261, 428
17: 150, 173, 205, 287, 288, 290, 315, 549, 556
17A: 148, 192, 536
18: 66, 73, 74, 79, 84, 163, 184, 506, 509, 566, 607
19: 38, 39, 57, 76, 95, 110, 123, 497, 511
20: 281
21: 65, 81, 126, 144, 221, 232, 253, 285, 554
22: 160, 162
24: 67, 234
25: 68, 130, 139, 212

26: 3, 4, 283, 347, 355, 360, 376, 502, 547, 552, 568, 593
27: 379, 604
28: 357
29: 213, 267, 270, 338, 248, 363, 370, 5 605
30: 244, 259, 316, 333, 344, 351, 354, ʒ 583
31: 210, 218, 236, 293, 306, 308, 314, 346, 359, 371, 373, 504, 519, 540, 553, 586
31A: 385, 389
33: 313, 328, 374, 526
34: 136, 203, 205, 217, 249, 274, 278, 307, 309, 312, 343, 352, 361, 362, 388
36: 330
37: 336
38: 500
39: 48, 233, 572
40: 132, 223, 366, 367
42: 267, 271, 292
43: 105, 111, 182
44: 216, 378
45: 275, 332, 601
46: 103, 104
47: 364
48: 179, 263, 402
49: 246, 468
50: 467, 585
53: 411
57: 251
58: 43, 565
60: 54
61: 17, 60, 63, 83, 101
62: 587
63: 69, 87, 171, 512
65: 196, 202, 503, 603
66: 113, 121
67: 369
68 124
70: 353
71: 380, 382, 383, 384, 390
73: 20, 21, 22, 115

Appendix 3
Plates Illustrating RS Wing Marked Objects

R.S. Wing marked objects are exceptionally hard to find, as they are among the earliest marked examples of R.S.Prussia. We have included all examples known to us, yet we provide less than two dozen illustrations. The presentation of R.S. Prussia by the different types of mold patterns does not allow us to group all R.S. Wing marked objects into one section. Here, we provide the cross reference needed to locate R.S. Wing marked examples. This appendix allows the reader to access these examples for comparison purposes, as well as for price information.

We find it very difficult to have to hunt through a volume of illustrations to find one we are looking for. Here, we provide a complete listing of illustrations of RS Wing marked objects with corresponding mold patterns. We frequently use this information to compare a transfer pattern at hand to those of known origin. The list also facilitates the acquisition of new items, for it quickly identifies the molds we should examine when shopping.

Plate	Mold
45	OM 2
54	OM 3
57	OM 4
76	OM 7
77	OM 7
101	OM 9
158	OM 14
186	OM 17
198	OM 17C
394	OM 192
396	OM 102
398	OM 103
402	OM 105
506	
510	
535	
544	
545	
571	
581	